THE SYMBOLISM
OF THE CHRISTIAN TEMPLE

Nihil Obstat
Versailles, June 1, 1962.
André Lebas, p.s.s.,
Cens. Dep.

Imprimatur
Versailles, June 7, 1962
Pierre Dornier, p.s.s.,
Vic. gén.

JEAN HANI

THE
SYMBOLISM
OF THE
CHRISTIAN TEMPLE

SOPHIA PERENNIS

SAN RAFAEL, CA

Originally published in French as
Le Symbolisme du Temple Chrétien
© Guy Trédaniel, Éditions de la Maisnie, 1978
English Translation © Sophia Perennis, 2007
First English edition, 2007
All rights reserved

Translated by Robert Proctor
Edited by G. John Champoux
Series editor: James R. Wetmore

For information, address:
Sophia Perennis, P.O. Box 151011
San Rafael, CA 94915
sophiaperennis.com

Library of Congress Cataloging-in-Publication Data

Hani, Jean.
[Symbolisme du temple chrétien. English]
The symbolism of the Christian temple / Jean Hani.

p. cm.
Includes bibliographical references (p.).
ISBN 1 59731 066 2 (pbk: alk. paper)
ISBN 1 59731 067 0 (hardcover: alk. paper)
1. Temple of God. I. Title.
BS 680.T4H313 2006
226—dc22 2006021559

Open ye to me the gates of justice: I will go in to them, and give praise to the Lord.

This is the gate of the Lord, the just shall enter into it. . . .

The stone which the builders rejected; the same is become the head of the corner.

This is the Lord's doing, and it is wonderful in our eyes.

PSALM 117:19–23

CONTENTS

INTRODUCTION

THAT SACRED ART no longer exists today is all too clear, despite the intense efforts of some to make us believe in the value, in this respect, of the most questionable productions. We can perhaps speak of a *religious* but certainly not a *sacred* art; indeed, between these two notions lies a radical difference rather than a nuance. On the other hand, our age is at the same time paradoxically confronted with both evidence for and the most numerous discoveries of authentic sacred art ever seen. While art historians like Mâle and Focillon were listing and analyzing the riches of our cathedrals, ethnologists, historians of religion, and architects, like Eliade, Mus, Coomaraswamy, Schwaller de Lubicz, Hambidge, Moessel, Ghyka, etc., who were studying the sacred edifices of the Far East, India, Egypt, and classical antiquity, were opening previously unsuspected perspectives on the very meaning and conception of these monuments. Their conclusions, equally verifiable on our own religious edifices, particularly those of the Middle Ages, should completely overturn our ways of understanding them, dominated, unfortunately, as they have been since the Romantic era by sentimentalism, moralism, and 'aestheticism', or otherwise put, by an individualistic and 'literary' conception of sacred art. Now these are precisely the characteristics of *religious* and, of course, profane art, whereas true sacred art is not of a sentimental or psychological, but of an ontological and cosmological nature. This being so, sacred art will no longer appear to be the result of the feelings, fantasies, or even 'thought' of the artist, as with modern art, but rather the translation of a reality largely surpassing the limits of human individuality. Sacred art is precisely a supra-human art. We believe it is a matter of urgency that the consequences of this rediscovery of the meaning and principles of the art of building be put into practice at a time when so many churches are being constructed that may perhaps satisfy 'snobs' always concerned with appearing 'avant-garde', but

certainly not the true intellectual elite nor the immense majority of the people.

For this to happen, it is first of all necessary to remember the immense dignity of art, which is the translation onto the sensible plane of ideal Beauty: for Beauty is a form of the Divine, an attribute of God, 'a reflection of the Divine Beatitude' (F. Schuon) as well as of the divine Truth, which is the foundation of Being. We thus see why Beauty is 'the splendor of the True,' according to the Platonic formula. Sacred art is the vehicle of the divine Spirit. The artistic form allows transcendent and supra-rational truths to be directly and not discursively assimilated, as is the case with reason. It should also not be forgotten that art can just as easily vehicle evil influences: the ugliness of forms, when of a certain type, is a manifestation of Satanism, that inverse pole of divine Beauty, as is the case with certain productions of contemporary religious art derived to some extent from surrealism, [the demonic character of which goes unquestioned even though affirmed by their own creators.[1] To measure the true scope of sacred art, we need to grasp it in its first cause, which is the creative Word. Because, precisely, creation implies the gift of form, it can be said that the Word, as the formal principle dominating chaos, or 'light' lighting up the 'darkness', is the supreme Artist. According to Dionysius the Areopagite, the perfection of the Word is 'form informing all that is unformed'; but he adds that 'insofar as it is the formal principle, it is nevertheless informal in all that has form, because it transcends all form'. The aim of art, precisely, is to *reveal* the image of the divine Nature imprinted but hidden in creation, by producing visible objects capable of being symbols of the invisible God. Sacred art therefore prolongs the Incarnation, the descent of the Divine into the created, and regarding this we can extend the justification of icons given by the Second Council of Nicea to art in general:

1. The demonic character of surrealism is proved above all by the 'falsehood' it spreads concerning its very object; what in effect it aims to reach and calls 'surreality' is, quite the contrary, only a 'sub-reality', a mirage of nothingness, a fall into infra-human chaos, into the 'unconscious' that Gide, truly inspired on that occasion, called 'the haunt of the devil'.

The indefinable Word of the Father is Himself defined in becoming flesh. . . . Reinstating the soiled image in its original form, He penetrates it with divine Beauty. Confessing this, we reproduce it in works and actions.

Quite obviously, in an art so conceived, having a quasi-sacramental value, the artist cannot let himself be guided by his own inspirations. His work does not consist in expressing his personality, but in searching for a perfect form answering to the sacred prototypes of celestial inspiration. This is to say that art is sacred, not through the *subjective* intention of the artist, but through its *objective* content, and the latter, in its turn, is only the ensemble of visions corresponding in the domain of sensible forms to the cosmic laws which themselves express universal principles. Thus aesthetics is hierarchically linked to cosmology and through it to ontology and metaphysics. This hierarchic order determines the essential character of sacred art, which is to be *symbolic*, that is to say, to translate through polyvalent images the correspondence linking the different orders of reality, and through the visible to express the invisible and lead man to it.

Returning to the more precise object of this book, a church within this perspective is not simply a *monument*, but a *sanctuary*, or *temple*. Its purpose is not only to 'assemble the faithful', but to create an ambience for them in which Grace can better manifest itself; it achieves this to the extent that through a subtle play of influences it succeeds in channeling the flux of sensations, feelings, and ideas, and leading them within towards a goal: communion with the Divine. The temple of former times—and it is to this that we should look in order to recover a teaching conforming to principles and eventually applicable to new productions—was an 'instrument' of recollection, joy, sacrifice, and exaltation. First through the harmonious combination of a thousand symbols founded in the total symbol that it itself is, then by offering itself as a receptacle to the symbols of the liturgy, the temple together with the liturgy constitute the most prodigious formula capable of preparing man to become aware of the descent of Grace, of the epiphany of the Spirit in corporeity. We have mentioned the liturgy for it cannot be

separated from the temple, which is made for it, and we hope to show the underlying unity governing the organization of both.

These preliminary remarks, by defining the spirit of our study, should convince our readers [from the start] that we do not intend to conduct a polemical tour. There have already been numerous 'debates' about sacred art and there will doubtless be many more for a long time to come. They could even be prolonged indefinitely, we believe, and to no purpose, if the true nature of such art, particularly as it touches upon architecture and its essential principles, is not recalled. The decadence of current art is due to the near total forgetfulness of these principles; their rediscovery should once again lead artists to create works, not identical, certainly, to those of the past, which is neither possible nor desirable, but analogous, because emanating from the same spiritual source. To recall the principles: such is our aim. The merit, if any, of our reflections will be precisely never to transmit an individual point of view, but always, on the contrary, truths of an authentically traditional[2] order, the only ones that have any interest in this domain. Without in the least aiming to write a didactic treatise, we would simply like to help the reader rediscover the profound meaning concealed in a church when a church is what it should be. With the goal thus defined, the limits of our study are at the same time clearly marked; our aim is not to say all that could be said, far from it, but simply to sketch the major outlines of the symbolism of the temple and, by way of conclusion, show how it is ordered to liturgical activity.

This book is addressed to the well-informed public and not to specialists. Accordingly, we have generally abandoned giving references except when it is a question of a very particular view or a very informative detail. As for the works underlying our study, we have

2. Let us immediately define what we mean by this word, which will appear often in what follows. 'Traditional' is taken by us in its strict sense, and designates all that is in conformity with authentic, non-human tradition, which, in the domain under consideration here, assumes a double form: ecclesiastical canons, belonging to Christian art as such, and universal canons of sacred art deduced from metaphysical sciences. It can thus be seen that in our thinking the word 'traditional' signifies something quite different from 'traditionalist'.

only cited them in the bibliography at the end of the book, as constant references to them would have considerably burdened this study.

Among these works, we should especially mention those of René Guénon, which have been fundamental for us. Thanks to him the principles of architectural symbolism can be known so clearly today. Following him, and in the same spirit, F. Schuon, T. Burckhardt, A.K. Coomaraswamy and Luc Benoist have explored this domain, bringing to it a still much unappreciated light that has been of great profit to us. Finally, from a properly 'technical' point of view, the works of Ghyka have been indispensable. We are pleased to acknowledge our indebtedness to all of them; may they find here the true homage due to them.

NOTICE TO THE SECOND EDITION

For many years there has been a demand from all quarters, both in France and abroad, for the re-publication of our study on the symbolism of the Christian temple.

Indeed, the reality of the teaching reflected in this book is as urgent today as it was when it was first published, if not more so; and the situation of religious art, and especially religious architecture, alluded to in our 1962 introduction, so far from improving is today worse than ever. This phenomenon is but a consequence of the alarming deterioration in the liturgy and theology of the Western Church. Over the past few years, this now long-standing deterioration has suddenly accelerated and is in the process of becoming a veritable debacle before our eyes. And it would be a mistake to minimize the importance of this state of affairs as it concerns art, for, as we have already said—and it can never be repeated too often—the sphere of art is a favorite field of activity of the forces of subversion, for the work of art is a particularly effective way of penetrating and acting upon the soul, both for good and evil.

It is a matter of urgency, then, to recall what is true sacred art, especially since—praise God—here and there more and more active signs of resistance to the anarchy and subversion manifest them-

selves, and a pressing call is felt to recover the traditional conceptions that must form the basis and condition of any restoration.

Since 1962, the date of its first publication, many documents have come to our attention that could throw light upon or clarify some point of the symbolism of the temple. However, taking all of them into account would have meant rewriting each chapter, and to rewrite a book is always hazardous, for in doing so the rhythm animating it, that of its first inspiration, is often broken. We will rather correct certain errors here and there, adding some notes, and substantially enlarging the bibliography. This second edition is also enriched with illustrations, thanks to the kindness of Editions de Maisnie whom we cannot thank enough for having allowed this book to start a new career.

Jean Hani

1

THEOLOGICAL SYMBOLISM
AND
COSMOLOGICAL SYMBOLISM

THE SYMBOLISM OF CHURCHES is not altogether unknown to the faithful; remarks, sometimes pertinent, contained in many a consecration sermon and information gathered here and there in the course of reading cannot fail to leave traces in the memory. They are aware that the church of stone represents the church of souls or the mystical body, that the stones of the building allegorically designate the 'living stones' of the faithful, that the earthly temple recalls the heavenly Jerusalem, etc. This, however, speaks to the soul in a mediocre way only, because more often than not people remain content to proceed by way of pure and simple assertions, no doubt based on Scripture and therefore worthy of belief, but not understood and tasted in depth by the soul of the listener because, not situated in the context of a much broader symbolism that will shed light on them, they do not stimulate the spirit. On the other hand, when the attempt is made to explain the mystical meaning of the temple more fully, it is generally limited to the ingenious oversimplifications transmitted by Durandus of Mende in his *Rational of the Divine Offices*, and without other serious explanation. Thus one learns that the church's windows signify open-hearted hospitality and tender charity, that the stained glass represents the Holy Scriptures, that the paving represents the foundation of our faith or, because of their humility, the poor in spirit, that the beams joining the different parts of the church together are the princes of this world or the preachers who defend and support the unity of the

Church, the stalls emblems of contemplative souls, the sacristy, where the sacred vessels are kept, the bosom of the Blessed Virgin Mary, etc., etc. While these meanings are perhaps not to be rejected completely, it can definitely be said that they are quite secondary and superficial, and that the proliferation and abuse of this allegorizing has in large part contributed to the discrediting of true symbolism. For what importance should the latter be accorded if it is reduced to this insipid emblematic,[1] for we believe it important to distinguish with care two very different types of symbol: the intentional (or conventional) and the essential. The meanings of stalls, windows, beams etc. given by Durandus are intentional and, to a certain extent, artificial symbols, for they do not appear to be immediately justified by the nature of the object that is their primary end. The spiritual or moral meaning seems to be 'added' and is hardly convincing, for we readily feel that it is interchangeable, the best proof of this being the fact that the objects in question have sometimes been given totally different meanings, which would be impossible in true, or essential symbolism. This latter is defined by that intimate and indissoluble bond that connects the material object to its spiritual meaning, and this through the substantial and hierarchic union of visible and invisible realities analogous to that of body and soul, a union that is perceived by the spirit as an organic whole, a veritable conceptual hypostasis, a dazzling synthesis of awareness and nearly instantaneous intuition. Symbolism, in this case, simply makes explicit a spiritual reality already implicit in the object, in the heart of the object, where it lodges as the intimate being thereof. Such is the case with the water of baptism and the Eucharistic bread. But here yet another distinction must be

1. At the same time, we do not believe Durandus of Mende's book is without value. Besides the traits just cited, which could be multiplied, exact and altogether traditional symbols are to be found, as we shall have occasion to point out. The limitation is that this work is a jumble in which the good and indifferent are placed alongside each other. In any event, the *Rational* is the most complete resumé of liturgical symbolism of the middle ages; it transmits the essentials of previous authors who treated the same subject, such as Beleth, Sicard, and Honorius of Autun. — (On this literature, see J. Sauer, *Die Symbolik des Kirchen-gebandes*, 1902, pp 1–37.)

introduced. There are two orders among essential symbols, the *cosmological* and the *theological*, based upon the very nature of the objects. For example, when it is said that the church of stone is the figure of the heavenly Jerusalem, of the Bride of Christ, or the faithful soul, or Body of Christ, or Mystical Body, the symbol is a *theological* one. In its essence, this symbolism is certainly most elevated, but at first glance hardly seems so, or rather seems to the uninformed nearly identical to conventional symbolism. Now this is not the case. Theological symbols, at least the great ones, of the kind just cited, are essential symbols. Why, then, are they not perceived as that dazzling synthesis, that instantaneous intuition we spoke about above? In light of this question we are led to make an observation of the greatest importance. The reason for this failure of recognition is that a whole series of cosmological representations, an 'image' or, as Duhem put it, 'system of the world', needed to truly grasp these figures is absent from the mental system of the majority of our contemporaries. Modern man perceives the world as a conglomeration of phenomena, whereas for traditional man—in the main, until Descartes in the West—the world is a harmonious and hierarchical organism, the Christian formulation of which is found in Dionysius the Areopagite, and which, through him, goes back to Plato. The modern conception is purely *quantitative*, that is to say the world is perceived as force and matter producing phenomena. Consequently, there is no 'key' to the world, and modern science exhausts itself in discoveries, undoubtedly spectacular, but which defer the hope of a true explanation of things indefinitely. In the traditional and *qualitative* conception, on the other hand, the concern is less with phenomena and material forces than with the internal structure of the world, its spiritual architecture deduced from metaphysic, Plato's, which was adopted and adapted by the first Fathers.[2] In this latter vision of the world, or cosmology, the quasi-spiritual unity uniting the parts of the universe favors the discovery of analogies and correspondences, first of all between themselves,

2. This was the case until the twelfth century. We then notice a re-adaptation according to an Aristotelian orientation (St Thomas), a re-adaptation required by the development of minds, but always in conformity with the Truth.

and then between themselves and their ontological model, which is in God and through which God created and realized them in the order of space and time. Such is the foundation of cosmological symbolism, which is developed at two hierarchical levels: the symbolism of the part with respect to the whole within the universe, and, on a higher plane, the symbolism of the universe and its parts with the divine world.

As an illustration of this higher 'vertical' symbolism, from the world to God, we have the following words of St Bonaventure:

> Everything, in each of its properties, shows the divine Wisdom, and he who knows all the properties of beings will see this Wisdom clearly. All the creatures of the sensible world lead us to God, for they are the shadows, pictures, vestiges, images, representations of the First, All-Wise, and excellent Principle of all things; they are the images of the Source, of the Light; of the eternal Plenitude, the sovereign Archetype; they are the signs given to us by the Lord Himself.

And to illustrate the 'horizontal' symbolism of the parts to the whole and amongst themselves is a text by Mgr Landriot:

> Symbolism is an admirable science that casts a marvelous light on the knowledge of God and the created world, on the relations of the Creator with His work, on the harmonious correspondences binding all the parts of this vast universe together . . . the key to high theology, to mysticism, philosophy, poetry, and aesthetics, the science of the relationships uniting God and Creation, the natural and supernatural worlds, the science of the harmonies existing between the different parts of the universe and constituting a marvelous whole, each fragment of which reciprocally supposes the other, a center of clarity, a source of luminous doctrine.

Thus the missing element—missing to contemporary man—necessary to perceive the profound reality of the theological symbols offered by the Church for his contemplation, is restored to the

ensemble of mental representations. In fact, more often than not these theological symbols are only understandable with reference to the cosmological symbols that underlie and, so to say, subtend them, and this is so for the very simple reason that man, being immersed in the sensible world, is obliged to rejoin the divine by way of the 'figure' of this world, with the help of art, precisely. For traditional man, breathing and thinking with his whole being in an organic and hierarchic universe, there is no difficulty: for him, the cosmological symbol, the key to the theological, is present and evident, although nearly always implied, in the creations of art. For modern man, it no longer exists, and it is important to revive it.

These remarks have thus led us to define our aim in this work more precisely: starting from the facts of theological symbolism based on Scripture, we shall attempt to rediscover the underlying cosmological symbolism, sometimes near the surface, but at others deeply buried, as a result of which theological symbolism will take on all its fullness and recover all its splendor. For, as St Thomas says, 'God, like an excellent master wanting to ensure there be nothing missing in our education, took care to leave us two perfect books: Creation and Holy Scripture.'

However, before coming to grips with our subject, we have a final observation to make, which is not only connected with the above, but which is of the greatest importance in our view, for it will partly govern the whole perspective of our work. Our final observation is as follows: first, the symbolism of the temple and the liturgy is at heart cosmological, which is a fact; second, Christianity in itself and originally, however, did not possess cosmological symbolism, at least directly. The Christian—or more exactly Christic—vision of things does not assume this aspect and has no cosmological language; it is purely spiritual and mystical. And yet from the start Christianity, in its areas of expansion, encountered religious traditions which used this language; the ancient religions of the Mediterranean Basin and the Near East were what one calls 'cosmic religions', being for the most part solar, which is the usual form of the great religions said to be 'natural'. Christianity had no reason to reject the elements of these traditions capable of helping with the religious life it wished to establish. It is, on the contrary, one of the

fundamental traits of Christianity to be 'catholic', that is to say 'universal', in all domains and particularly in this matter: Catholicism has always affirmed the existence of an original Revelation, which, despite successive degenerations, persisted in a sporadic way in all religious traditions;[3] in this regard, and with all due prudence, we can speak of a pre-Christianity or, more exactly and borrowing Joseph de Maistre's words, an eternal Christianity, which is but one with that original revelation made in the Garden of Eden. From the beginning Christianity needed in particular to assume the heritage of the artisanal confraternities, above all those of the builders, who, by the very nature of their work, used a cosmological symbolism necessarily linked to that of the ancient religions.[4]

We should not be at all surprised, therefore, to discover in our sacred art the themes of this symbolism mixed with properly Christian themes, with which, moreover, they are in perfect accord through their conformity to universal sacred norms.

3. The meeting of the Jewish people with this primordial tradition in its yet pure core occurred at the moment of the investiture of Abraham by Melchizedek, the previous holder of Orthodoxy.

4. An analogous phenomenon is found in another domain, that of jurisprudence. Christianity, not having a revealed law, adopted Roman law, which, to the very extent it was acceptable, represented the natural law.

2

THE CELESTIAL
ORIGIN OF THE TEMPLE

OUR REMARKS ON THE DUAL SYMBOLISM of religious buildings
will permit us to shed light on the question that should be exam-
ined at the outset, for it conditions others: the question of the tem-
ple's celestial origin. In traditional thought the conception of the
temple is not left to the architect's personal inspiration, but is
imparted by God Himself. Otherwise put, the earthly temple is pro-
duced according to a heavenly archetype communicated to man-
kind through the intermediary of a prophet, this being the basis of
the legitimate architectural tradition.[1]

Thus, the various sanctuaries of the Old Testament were built
according to directions given by God. It is said of Betzaliel and Aho-
liab, the architects who designed the Ark of the Covenant, that God
filled them 'with ability, with intelligence, with knowledge, and with
all craftsmanship . . . with ability to do every sort of work done by a
craftsman' (Exod. 35:31, 35). Everything regarding the temple of
Moses gave rise to detailed prescriptions on the part of the Lord:
'And let them make me a sanctuary, that I may dwell in their midst.
According to all that I show you concerning the pattern of the taber-
nacle, and of all its furniture, so you shall make it' (Exod. 25:8–9).

1. One observes the existence of this celestial archetype in other domains. It was
thus that the *Book of Revelations* was composed, dictated by an angel; that the plan
of the *Lower Castle* was presented to St Theresa of Avila in the form of a resplendent
vision; that the holy icons of Christ and the Virgin were traditionally painted
according to 'acheiropoietos' (not made by human hand) images, particularly the
famous *Mandilion*, which has disappeared, but a copy of which is in the Laon
Cathedral.

David gave his son Solomon the rules received from God that would direct the construction of the temple:

David gave to Solomon his son a description of the porch, and of the temple, and of the treasures, and of the upper floor, and of the inner chambers, and of the house for the mercy seat. . . . All these things, said he, came to me *written by the hand of the Lord*, that I might understand all the works of the pattern (1 Chron. 28:11, 19).

Solomon says to God,

Thou hast commanded me to build a temple on thy holy mount, and an altar in the city of thy dwelling-place, *a resemblance of thy holy tabernacle, which thou hast prepared from the beginning'* (Wisd. 9:8).

Ezekiel, in his turn, saw in a vision a description of the temple to be built; he perceived a supernatural being, holding a measuring rod, who gave him all the measurements, together with the description, of the temple. And finally God speaks to Ezekiel:

And thou, son of man, show to the house of Israel the temple and let them measure the building. . . . Show them the form of the house and of the fashion thereof, the going out and the comings in, and the whole plan thereof and all its ordinances and all its order and all its laws. And thou shalt write it in their sight, that they may keep the whole form thereof and its ordinances and do them (Ezek. 43:10–11).

We could also cite the case of Noah's Ark, of which the details of construction and measurement were given by God (Gen. 6), for the Ark is considered a figure of the Church and, consequently, the visible temple. Among the early Fathers, the shape and dimensions of the Ark were interpreted in a clearly ecclesial sense.[2]

But we are aware of the objections about to be raised. It will be said that this conception was perhaps true for the temple of Jerusa-

lem, but not for the Christian church. At present, there exists a tendency among some liturgists to refuse to admit any connection between the Christian church and the temple of Jerusalem and, *a fortiori*, all non-Christian temples, for the Christian church has no reason for existence other than to act as a shelter for 'the assembly of the faithful', and in no way plays the role of the Hebrew temple as the dwelling-place of the Divinity, and thereby as a sacred object in itself, conforming to a heavenly model. For those holding this theory, the only true temple is the spiritual temple constituted by the community of the faithful.[3]

This is a totally inaccurate point of view which undervalues both tradition and, as we shall see later on, the very nature of things.[4] Do we counter those who advocate this thesis by pointing to the consecration ritual of churches, which ceaselessly establishes a parallel between the Christian temple and that of Solomon? Such considerations do not disturb them in the least, for, according to them, this ritual is 'overloaded' and 'burdened' with details and 'embellishments' unrepresentative of the 'pure primitive Christian conception'.

2. On this subject see J. Daniélou, *Sacramentum Futuri*, pp 86 ff. — In this work we limit ourselves to studying the architectural symbolism of the temple, not its nautical symbolism, which is less essential and has only left traces, in particular the word *nave* applied to the body of the building.

3. To clarify the question, it would be necessary to study the successive official designations for a temple (*naos*): *basilica, kyriakon* (whence *church, Kirche, Kerk*) and *ecclesia*. Cf. Ch. Mohrmann, in *Apoc. des sciences relig.*, 1962, 155–174. Regarding the mediaeval term *House of God*, it will be noticed that it is exactly the same as that of the Egyptian temple: *hat-neter* or *per-neter*.

4. At a very general level, which is only seen by dint of 'interiorizing' religion in this way, the result is necessarily a neglect of what is 'external' and a complete abandonment of it to the profane point of view. The dangers of such an attitude cannot be exaggerated. The external world is stripped of its sacred content (there are people today who claim this as 'progress'!) and in this way a breach is opened in the whole of society through which the lay spirit is precipitated. This spirit, applied first to the outer, ends by flowing back towards the inner, which is to say into the soul, where it upsets all spiritual notions. Thus the never satisfied desire of a certain exaggerated 'purity' leads to a diametrically opposite result, once again justifying Pascal: 'He who would act the angel, acts the beast.' In any case, it is this way of seeing things that is largely responsible for the decadence of our so-called 'sacred' art, which is no longer sacred at all and often barely 'religious', being the fruit of pure individual inspiration.

We will not enter into debate with these people, for we believe that our account of the realities belonging to the symbolism of the temple will of itself confound them and show that the traditional science of the men of the Church and particularly of the holy founders of the liturgy and rituals, has a quite different value from the 'historicist' science of certain modernists, which is sometimes imposed upon the vulgar, fortunately without in the least disturbing those with a true spiritual sense.

Whatever these 'purists' may think, the Christian temple, with certain differences, clearly follows on from the Jewish temple, which is what tradition asserts from the very earliest times. Regarding this, a document of capital importance is that of St Clement of Rome in which, treating of the divine offices, he says, 'by virtue of His Supreme Will, God Himself indicated where and by whom these offices should be celebrated' (*Ad Cor.*, 1, 40). Commenting on this passage, Mède very rightly says that, if the Lord said this, it was in the Old Testament, which is what St Clement wished to indicate.

Such also, it seems, was very likely the thought of St Paulinus, Bishop of Tyre and builder of its church. In his *History of the Church*, Eusebius preserved this saint's panegyric, in which he says that he raised the temple according to the principles of a divine inspiration: with the eye of the spirit fixed upon the supreme master and taking for archetype everything he saw Him do, he reproduced its image as exactly as possible, like Betzeliel who, filled with the spirit of God, with the spirit of wisdom and light, was chosen by Him to reproduce in the symbol of the temple the material expression of the heavenly type; likewise, Paulinus, forming in his mind an exact image of Christ, the Word, Wisdom, and Light, and basing himself on the model of a most perfect temple, constructed a magnificent temple to the Most High as a visible emblem of the invisible temple (x, 4, 21): the edifice was built 'according to the descriptions furnished by the holy oracles' (x, 43); and further: 'Above all the marvels are the archetypes, prototypes, and significant and divine models (of temple architecture), I mean the renovation of the reasonable and divine edifice within the soul' (x, 54). The whole disposition of the church was presented in detail with its symbolism. And the author finishes by saying that the Word, the great disposer of all

things, was Himself made a copy on earth of the heavenly type that is the Church of the 'first-born enrolled in heaven', the Jerusalem On-High, Zion, Mountain of God, and City of the living God (x, 65).

This document is interesting, for it shows that among the first Fathers the Christian conception of the temple, with its own originality, was nevertheless situated within the same perspective as that of the Old Testament: the Christian temple is the reflection on earth of a celestial archetype, the Jerusalem of the Apocalypse, presented by St John in a manner similar to that of Ezekiel. Like the prophet, St John transmitted the prototypal dimensions of this new Jerusalem, dimensions calculated by an architect angel with the help of a golden reed (Apoc. 21). This heavenly Jerusalem is the essential symbol for the study we are undertaking. It lies at the centre of the liturgy of Dedication, and from it the temple draws all its fundamental meaning. Now, the heavenly Jerusalem—and we say this to conclude the question of the archetype of construction and its references to Judaism—the heavenly Jerusalem synthesizes the Christian ideas of the 'community of the elect' and the 'mystical body' with the Jewish idea of the temple as the dwelling-place of the Most High, assuring the continuity from one Testament to the other, and hence from one temple to the other.

All of this will become even more apparent through a study of the cosmological symbolism of this heavenly Jerusalem.

3

TEMPLE AND COSMOS

EVERY SACRED EDIFICE IS COSMIC, which is to say it is made in imitation of the world. According to St Peter Damian, 'the church is the image of the world,' because our body is linked to the world, and we need to pray to God even in our bodily condition.[1] This image is first of all a 'realistic' image, in the sense that the earth and sky, animals and plants, the labors of man and the various social ranks, and natural and sacred history are represented upon the church's walls and pillars in such a way that it has been said of cathedrals that they were visual encyclopedias. But this is only an external aspect of what St Peter Damian meant, and belongs above all to large edifices. The temple is not only a 'realistic' image of the world, but even much more so a 'structural' image, which is to say it reproduces the innermost and mathematical structure of the universe. And herein lies the source of its sublime beauty. For beauty of form, says Plato in *Philebus*, (51C),

> is not what most people generally understand by this word, as for example that of living objects or their reproductions, but something rectilinear and circular, the product of the compass, cord and square. For these forms, unlike the others, are not beautiful under certain conditions, but always so in themselves.

The square shape of the heavenly Jerusalem (Apoc. 21:12 and ff.), which we shall discuss in due course, is directly related to the very

1. Let us be precise: the temple is an image of the world, but this is because the world as a work of God is sacred. The temple therefore expresses the image of the transcendent world, in God, which is the constitutive essence of the cosmos.

principle of temple architecture. Effectively, all sacred architecture comes back to the 'quadrature of the circle' or transformation of the circle into a square. The founding of the edifice begins with the orientation, which in a certain respect is already a rite, for it establishes a relationship between the cosmic and earthly or, rather, divine and human orders. The traditional, and may we say universal, procedure, for it is to be found wherever a sacred architecture exists, was described by Vitruvius and practiced in the West up until the end of the Middle Ages. The foundations of the building are oriented thanks to a gnomon enabling one to mark the axes (*cardo*, north-south, and *decumanus*, east-west). At the center of the chosen site a pole is erected around which a large circle is traced; then the following are noted: the shadow cast upon the circle, and the maximum difference between the morning and evening shadows indicating the east-west axis. Finally, two circles centered on the cardinal points of the first indicate by their intersection the angles of the square. This last is the quadrature of the solar circle.[2] It is important that the three founding operations be remembered: first, the tracing of the circle, then the tracing of the cardinal axes and the orientation, and finally the tracing of the basic square, for it is these that determine the fundamental symbolism of the temple, with its three elements corresponding to the three operations: the circle, the square and the cross by means of which one passes from the first to the second.

2. In the case of most Western churches, the plan is not a square but a rectangle flanked by three squares, two forming the arms of the transept and a third, prolonged by a semi-circle, forming the choir and apse, the whole embodying the cross of the cardinal axes. But this changes nothing of the profound meaning of the rite of foundation we are describing, because in geometry the rectangle is nothing but a variety of square, and is nearly always inscribed within a governing circle, as we shall see later. Let us also note that if the procedures used in modern times for the foundation and orientation of churches are no longer exactly the same as of yore, this in no way essentially modifies the symbolism attached to the figure and position of the building, given that this symbolism belongs to the nature of things and it cannot be avoided completely, to the extent, at least, that we do not depart too far from traditional architectural forms by adopting 'aberrant', or even 'subversive' ones. In a Coptic church the four entrances are expressly identified with the four cardinal points, as is the case with the four parts of the building in a Greek church.

The circle and square are primordial symbols. At the highest level, in the metaphysical order, they represent Divine Perfection in its two aspects: the circle or sphere, the points of which are all equidistant from the center, which is without beginning or end, represent the infinite unity of God, His Infinity, His Perfection, while the square or cube, the form of every stable foundation, is the image of His Immutability, His Eternity.[3] At a lower level, in the cosmological order, these two symbols summarize the whole of created Nature in its very being and dynamism: the *circle* is the form of heaven, more especially of the activity of heaven, the instrument of divine Activity, which regulates life on earth, the figure of which is a *square* because, relative to man, it is in a way 'immobile', passive, and 'offered' to the activity of Heaven. We have here a double symbolism, at once cosmological and ontological: Heaven and Earth—the cosmological order—are the external forms, the last stage, if one wishes, of manifestation or Creation, the two poles of which are the Universal Essence and the Universal Substance, represented in the corporeal order by the Sky and the Earth respectively. Man is the center of this creation; he synthesizes it and establishes a link between the Upper (Essence-Heaven) and the Lower (Substance-Earth): and this relation is symbolized, precisely, by the sign of the cross. We shall see later the consequences to be drawn from this observation. If we transpose this 'static' symbolism into its 'dynamic' form, we see that in its movement the celestial circle engenders the temporal cycle,[4] which, starting from its higher pole (corresponding to Heaven) unfolds towards its lower pole (corresponding to the earth), or if preferred, from the sphere, the least specified and most perfect form, to the cube, the most specified and 'heaviest' form: the vertical axis uniting them measures the very extent of the cosmos and time. It is to this role of the circle at the beginning of creation that Scripture alludes in making Wisdom say, 'When he established the heavens, I was there, when he drew a circle

3. The circle is also the symbol of the Divine Love. See St Dionysius the Areopagite (*The Divine Names*, 4, 14; *The Celestial Hierarchies*, 1, 1), and Dante (*Paradise*, 33).

4. Whence the importance of the zodiac, of which we shall often speak.

on the face of the deep' (Prov. 8:27; cf., Job 26:10). This correspondence between the cosmic and architectural orders is magnificently summarized in this lapidary formula engraved on one of the walls of the temple of Ramses II: 'This temple is like heaven in all its dispositions.'

The above point of view highlights the superiority of the circle—Heaven—over the square—earth. But from another point of view, the square, which metaphysically symbolizes the Divine Immutability, is superior to the circle as the image of indefinite movement. This is the point of view that dominates in architecture, the ruling quality of which is 'stability', without of course excluding the other aspect of symbolism, as we shall have occasion to show. From this latter point of view, which emphasizes the 'square', we can say that it is in the square that the temple in its construction fixes or 'crystallizes' the circular movements of the temporal cycles.

These two points of view apply perfectly to the 'heavenly Jerusalem' of the Apocalypse, the prototype of the Christian temple. An angel 'carried me away to a great, high mountain, and showed me the holy city Jerusalem coming down out of heaven from God' (Rev: 21:10), says St John, and a little further on: 'The city lies foursquare' (21:16). Thus the city's movement of descent corresponds to the first point of view, that presiding at the rite of foundation: Jerusalem 'descends from heaven' (circular) 'from God' upon the earth where it appears as a square reflecting the activity of Heaven, or the divine world. But, from the second point of view, this square represents the crystallization of the cycles, of temporal unfolding, which is amply proved by the twelve gates, arranged in threes on its four sides, corresponding to the signs of the zodiac. We shall speak of this again in connection with the doors of the church, where it is a question of the transformation of the zodiacal cycle subsequent to the arrest of the rotation of the world and to its fixation in a final state that is the restoration of the primordial state.[5] Regarding this, we can also note the correspondence at the two extremities of the temporal cycle between the earthly Paradise and the heavenly Jerusalem. Paradise is circular, as a direct reflection of Heaven, but divided by the cross of four rivers, the center being marked by the Tree of Life; the Tree is also found at the center of the heavenly

Jerusalem, as are the four rivers, since it is said that they flow from the mountain where the Lamb is enthroned upon a sealed book. The passage from circle to square represents the temporal rotation of the world and its cessation, which is at the same time the transmuting of this 'age' into the 'age to come'.

This relationship of circle to square or sphere to cube is truly the foundation of sacred architecture, starting from which the whole building is conceived and realized. Indeed, if we pass from the horizontal plane, which has occupied us up to this point, to the vertical, and at the same time pass from plane to three-dimensional geometry, we observe that the whole building leads back to the basic pattern of the *dome* and the *cube*. The 'dome' or vault surmounts the 'cube' of the nave, as the physical sky is 'placed' above the earth, which is why of old the majority of vaults were painted blue and covered with stars. In following the vertical that rises from the floor to the vault—an inverse movement to that presiding at the rite of foundation—we pass from the 'cube' to the 'sphere', that is to say from the earthly to the heavenly state. In following this direction, the gaze of the believer finds therein the symbol of his spiritual ascent, and thus the internal dynamism of the temple serves as a support and guide to prayer and meditation. The vertical line is the direction of heaven. It is on high that our eyes are lifted in prayer, just as the Host is lifted in offering, and it is from on high that the divine blessing descends like the rain. It is according to this dimension that God descends into man and man ascends towards God. In certain buildings an ornamental detail underlines the allusion to this spiritual ascension: the cupola of the transept is frequently surmounted with a cross or an arrow in flight, embodying the axis of

5. The twelve signs of the zodiac are sometimes called the 'twelve suns', that is to say, stations of the sun. In the heavenly Jerusalem, these 12 suns have become the twelve fruits of the Tree of Life (Apoc. 22:1–2). The form of the heavenly Jerusalem is also that of the palace of the emperors of China, the Ming-Tang. Constructed after the image of the Empire divided into 9 provinces arranged in a square with one in the center, the Ming-Tang had nine halls arranged in parallels and twelve openings on the outside corresponding to the twelve months. The four facades were oriented according to the cardinal points and the seasons. It was therefore a terrestrial projection of the zodiac.

the vault, which signifies the exit from the cosmos in imitation of Christ who, at the time of the Ascension, rose 'above all the heavens'.[6] Belfries repeat the dome-cube pattern when their towers are capped with a spherical calotte, which is rare in the west, or with an octagonal or hexagonal 'pyramid', the form of which constitutes an intermediate phase in the passage from the sphere to the cube.

On the horizontal plane, the spherical and heavenly element of the dome and vault is reflected in the semi-circle of the apse, which, on earth, is the most 'heavenly' place, corresponding to the Holy of Holies of the Temple at Jerusalem, Paradise, and the Church Triumphant. At Issoire, so as to mark better the heavenly character of the apse, its circular chevet bears the twelve signs of the zodiac sculpted on the outside. In this semi-circle prolonging the rectangle of the nave, we sees that the basic basilica plan is a plane projection of the vertical volume of the building. The axis of the nave, from the door to the sanctuary, is therefore also the plane projection of the vertical axis from the ground to the vault, from earth to heaven; this is why it also represents the 'Way of Salvation'.

This is also true of the portal, which is a rectangle surmounted by an arch, and for the ciborium, which surmounts the altar and is composed of a dome on four columns. In the last instance, the dome has clearly been felt to represent heaven, since on occasion it is painted blue and covered with stars just like the vault of the nave. An example of this is the ciborium situated above the cistern at the Baptistery of Dura (third century).

The sacred building appears then as a symphonic variation of the same architectural theme, indefinitely repeating and adding to itself, so as to recall the fundamental symbolism of the temple, the union of heaven and earth, the 'tabernacle of God amongst men,' as St Maximus the Confessor magnificently put it in his poem on St Sophia of Edessa:

6. By means of this cupola, which is sometimes replaced with a tower lantern, the whole building 'takes on height' and is identified with the cosmic mountain, the prototype of the Hindu temple. This aspect appears clearly in the Greek church, the Romanesque church of Auvergne, and above all the Russian church.

Truly wonderful it is that in its smallness, (this temple) is similar to the vast world. . . .

See how its roof spreads out like the heavens; without columns, arched and closed; and ornamented, too, with golden mosaics, as is the firmament with brilliant stars.

And see how similar its lofty cupola is to the heaven of heavens and how, like a helmet, its higher part rests solidly on its lower.

Its vast and splendid arches represent the four sides of the world, and by the variety of colors, resemble the glorious rainbow, too.

The allusion to the vertical axis of the vault takes us back to an aspect of the foundation rite that we have neglected until now. Earlier we mentioned that the first act consisted in tracing a large governing circle on the ground starting from a center marked by a pole. This pole is itself an axis and represents the future vertical axis of the building; we shall see the full importance of this remark when we come to speak of the altar. For the moment, let us content ourselves with considering the operation itself. It constitutes the fixing of a center, and in architectural symbolism such a center is regarded as the center of the world: it is an *omphalos*. Any point on the surface of the earth can in fact be taken as the center of the world, since all vertical lines radiating towards heaven from all the points on the earth are 'infinite', as is the distance to the stars. When the center is chosen and oriented to the heavenly rhythm, it is truly assimilated to the Center of the World, to that immobile axis around which the 'cosmic wheel' turns. This center, or axis, symbolizes the Divine Principle acting in the world, God the 'Immovable Mover'. This is a sacred point, the place where man comes into contact with the Divinity, and this is why all holy cities, like all temples, are symbolically situated at the 'center of the world'. This is true of Jerusalem, which also was itself a reflection of the heavenly Jerusalem.[7]

A building derives all its meaning from orientation and the determination of a center, which is what allows us to justify the cosmic symbolism of architecture, the interest of which perhaps seems evident to few people today. The church, being an *oriented* and

centered cardinal cross, truly sanctifies space. It is the *omphalos* of the city from which it radiates, as the cathedral is the *omphalos* of the diocese, the metropolia that of the nation, and the papal basilica that of the universe.

7. All these considerations will be developed more fully with regard to the altar (p 86 ff). It appears that in the *Ecclesia Major* of the Holy Places, precisely in the apse, there was a spherical omphalos similar to that at Delphi. See M. Piganiol, *Cahiers archeologiques*, 1955. Moreover, according to Cyril of Jerusalem, the place where Christ died and rose is the omphalos of the redeemed world (PG 33, 805).

4

NUMERICAL HARMONIES

THE CONSTRUCTION OF THE TEMPLE imitates the creation of the world. From different points of view, the same applies to the operations of all the trades and arts, for it is said that man was placed on earth *ut operaretur* 'in order to work therein', that is to say, to continue creation. Essentially, creation is *cosmos* succeeding *chaos*, that is to say order or organization out of disorder or the 'tohu-bohu' of Genesis. *Ordo ab chao*. It is Spirit penetrating unformed Substance. In the same way, the architect makes an organic building out of raw material and in doing so imitates the Creator, who, following Plato, has been called the Great Architect of the Universe, for, as the philosopher further said, 'God is a geometer'. Geometry, the basis of architecture, was until the beginning of the modern era, a sacred science, and its formulation in the west comes precisely from Plato's *Timaeus* and, through it, goes back to the Pythagoreans.[1]

The metaphysical foundation of this symbolism is as follows: geometric forms translate the internal complexity of the Divine Unity, and the passage from indivisible Unity to multiple Unity—the metaphysical formulation of creation—finds its most adequate symbol in the series of regular geometric figures contained in the circle, or regular polyhedra within the sphere. This leads to a consideration of the role of Number, which in traditional thought is

1. In the West, it was through St Augustine that the Platonic mysticism of number was transmitted to scholars. In his treatise *De Musica*, St Augustine developed this idea that Number guides the intelligence from the perception of creation to divine reality. He also expounded the theory according to which music and architecture are sisters, daughters of Number and mirrors of the eternal harmony. Builders in the Middle Ages knew the analogy between architectural proportion and musical intervals, and sometimes inscribed it in stone.

not only something quite different from 'figure' but, in particular, is always considered in relation to geometry. For Plato, the five regular polyhedra are the archetypes of creation. Number thus conceived is therefore the model of the universe: 'Everything is arranged according to Number,' said Pythagoras, in a *Sacred Discourse* reported by Iamblichus, which is something a Christian cannot doubt, for Scripture says as much. As Pius XI said, 'The universe is only as resplendent with divine beauty as it is because its movements are regulated by a divine mathematical combination of numbers, for according to Scripture God created everything 'with *number, weight* and *measure*'. Things have a mathematical structure, which is the copy of the model perceived by the Word, the Creative Logos. This structure, resulting from Idea and Number, is the only true reality of things; Number is the governing archetype of the Universe:

Everything Nature has systematically arranged in the Universe appears to have been determined and ordered as a whole and in its parts according to Number, through the foresight and thought of Him who created all things; for, like a preliminary sketch, the model was fixed for the domination of Number pre-existing in the mind of God the Creator of the world, a number-idea purely immaterial under all relationships, but at the same time the true and eternal essence, such that with it as with an artistic plan, all these things, together with Time, movement, the heavens, stars, and all the cycles of everything were created (Nicomachus of Gerasa).

In particular, this mathematics explains what at first appears inexplicable to the admirer of cathedrals; their subtle ambience, the quasi-divine harmony and the impression of perfection they produce does not depend upon *subjective* intentions, religious sentiment, or affectivity of the artist—as is thought these days—but upon *objective* laws arising from the Platonic geometry transmitted to the organizations of builders. For them, the essential element was the notion of *relationship* and *proportion* between the different parts of the building. The principal one, still called 'the divine proportion', was the famous 'golden number' or 'golden section' (1.618 = Φ).

Through a subtle analogy, a eurhythmy based upon this golden number linked forms, surfaces, and architectonic volumes. The two numbers that played the biggest role in the construction of these forms and volumes were the Decad, whose root is the *Tetraktys* (sum of the first four numbers: $1 + 2 + 3 + 4 = 10$), and the Pentad. The Decad was the very number of the Universe, the basis of the generation of every figured number, plane or solid, and therefore of the regular bodies corresponding to certain of them, and the basis also of the essential musical chords. The Pythagoreans called five the nuptial number, that is to say the abstract archetype of generation, for it unites the first even number, called the 'matrix', to the first uneven called the 'male' ($2 + 3 = 5$). Five is the number of harmony and beauty, particularly in the human body. The pentagram or five-pointed star was the symbol of creative love and harmonious, living beauty, the expression of this rhythm imprinted by God upon universal life. It serves to determine harmonic correspondences for, among all the starred polygons, it is the one that directly yields a rhythm based upon the 'golden mean or number', which is the characteristic par excellence of living organisms. This proportion, however, is also found in figures derived from the *decagon*. It has been shown that the structures of inorganic beings are governed by regular figures resulting from the cubic or hexagonal type, whereas those of organic beings follow a pentagonal symmetry. Thus a square or hexagonal symmetry expresses an inert 'mineral' equilibrium, whereas a pentagonal expresses a rhythm of living growth. These two symmetries have been shown to be most skillfully combined in traditional architecture. Moessel, who made a list of the principal monuments of Egypt, Greece and Rome, has shown that all the geometric diagrams (plans or sections) can be reduced to the inscription within a circle or several concentric circles of one or several regular polygons.[2] This brings us back to the foundation rite, for often the governing circle of the plan derives from the circle of orientation mentioned above. This governing circle is segmented either 'astronomically' into 4, 8, or 16 parts, or, more generally, into 10 or 5,

2. E. Moessel, *Die Proportion in der Antike und Mittelalter.*

that is to say by means of the inscription within it of a regular deca-
gon or pentagon which results in radiating plans in which the ele-
ments and their combinations are connected by series of
proportions based on the 'golden number'. Sometimes there are two
concentric governing circles: the bigger one, divided into 8 or 16,
envelops the perimeter of the building, while the other, divided into
5 or 10, corresponds to the inner outline; the major altar always
occupies one of the centers. This mixture allows for a eurhythmic
compensation: the division of the circle by 4, 8, or 16 gives an
impression of stability, the division by 5, an impression of organic
life, for the architectural 'impulses' are then imitative of those of liv-
ing beings.

A remarkable example of these numerical harmonies is to be
found in the Cathedral of Troyes.[3] The body of the building, from
the entrance to the semi-circle of the sanctuary, is inscribed within
a golden section rectangle;[4] the semicircle of the sanctuary is
inscribed in a half-decagon with a 4.40 side, which is the golden sec-
tion of the radius of the circumference passing through the axis of
the pillars of the sanctuary (radius = 7.10). Now remember that the
decagon derived from the tetraktys was, according to the *Timaeus*,
the ideal figure used by God in laying out the universe. Measure-
ments made in the central nave have shown that the piers of the
structure widen gently as they approach the sanctuary according to
a golden modulation, so that 'at each bay the faithful who approach
the altar cross a new golden threshold.' In the same way, in the side-
aisles, the relation of the height of the capitals to that of the key-
stone of the vault is 'golden', as is the distance between the piers in
relation to the height of the framing capitals. To this plastic har-
mony, moreover, is added a yet more mysterious one of a mystical
order. It has been noted that the height of the choir keystone, when

3. All that follows is based on Ch.-J. Ledit. An abundance of architectural dia-
grams can also be found in the books of Ghyka, who has served as our guide in this
matter, and who summarizes and coordinates the results of Hambidge, Lund, and
Moessel, in particular.

4. This is a rectangle two sides of which are in a golden relationship, that is:
$L/1 = \Phi = 1.618$.

reduced to feet and inches, as it should be, is 88 feet 8 inches. Now the number corresponding to the name of Jesus in Greek is 888.[5] What is more, the immolated Lamb and the triumphant Christ are represented on the keystones of the choir vault at this height of 88.8, and in some measures of the window where St John writes his prophecy. The number 888 is also found around the altar (symbol of Jesus): the sanctuary is surrounded with 8 pillars and it opens out onto seven pentagonal apses representing the raying-out of the 7 churches of the Apocalypse. The Johannine Book seems to have thoroughly dominated the inspiration of this building, for the other pillars, with the exception of those of the choir, are 6 feet 6 inches tall and the vaults are supported by 66 pillars: this is related to another Apocalyptic number: 666, which is the number of the Beast (Apoc. 13:11 and 18) that the pillars should crush.[6] We recognize a third Johannine number, 144,000, the number of the elect: in the triforium, from the chevet to the western rose window, there are 144 windows in which all those bearing the seal of the Lamb shine. Finally, the angle at the summit of the triangle traced from the keystone of the sanctuary vault to the base of the great piers measures 26°; now, 26 is the number of the great Divine Name: YHWH.

5. This figure is the result of an operation arising from *gematria*. Gematria is a traditional science that aims at interpreting words symbolically by the corresponding value of their letters. Obviously this operation is only possible in languages with letters having a numerical value, such as the Semitic or Greek. Thus 888 is the result of the addition of the six Greek letters composing the name IHCOVC: $I(10) + H(8) + C(200) + O(70) + V(400) + C(200) = 888$.

6. In fact, we shall see that the pillars symbolize the Apostles. The number 666 is generally obtained by adding the letters of *Cesar Neron* according to their Semitic value. Let us point out, however, the little-known but yet far more meaningful interpretation of Mgr Devoucoux: 666 = *k-elohim* (like God), the name given to Adam and Eve by the Tempter: 'You shall be like God', and through an absolutely remarkable convergence we also have 666 = *panathesmios* (in Greek = those beyond-the-law, the wicked). Mgr Devoucoux places the number of the Beast alongside that of the Elect: 144,000, that is 144 x 1,000: 144 = *qedem* (old), 1,000 = *aleph* (family, community, doctrine); the number of the elect therefore designates simultaneously 'the original, orthodox teaching' and 'original humanity' restored at the end of the ages. These two numbers, 666 and 144 000, says the learned archeologist, are 'the two most natural numerical hieroglyphs of the idea of Revelation and of the idea of philosophic investigation free of every rule.'

With regard to the observations above, Troyes is not an isolated case. The majority of traditional religious buildings were definitely constructed not only according to the 'golden mean', but also according to 'gematric' relations, which is to say that their measurements were based on the numerical value of Hebrew or Greek 'Divine Names'. From this last point of view, the temple appeared as a divine name captured in stone, whereas, from the point of view of golden proportions, it was the crystalline form of spiritual archetypal numbers.

In our view, Mgr Devoucoux's barely known research (see the bibliography) is decisive in this regard. There can be no question even of summing up his learned writings here. We shall only draw some important conclusions from them, which will confirm by analogy the results obtained at Troyes. Mgr Devoucoux shows that the temples of Janus and Cybele were constructed according to the rules of gematria, as was the temple of Artemis of Ephesus, who was assimilated to Isis in late antiquity. In the latter building the length and breadth, respectively of 425 and 220 feet, corresponded to the invocation *Isis ei is* (Thou art powerful, O Isis). This architectural conception passed to the Christian builders and thinkers. Already among the authors of the first centuries we find the idea that the three dimensions of the Hebrew sanctuary gave a number equivalent to Isho, the name of Jesus, calculated in a certain way. At Tournus, the proportions of the oldest part of the church are based on the Hebrew name AMUN, identical to AMEN, which is a Divine Name meaning 'faith', or 'fidelity', and especially applied to Christ in the Apocalypse. AMUN, or 2,296, divided by 26 (= YHWH), gives 88 + 8/26, an incommensurable number that Mgr Devoucoux calls 'the harmonic progression of the name of Jesus' (in Greek: 888). These proportions are found again at Rouen, specifically at Saint-Ouen and in the Lady Chapel of the cathedral. At Autun, the length and breadth of Saint-Nazaire, 144 and 113 feet respectively, correspond to the words KEDEM (old/ancient) and PHELAG (divider), which designate the types of the square and diameter; their sum, 257, is equivalent to NAZER (the crown of the prince), a word that 'assonates' with Nazarius and ultimately means: the crown of King Jesus, the Nazarene, NAZARENUS.

Still at Autun, at Saint-Lazare, the following correspondences are found: total length = 240 = ROM (power, strength); breadth of the three naves = 65 = ADONAI (Lord); breadth of the transept = 95 = DANIEL (judgment of God); height of the cupola = 90 = MAN (the efficient Cause, name of the original legislator). The sum of these four numbers, 490, assumes a very complex meaning that the author strives to elucidate. At one end of the transept, there are five windows of which the number is 650, that is to say ADONAI (= 65) multiplied by 10 (= the law of rigor); but this notion is tempered by the light coming from three opposite windows, which windows yield 390, which also designates the 'city of the heavens', the number being obtained thus: 364 (= HA-SHATAN, Satan) + 26 (= YHWH). On the arch of the transept where the 3 windows cast their light, the measurements give 416, that is, 390 + 26 (further addition of YHWH) = 416 = 'the true sheep' of the Good Shepherd. This measurement, 416, is that of the length of Saint-Ouen (Rouen), whereas at Notre Dame in Paris we have 390, and at St Peter in Rome, 607 (= ROTHA, the dove, the celestial vision).

According to Mgr Devoucoux, the proportions of Cluny, 415 x 226, were an allusion to those of the Artemision of Ephesus and a rectification of the latter in the direction of traditional orthodoxy; their meaning was: 'The Cross is the test that purifies. The Lord is the Mighty God, Absolute Life.' Gematria was certainly also used in the buildings at Citeaux. The church of Citeaux is 282 feet long and 60 wide. 282 = BAIR (*in hoste*), 60 = DUN (*judicium*), that is to say: 'judgment against the Enemy'. 282 + 60 = 342 = BOSHEM (sweet-smelling unction), which is to say, the Cross, which according to St Bernard, is the great remedy against the spiritual Enemy. The dormitory yields length = 168 feet, breadth = 50 feet. 168 = KAPP (pure), 50 = KOL (all), which is immediately understandable. Finally, the chapter, which is the place of 'faults' and judgments, measures 60 x 60 feet; 60 = DUN (judgment).

To complete these valuable indications and show that gematria served not only to determine the dimensions of a whole building but also to specify its least details, let us mention a fact not reported by Mgr Decouvoux. At least a quarter of the tiles of the Liberian basilica in Rome, constructed under Sixtus the Fifth (422–444), are

marked with an acronym composed of three Greek letters the numerical sum of which designates the Holy Trinity: XMΓ = 643 = HE HAGIA TRIAS.

All these considerations, which have led us to a temporarily abandon our examination of cosmic symbolism, enable us to understand how, always thanks to 'numerical harmonies', theological symbolism, and in particular that of the Heavenly Jerusalem and the Divine Names, can be added and adapted to cosmic symbolism. We thus discover with wonder the hidden and unsuspected riches that make of these temples 'intelligent' monuments in the strongest sense of the term.

As conceived in sacred tradition, the temple in itself, and before any liturgical action, is already a *divine revelation*. It continues the cosmic revelation of the Word or Logos in creation. Indeed, Christ can be envisaged under three aspects: the celestial Word, Second Person of the Trinity; the cosmic Word or creative Logos; and, finally, the Word incarnate, or God-Man. Under His second aspect, He is the internal disposer of the world, who through His Wisdom, His Sancta Sophia, penetrates its smallest parts, sustaining them in existence and giving them their form. It is this aspect of the Word that is first expressed by the temple, before the aspect of the God-Man. And this is necessary if the temple is to answer fully to its purpose, which is to be the residence of God among men—that is to say, in the corporeal world first of all—and the place of His Glorification and the spiritualization of men and the whole world through the Holy Liturgy. In fact, every spiritual act aimed at bringing us back to God initially requires a reintegration of all the positive aspects of the world and of their inner equivalents in man in a sort of symbolic *furnace* where they are sublimated before being offered up. The temple is precisely this furnace: it not only represents, but *is* regenerated nature, insofar as a mystical entity like the Church (here again, we see the juncture between cosmic and ecclesial symbolism); it is regenerated nature to the extent that, by means of its very construction and structure, it already shows the Spirit, the Immanent Spirit, descending through its Energies into Substance for the ordering of the world. The temple is a sanctified and consecrated cosmos.

5

RITUAL ORIENTATION

THIS SANCTIFICATION OF THE WORLD, of space, also appeared
clearly in the orientation of the building.

Orientation is of prime importance in traditional civilizations,
and if this should astonish our contemporaries, it is because they
are unaware of the real motives. Furthermore, despite what certain
people might think, the Catholic Church has never abandoned the
principle of the orientation of religious buildings. Accordingly, we
shall not be wasting our time by focusing a little on this aspect.

We have seen that orientation was part and parcel of the founda-
tion rite, in the tracing of the cardinal axes within the governing cir-
cle. The Christian church is ritually oriented on the east-west axis,
with its head (chevet) turned towards the east. This is an attested
tradition from the very earliest times. The orientation of churches is
prescribed in the *Apostolic Constitutions,* which, while perhaps not
going back to the Apostles themselves, nevertheless reflect the oldest
customs (II, 7). It flows moreover from the ritual orientation for
prayer. Hipparchus, a member of one of the first Judeo-Christian
communities, had in his house a specially arranged prayer-room
with a painted cross on its *eastern* wall. It was there, *facing east,* that
he prayed seven times a day.[1] Origen, basing himself on the text,
'[O]ne must rise before the sun to give you thanks, and must pray
to you at the dawning of the light' (Wisd. 16:28), wrote in his *Trea-
tise on Prayer,*

1. *The Acts of Hipparchus and Philotheus,* cited in J. Daniélou, *The Theology of
Jewish Christianity* (1964), p 268.

Since there are four cardinal points, north, south, west and east, who would not immediately acknowledge that it is perfectly clear we should make our prayers facing, since this is a symbolic expression for the soul's looking for the rising of the true Light.[2]

For his part, St Augustine says, 'When we stand up to pray, we turn towards the east, the place where the sun rises.' Corippus, a sixth century Christian poet from Africa, explains it in the following way: 'The pagans had no laudable reason for observing the ancient custom of turning to the east when praying, for they foolishly believed the sun to be God. But when the creator of the sun duly wished to make himself visible beneath the sun, and God himself had taken flesh in the womb of the Virgin, this adoration then related to Jesus Christ.'

This ritual orientation for prayer has been perpetuated throughout the Christian centuries. Thus, in the twelfth century it is attested in what is however a thoroughly worldly work, the romance of *Tristan and Isolde*. When Isolde found Tristan dead, 'she turned to the east, and with great pity prayed for him.'[3]

In Corippus' text, as in St Augustine's and Origen's, we find an indication of the essential motive for orientation: the sun rising in the east is the symbol of Christ who is called 'Sun of Justice' and 'East' ('I shall bring My servant the East,' Zech. 3:8). St Thomas Aquinas summarizes the reasons justifying the rule of orientation, saying, 'It is fitting that we worship facing east: first, to show the majesty of God, which is manifested to us in the movement of heaven, which starts from the east; secondly, because the earthly Paradise was in the east and we are looking to return there; thirdly,

2. XXXII. Origen's lines will help to fathom the true meaning of ritual orientation, the symbol of inner orientation, which is none other than 'good will', that is to say, right will, and finally the 'Way', namely Christ, who said, 'I am the Way.' The symbolism of orientation works on three planes: on the physical plane it refers to the East, the visible sun, and the city of Jerusalem; on the subtle plane, to 'good will' and the 'straight path'; on the spiritual plane to the Divine Sun, the Light, the Way, that is to say to Christ.
3. Thomas, *Tristan and Isolde* (v. 625 ff.).

because Christ, who is the light of the world, is called East by the Prophet Zechariah and because, according to Daniel, 'he rose to the heaven of heavens, in the East'; fourthly, and, finally, because it is from the east that He will come on the last day, according to the words of the Gospel of St Matthew (24:27): 'For as the lightning comes from the east and shines as far as the west, so will be the coming of the Son of man.'

The last motive emphasizes the Parousia, the glorious return of the Lord. And we can imagine what value ritual orientation had for the Christians of those early years when, at the end of the Easter vigil for example, as they awaited the resurrection of the Savior, they could not help but see in the first rays of the visible sun that illumined the temple the promise and pledge of the glorious Return. This ritual orientation for prayer was so important that in the Constantinian basilicas in Rome, which it had not been possible to orient towards the east and which had their chevets to the west, the altar was turned around so that the priest could face east during the holy mysteries.[4] Accordingly, the principal axis of a correctly oriented temple points east-west with the choir and altar on the side from whence come the rays of the visible sun and those of the 'Sun of Justice' whose light 'lightens every man coming into this world.' The nave is a long rectangle or square, extending from east to west: the door is to the west, to the setting of the sun, the place of least light, symbolizing the profane world or even the land of the dead. In entering through the door and advancing towards the sanctuary, we go to meet the light. This is a sacred journey and the rectangle is like a road; it represents the 'way of salvation', that which leads to the 'land of the living', to the 'city of saints' where the Divine Sun shines.[5] The temple itself, parallel to the equator, moves with the earth, and goes to meet the Sun and the Eternal East. The secondary axis (transept) points to the north and south, and thus the very

4. And not, as has been claimed, in order to face the faithful, with the intention of making it a more 'communitarian' celebration.

5. In Egypt, the Holy of Holies was sometimes identified with the *akhet*, the 'eastern horizon', or with the primordial hill over which the sun rose on the first day of the world.

shape of the temple is that of the cross of the cardinal axes. Now these axes correspond to the two lines respectively joining the two solstitial and the two equinoctial points, that is, the horizontal cross. If on the other hand, we consider the line joining the poles, which is perpendicular to the plane of the equator, we have the vertical cross. These two crosses, which have the same center, together form the solid or three-dimensional cross, which defines the very structure of space, a space qualified by the directions corresponding moreover to the movement of the seasonal cycle and the sun. We encounter this solid cross as an ornamental motif in Greek Churches and even in certain Latin Churches. And so, from the point of view of its plan, the temple reproduces the cardinal axes or four directions of the world related to the four seasons of the annual cycle, whereas, if we consider its volume, it is identified with the whole of space, being in fact a solid cross. The vertical axis, which passes through the center of the governing circle which is generally also the center of the transept, is identified with the Axis of the world joining the two poles, the already alluded to image of the 'Unmoved Mover'. This three-dimensional cross has branches oriented according to the six directions of space (the four cardinal points, zenith, and nadir), which, together with the center itself, form the septenary. Now, seen as the polarization of undifferentiated space, which is like the Divine Unity, the directions of space in relation to a center, correspond to divine Attributes. Indeed, Clement of Alexandria tells us that from God, 'the Heart of the Universe', issue indefinite extensions, one of which is directed above (zenith), another below (nadir), this one to the right (south), that one to the left (north), one to the front (east), another to the back (west):

> turning His gaze in these six directions, none of which extends further than the others, He accomplishes the world; He is the beginning and the end; in Him the six phases of time are accomplished, and from Him they receive their indefinite extensions; herein resides the secret of the number seven.

St Paul makes use of the same symbolism, when he speaks of 'the breadth and length and height and depth' (Eph. 3:18) of the love of

Jesus Christ. The breadth and length correspond to the horizontal cross, the height and the depth to the two halves of the vertical axis.[6] This is the manifestation of the Logos in the world, at the center of all things, in the primordial point, of which all extensions are only the expansion. The three-dimensional cross thus sums up space, and this space symbolizes the universe filled with God. The polar axis is the line about which everything rotates: it is the principal axis. On the horizontal plane, the solstitial and equinoctial axes run from north to south and east to west respectively. We shall soon see that this cosmic meaning of the cross is far closer to its usual meaning than would be supposed at first sight.

The above remarks will perhaps shed light upon one of the more mysterious rites in the consecration of churches. We have in mind the *Inscription of the double alphabet*, which is performed immediately after the opening of the door and the entrance of the bishop into the new temple. A St Andrew's Cross or large elongated X, joining the four corners, is traced in ash on the floor of the nave. Using the tip of his cross, the consecrating bishop inscribes both the Greek and Latin alphabets (formerly, sometimes, the Hebrew alphabet) on the branches of this cross. Various rather unsatisfactory explanations of this rite have been offered. According to Durandus of Mende, it signifies the union of Gentiles and Jews (why, when the Hebrew alphabet is not inscribed?), the letters of the two testaments (why?) and the articles of the Faith (why?). According to a treatise of Remi, an eleventh century monk of Autun, the cross and the alphabet, starting from the eastern corner and pointing to the western,

6. In light of this, it is interesting to read a passage from the life of St Mechtilde: 'One Good Friday, St Mechtilde, in her love, wrote "O, dearly Beloved of my soul, if only my soul were of ivory, that I might fittingly bury You there!" To which Jesus replied, "It will be I who shall bury you in Me. I shall be *above* you—hope and joy—and shall raise you; *within* you, a vivifying life, a wealth that will gladden and enrich your soul; *behind* you, a desire that will push you forward, and *before* you, a love that will allure and attract your soul; *to your right*, I shall be the praise that gives perfection to all works; *to your left*, a support of gold to support you in tribulations; *below* you, I shall be the firm foundation bearing your soul."' (Cited in R. P. Saudreau, *Les divine paroles*, Vol. II, p182.) In perfect conformity with Clement's text, the divine presence is affirmed here in six places around the saint, and in a seventh, within herself.

signify that the Faith came from the East to the West and that the peoples are joined in a common center (that of an X).

The most interesting explanation is Rossi's, who sees in the oblique cross a reminder of the two transverse lines or diagonals that Roman surveyors traced on land to be measured; the letters will be reminders of numeric signs combined with lines for determining the dimensions of the perimeter.[7]. Thus, in a way, it is a sign of the taking possession of a piece of ground in the Name of Christ. But perhaps we can go further. Is this cross not a recollection of that which served for the *squaring of the circle* at the foundation? Its inscription within the rectangle, the base of the building, will recall the celestial movement and its symbolic insertion in the church. Finally, we believe the rite can be clarified by linking it to a symbolism of Jewish origin, related to what was said a moment ago about the six-directional cross. In fact, the most enigmatic element of the rite, at first sight, is the inscription of letters. Now, it needs to be remembered that among the Hebrews, as also the Arabs, Egyptians, Hindus and many other peoples, language, and therefore the alphabet, is considered sacred. In the Hebrew tradition, there is a mystical current according to which the letters of the alphabet have a creative power. This current could very well have influenced the consecratory rite of our churches. The mystical book entitled *Sepher Yetsira* teaches that the Divine Word created the world by means of Number and Letters. Furthermore, in this doctrine the symbolism of the Letters is related to that of the spatial directions as expounded by Clement of Alexandria, who, moreover, very probably used a Hebrew source. According to the *Sepher Yetsira*, God, from the 'inner Palace' which is the 'Center', made his activity felt in the six directions, and these are the three letters of the Great Divine Name: YHWH (the fourth, H, being but the repetition of the second), which, through their sextuple permutation according to the six directions of space, made the formation of the universe possible.

The hypothesis we are advancing is all the more probable in that the Greek alphabet was traced on the cross on the ground, and the two extreme letters thereof, A and Ω, are the well-known mystical

7. In Dom Cabrol, *Le Liver de la Priere antique.*

acronym of the Word, the Beginning and the End, and so the cosmic extension of the Word both in space and time.[8] It is also possible to support this hypothesis with other converging symbolisms. In Greek, the X is the first letter of the name of Christ—ΧΡΙΣΤΟΣ— and in Latin it represents the number Ten or the Decade, which we have seen is the Pythagorean and Platonic symbol of multiple Unity, of the Creation in its perfection. Thus, the large X containing the letters of the alphabet can, in several ways that are not mutually exclusive, symbolize the consecration of the ground and temple: by causing the heavenly influx to descend thereon, the consecrator in a way makes them the Body of Christ. This is another aspect of the symbolism of the temple that we should now consider.

8. If we add up the extreme letters of the Latin, Greek, and Hebrew alphabets, that is to say, AZ, AO, ATH, putting A as a common factor, we obtain the word AZOTH. Now the Alchemists, whose connections with the builders are well known, used this word, deliberately constituted as we have seen, to designate the 'Philosophers Stone', the *beginning* and *end* of all bodies. And to a certain extent, they have on occasion also assimilated it to Christ, because in the physical world this stone was an aspect of the first and final Cause, which could, as the Divine Word, reproduce, fertilize and engender itself. —This remark has led us to point to a correspondence between the art of the builders and that of the Alchemists. Many other, and more firmly attested, examples exist, in particular at Notre Dame in Paris. But this is a question we have excluded from our account, which is intentionally limited to the properly constructive art itself. It is outlined in R. Gilles, *Le Symbolisme dans l'Art religieux*, and developed in detail in the classic works of Fulcanelli (see bibliography).

6

THE TEMPLE,
BODY OF THE GOD-MAN

CHRIST STATED VERY CLEARLY that His Body is a temple, or rather *the* Temple:

> Jesus answered them, 'Destroy this temple, and in three days I will raise it up.' The Jews then said, 'It has taken forty-six years to build this temple, and will you raise it up in three days?' But he spoke of the temple of his body (John 2:19–22).

This verse conceals a teaching of the highest importance. With the individual man, the body is the habitation of the soul; with Jesus, as God-Man and Universal Man, the Body is the habitation of the Divinity. 'For in him the whole fullness of deity dwells bodily' (Col. 2:9) because the 'Word became flesh and dwelt among us' (John 1:14), thus realizing what the Mosaic temple was in figure only: the habitation of God *among* men, and even *in* men.

For the Christian assembly, the temple represents the Body of Christ, but as the Body of Christ it is also the assembly; the latter constitutes the spiritual temple, the mystical Body of Christ. Finally, the individual soul itself is capable of becoming this temple. The sacred building can therefore be considered from a triple standpoint: as the Humanity of Christ, as the Church, and as the soul of each of the faithful, these three points of view being moreover inseparable, because the last two are but the consequences of the first.

In the first place, then, the temple represents the Body of Christ. While this symbolism is absolutely independent of the cruciform plan—and this should be remembered—the latter architectural

feature has nevertheless magnificently highlighted it. It is a very old conception both in the East, for example with Maximus the Confessor, and the West. In his *Mirror of the World*, Honorius of Autun established the following correspondences: the choir represents the head of Christ, the nave His body, properly so called, the transept His arms, and the high altar His heart, that is to say the center of His being. And Durandus of Mende wrote:

> The layout of the material church represents the human body; the chancel, where the altar is placed, represents the head, the crossing to either side, the arms and hands, and, finally, the remainder, extending from the West, the rest of the body.

We notice a certain divergence between Durandus and Honorius, who follows St Maximus with regard to the meaning of the altar and, consequently, its placement in the choir or the transept. We shall speak of this again. At any rate, the obligatory separation of the nave and sanctuary hierarchically divides the assembly: in the upper part, the sanctuary, corresponding to the head, sit the clerics, the 'thinking' portion of the assembly, in the lower part, the people, the 'acting' portion.

This assimilation of the temple to an outstretched man with his head to the east is, moreover, not peculiar to Christianity, although it has been far more developed there than elsewhere. It serves equally as the point of departure in the construction of the Hindu temple: the extended man then represents the body of Purusha or the Universal Spirit that is ritually incorporated in the building. Here we are face to face with a tradition that certainly goes back to the very origins of humanity, a tradition based, moreover, on a truth of the ontological order, namely that man is a reflection of the universe; he is a microcosm, the reflection of the macrocosm, to which a thousand interwoven ties unite him.[1] This is why, for example, the Greeks deduced the value of the number *Five*—the harmony of the universe—from the very harmony of the human body. The latter

1. 'Man can be considered a microcosm' (St Thomas). —'The human body is called a microcosm, that is to say a small world' (Honorius of Autun).

served as the canon of Greek architecture and its heirs, because the human body was considered to be the projection on the material level of the World Soul, whose harmonious life it reflects.[2] Thus it is as a figure of man that the temple is also, in a certain respect, a figure of the world. There are, for example, correspondences between the parts of the body and those of the world: the feet and senses correspond to the earth and the elements respectively, while the rounded head is related to the heavenly vault, or, in the case of the building, the semi-circle of the apse, etc. William of St Thierry observed that it is possible to inscribe a man with outstretched arms and legs in a circle with his navel as center. As can be easily seen, this figure is superimposed upon the diagram used in the foundation rite, the cross within the circle: the cross, formed by the man with extended limbs, is placed over the cardinal axes. A tradition going back to the beginnings of Christianity related this figure to the generic name of man: ADAM. In fact, the four letters of the word Adam, in Greek, are the initials of the words designating the four cardinal points: A = Anatole (East), D = Dysme (West), A = Arctos (North), M = Mesembria (South). In the same way, it is also curious to observe that the two groups formed by the letters, in the order they are presented, correspond exactly to the respective lines of the two axes: AD-AM: AD = East-West, AM = North-South.

Furthermore, the total numerical value of these letters is 46, which is precisely the number of years given for the construction of the temple (John 2:20). This symbolism is magnificently developed in an Easter hymn to the Cross in the ancient missals of St Gall: 'Christ offered the temple of His flesh as victim upon your Wood, this temple that was created in the number of days (this is surely an error; the author means: years) figured by the four letters of the name of Adam; but it was in order to rebuild after three days the world, whose extent is measured by the four points of heaven'.

2. 'If nature composed the human body in such a way that each member is in proportion to the whole, it is not without reason that the Ancients wished that, in their works, the same relations of parts to the whole should be seen to be exactly observed. But of all the works whose measurements they determined, they were chiefly concerned with the temples of the gods. . . .' (Vitruvius, III, 1).

Thus, once again, the cross is used as the measure of space and time. This latter aspect of things is illumined by the traditional diagram which represents man deployed, no longer on the cross of the cardinal axes, but in the middle of the zodiacal wheel: his head placed at the vernal point, 0° Aries, while his feet rejoin his head at 30° Pisces. This figure gives rise to two very important remarks. The position of the head at the vernal point corresponds to the Spring equinox and Easter, which should determine the exact orientation of the church chevet, according to Durandus of Mende. On the other hand, the Ram (or Lamb) and the Fishes are the Christic animals related to the Eucharist; finally, the Lamb is essentially Paschal. This zodiacal diagram signified the unity of the macrocosm and microcosm, a unity underlying the role of man, who should be the spokesman of the world before God, lending his voice to the former so as to enable it to sing the glory of the Creator.

But this unity is only fully realized in the God-Man, which is why the Body represented by the temple is first that of the God-Man. And it is here that the unity of the cosmic and Christic symbolism of the temple is realized to its fullest sense. The cosmos, considered in its weakest extension, that is to say the corporeal or physical world, of which the temple is the mathematical image, is itself only the most outward aspect of the integral Cosmos, which comprises all worlds and beings, 'earth' and 'heaven', the *visible* and *invisible* of the Creed. Now this integral cosmos is entirely comprised within Christ as the Creative Word: 'He is the image of the invisible God, the first-born of all creation (= the Principle of Creation)....' (Col. 1:15–17).

According to the expression of the Fathers, Christ is the 'recapitulation of Creation', the qualitative summing up of the universe at the same time as its principle, or again, the Archetype of creation. As Universal Man, He sums up and integrates in Himself the indefinite multiplicity of all the states of Being. And this is what the Cross, in its highest sense, symbolizes, being the measure not only of space, but of the integral universe, and 'sign of the Son of Man'. The sign also of Redemption envisaged in its fullness. Individual man, as microcosm and analogue of the whole of creation, since he bears in himself a reflection of angelic states and the image of God, is linked

to the entire world, and has been established as the intermediary between it and God, such that it awaits its own redemption from man, but from a 'God-bearing' man:

> For the creation waits with eager longing for the revealing of the sons of God; for the creation was subjected to futility . . . by the will of him who subjected it in hope; because the creation itself will be set free from its bondage to decay and obtain the glorious liberty of the children of God' (Rom. 8:19–21).

Christ has already realized this reintegration in principle. The sacrifice of the cross, on Golgotha, resounds to the farthest reaches of 'infinite space': 'Thorns, nails and lance pierce His body so tender, whence water and blood gush forth: earth, ocean, sky and universe, all in their stream are washed' (*Hymn of Good Friday*). And it is this that the cruciform temple expresses at its level: the universe restored to its original purity and offered by Perfect Man to the Father. The Word incarnate unites God and man, Heaven and earth; this union is as though sealed in the shape of the temple, in which the divine circle is joined to the terrestrial square. In this way the cupola united to the cube expresses the theanthropic mystery of the Church realizing the God-Man in the soul of the believer, for the redemption inserts man into the circle of the divinity and draws the whole world there in his wake.

This insertion of man into the temple can also be realized in other ways, a remarkable example of which is again offered by the cathedral of Troyes. The section of the building reproduces the stages of the human body regulated by the 'golden' mean, such that when the feet are on the floor of the sanctuary, the top of the head is at the keystone of the vault, which not only bears an image of the Resurrected Christ, but at the height of 88 feet, 8 inches also yields 888, the numerical value of the name of Jesus. Everywhere, the number of man, 5, is found in symmetry with the number of Christ, 8, (5 is the golden section of 8). Thus the master craftsman has, so to say, captured the substance of the redemptive mystery in stone, this mystery being the metamorphosis of fleshly man into spiritual

man: 'Man is realized in Christ through the mediation of Beauty (= the golden number).'[3]

There is reason to insist upon this, for the symbolism relating to Troyes applies to all temples, irrespective of their measurements in elevation, for the proportions determined by the numbers 5 and 8 only serve to underline a meaning belonging to the vertical structure of the sanctuary itself. This structure, constituted by the square base and spherical summit and arranged around the axial pillar, is in fact, a geometric image of a standing man.

In this way, just as the whole temple in its plan, so the sanctuary in its elevation simultaneously represents the Archetypal Man and the spiritual growth of the human individual, up to the coincidence of the latter with his archetype, or 'unto the stature of Christ', as St Paul put it (Eph. 4:13). The axial pillar, about which we shall have more to say in Chapter 12, is the axis vertically joining the keystone of the sanctuary to its center. While in the case of Universal Man it is identified with the World Axis, with individual man it corresponds to his spinal column, which is the pivot of his physical structure and determines his upright posture. The latter is the privilege of man, and like a concrete proof of the central position he occupies in the visible world:

Pronaque cum spectent animalia cetera terram
Os homini sublime dedit, coelumque tueri
Jussit et erectos ad sidera tollere vultus.

3. Ledit-Zelt, op. cit. — Mgr Devoucoux points out a pattern that must have played a role in sacred architecture, that of a man standing, feet together and arms extended, within a square determined by parallels to the line of the arms and the vertical body. By adding the number of digits of the feet and hands, which are of great importance in Jewish mysticism, and the number 6 (the relation between the height and mean width of the body is 1 x 6 = 6), we get 10 + 10 + 6 = 26 = YHWH; all of which means that man was created in the image of God. There is perhaps a connection between this and the fact reported above that at Troyes, at this same place in the sanctuary, the section of the building contains a triangle with an angle of 26° at its summit.

[While other animals look downwards at the ground, he gave human beings an upturned aspect, commanding them to look towards the skies, and, upright, raise their face to the stars.] (Ovid, *Metamorphoses*, bk 1, 84–86.)

Thus, through the symbolism of the sanctuary, we immediately see the correspondences established between Universal Man and individual man: just as the axial pillar joins the square base to the spherical summit of the building—earth to heaven—so in the individual, the spinal column is the link uniting the lower and earthly part of the body (called the 'base' and 'foundation'—*iesod*—in Jewish mysticism), to the upper and thinking part, or head, the spherical shape of which, we have seen, corresponds to the heavenly vault[44]. It is through the spine that the head has command of the rest of the body. This applies to the physical constitution of the individual. In his subtle constitution, there correspond to the spinal column and the nervous channels running through it, subtle channels in which energy of the same nature circulates. At their center, like the axial pillar in the building, is the channel the Hindus call *sushumna*. In the process of mystical development, as described in Tantric Yoga, spiritual energy, asleep at the base of the back (this is obviously a matter of symbolic localizations), is raised through this channel, successively awakening the subtle centers or *chakras* until the moment when, reaching the coronal chakra at the top of the head, it provokes illumination and the final transformation of the individual. It is said then that the 'lotus of a thousand petals' blooms, this last name designating the chakra in question.[5] In the West, the same reality is expressed by the shining halos around the

4. In India, where the human body is also assimilated to the universe and temple, it is said that the spine is analogous to Mount Meru, the mythical mountain determining the World Axis.

5. It is also called *Brahmarandra*, that is to say: 'opening of Brahma'. It is through this that the conscious principle of the being escapes at death. Let it be said only—since we cannot go into detail here—that rites like posthumous trepanation, practiced by certain peoples, and the tonsure of clerics, are directly related to this liberation of the conscious principle and the vertical ascent of latent energy in the body.

head of saints. This ascension of Energy through the spinal column symbolizes the ascension of the being, its passage from the earthly to the heavenly state.

Thus, in the figure of the Archetypal Man incorporated in the vertical structure of the sanctuary, the image of the axial pillar blossoming in the keystone of the 'heavenly' vault—often stamped with the cross or the Christic lamb—reminds the individual of the path of his spiritual growth up to the 'stature of Christ', which includes the 'communion' of all the 'saints', their consummation in unity, in the Mystical Body, as we will now see.

7

'CORPUS MYSTICUM'

UP TO NOW we have considered the sacred building in its completed or *static* state, which is altogether normal, this being the natural term of architectural art, of which the essential quality is stability or stable perfection. It can also be considered from a *dynamic* point of view, no longer as the *finished* temple, but one *in the making*. The process of construction can itself be taken in a symbolic sense, which is exactly what the whole tradition has thought.[1] The symbolism of this process of building from the placing of the first stone to the placing of the pinnacle, is centered not so much on the figure of the temple as upon the stone itself.

Christ proclaimed himself to be the 'corner-stone':

Jesus said to them, Have you never read in the scriptures: The very stone which the builders rejected has become the head of the corner; this was the Lord's doing, and it is marvelous in our eyes? (Matt. 21:42).

And Simon, who was to replace the Master as head of His

1. Thus already in the *Shepherd* of Hermas, one of the first works of Christian literature, written towards 140. In a vision (I, vision 3) the author perceives the 'building-site' of the Church Triumphant: the latter is a large town under construction, where use is made of squared and polished stones and different sorts of stones represent different orders of saints. — Here again mystical and cosmic symbolism are treated on an equal footing: the process of construction reproduces that of creation, architecture repeats cosmogony: 'Where were you when I laid the foundation of the earth. . . . Who determined its measurements—surely you know! Or who stretched the line upon it? On what were its bases sunk, or who laid its corner-stone. . . ?' (Job 38, 4–6).

Church, of the Church to be constructed, received for that reason a 'new name' as a sign of his function: 'And I tell you, you are Peter, and on this rock I will build my church' (Matt. 16:18).

These important texts are used in the ritual of the placing of the first stone:

> May the Name of the Lord be blessed, now and always! The stone rejected by the builders has become the corner-stone! You are Peter and upon this stone I shall build my Church.... Let us pray.—Lord Jesus, Son of the living God, who art truly God Omnipotent, the splendor and image of the eternal Father and Life eternal, who art the corner-stone taken from the mountain without human help, make firm this stone which is to be placed in Thy Name. Thou art the Beginning and End, it is through this principle that God the Father created everything from the beginning; be Thou, we pray Thee, the principle, the development, and the consummation of this work which is about to begin to the praise and glory of Thy Name....

After which the officiant traces a cross upon each face of the stone, thus assimilating it to Christ.[2]

St Peter comments on the words of Christ by showing that as individuals and together with Christ believers should construct a spiritual temple, which is none other than the *Corpus Mysticum* [Mystical Body]:

> Come to him, to that living stone, rejected by men but in God's sight chosen and precious; and like living stones be yourselves built into a spiritual house, to be a holy priesthood, to offer spiritual sacrifices acceptable to God through Jesus Christ. For it stands in scripture: Behold, I am laying in Zion a stone, a cornerstone chosen and precious, and he who believes

2. A complete account of the symbolism of the corner and foundation stones, and especially of the exact meaning of the expression 'corner-stone', will be found in the chapter on the Altar.

in him will not be put to shame. [Isa. 28:16] To you therefore
who believe, he is precious, but for those who do not believe,
the very stone which the builders rejected has become the head
of the corner, and a stone that will make men stumble, a rock
that will make them fall (1 Pet. 2:4–8).

St Paul's teaching continues St Peter's: it is necessary to build up
the Body of Christ. 'Walk ye in Christ Jesus the Lord, rooted and
built up in him on this foundation' (Col. 2:6–7). Christ

ascended far above all the heavens, that he might fill all things;
He has spread out his gifts over all for building up the body of
Christ, until we all attain to the unity of the faith and of the
knowledge of the Son of God, unto a Perfect Man, to the mea-
sure of the stature of the fullness of Christ (Eph. 4:10–13). [We
are] built upon the foundation of the apostles and prophets,
Christ Jesus himself being the cornerstone, in whom the whole
structure is joined together and grows into a holy temple in the
Lord; in whom you also are built into it for a dwelling place of
God in the Spirit. (Eph. 2:20–22).

Durandus of Mende sums up the now classic parallel between the
material church and that of souls:

Just as the corporeal or material church is constructed of stones
fitted together, so the spiritual church forms a whole composed
of a large number of men. All the stones of the walls, squared
and polished, represent the saints, that is, pure men, whom the
hand of the supreme Workman has arranged to remain always
in the church.[3] They are united through love, as with one same
cement, until, having become living stones of the heavenly
Zion, they be assembled through the bond of Peace.

3. As in most instances, Durandus does no more here than take up an idea with
a long history. 'You have resisted the masters of error,' said St Clement of Rome,
'you, the stones of the Father's temple prepared for God's building, lifted into
the air by Jesus Christ's "machine", that is to say His Cross.'—The image of the
'machine', which evokes the winch of carters and builders, is familiar to Greek

It is God who builds this expanding temple in the making. 'The Lord builds up Jerusalem' (Psalm 147); He is the master builder of the holy city. 'By faith he [Abraham] sojourned in the land of promise, as in a foreign land,' for he looked forward to the city which has foundations, whose builder and maker is God' (Heb. 11:9–10).

This image of God the Architect, builder of the spiritual City, as of the material world, accords with that of Plato and the Pythagoreans transmitted to the organizations of builders. Nichomacus of Gerasa, speaking of the Decad, wrote that it 'serves as the measure of the universe, as a square and cord in the hand of the Disposer.' In a decorative miniature of a fourteenth century Bible, God is represented, compass in hand, tracing a circle upon chaos depicted as the mouth of a dragon. And on a pillar in Notre Dame in Paris, an iron plaque is to be found, placed there by the Company of Masons; engraved upon it, above a pentagram, ruler, compass, and square, is the celebrated formula: 'To the glory of the Great Architect of the Universe.'

This city of eternal foundations, this spiritual temple, which is but one with the Mystical Body, will only be realized in the 'age to come', when it is joined to the heavenly Jerusalem, that is to say celestial Humanity reborn and glorified in God, of which the material temple is the sensible image. Such is the teaching of the liturgy, which, regarding the consecration and dedication of churches, recalls this City on High. 'I heard a loud voice which said: Behold the tabernacle of God among men; He shall live in the midst of them, they shall be his people and God Himself shall live with them' (*Epistle of the Mass of Dedication*).

This evocation is particularly suggestive in the rite of the anointing of the crosses that takes place during the consecration. Candles

Christian literature, where the Cross is commonly called the 'mechane ourania', the machine that raises to heaven, and St Ignatius of Antioch has this magnificent saying: 'The Cross is the *mechane* for the entire cosmos.' —As for the shape of the stones that need to be squared and polished, this is also an ancient tradition. In the *Shepherd* of Hermas we read that, 'just as a round stone cannot be squared without being cut and trimmed to some extent, so likewise the rich of this world need to be relieved of their riches.' For St Augustine, the square shape of the stones recalls justice and the four cardinal virtues, and for Hugh of St Victor, the stability of faith and the fidelity of Christians.

are lit before twelve crosses inlaid or painted on the walls of the church; the pontiff then anoints these crosses with oil during the singing of the anthem: 'Behold Jerusalem, the great heavenly city. She is adorned like the bride of the Lamb. . . .' We have already seen that the number twelve is characteristic of the heavenly city. There are twelve gates and twelve foundations, and the elect are divided into twelve tribes each of twelve thousand. The twelve crosses painted on the walls correspond to the twelve foundations, which are the twelve Apostles, whose names are written on the foundations of the heavenly Jerusalem: 'And the wall of the city had twelve foundations, and on them the twelve names of the twelve apostles of the Lamb' (Apoc. 21:14).

In addition, St Paul told the Christians, that they had been 'built upon the foundation of the apostles and prophets. . . .' (Eph. 2:20). We see here why the twelve Apostles were represented on the pillars of the church, as for example at the Sainte Chapelle in Paris. As for the twelve gates, they are marked with the names of the twelve tribes of Israel (Apoc. 21:12). There is also a correspondence between the Apostles and tribes, on the one hand, and both of these and the signs of the zodiac on the other. Here again, cosmic symbolism espouses mystical symbolism. The square plan of the heavenly Jerusalem corresponds, we have seen, to the transformation of the circle by the cardinal axes; the twelve gates correspond to the zodiacal signs grouped in threes on each of the four sides, oriented according to the cardinal points and in relation to the four seasons, that is to say to the temporal cycle found 'crystallized' there. But already within the Jewish tradition the twelve tribes of Israel were related to the signs of the zodiac; the same applied to the twelve Apostles representing the twelve tribes and grouped in a ring around Christ, the Divine Sun.

We shall speak again of this solar symbolism in our chapter on the door. For the moment, we would like to draw attention to another correspondence concerning the Apostles. It is said in the book of Revelation that the 'wall of the city is built of jasper' and that 'the city is of a pure gold'; furthermore, 'the foundations of the wall (= each foundation from one gate to another) are adorned with all sorts of precious stones.' There follows the enumeration of

the twelve precious stones: sapphire, emerald, topaz, amethyst, etc. Given the plan of the city, we see that these stones are arranged like the gates, three on each side. Now this is more or less the shape of the pectoral or breastplate worn by the Jewish High Priest. This pectoral was in fact a *square* plaque of gold upon which *twelve precious stones* engraved with the names of the tribes were arranged in four rows of three each (Exod. 28:17–21; 39:9–12). According to Philo and Clement of Alexandria, these stones were related to the twelve Patriarchs and the signs of the zodiac. This pectoral enabled the high priest to bring together in a way, in his person, the essence of the community of Israel. It is significant that the same symbol served in the book of Revelation to recall the community of the Church, the new Israel, whose faithful have been called from the *four* corners of the universe through the power of the *three* persons of the Holy Trinity, as St Augustine put it.

Finally, these precious stones have another meaning. Precious stones are the masterpieces of the mineral realm; in them are united the splendor of the light of Heaven and the quintessence of matter issued from the depths of the earth. They are matter transfigured, become diaphanous. Likewise, man as brute stone needs, with the help of God, to be cut into a cubic stone already subject to an order, in order to be adapted into the edifice of the church in the making, and when the completed building enters the 'age to come', its living stones will be transfigured, becoming these luminous, precious stones.

The 'Corpus Mysticum' is the assembly of believers, the total Church, the Temple par excellence. But since it is made all in all, each believer is also this Temple: 'Do you not know that you are God's temple and that God's Spirit dwells in you?' (1 Cor. 3:16). 'For we are the temple of the living God' (2 Cor. 6:16). 'As this visible building,' said St Augustine,

> has been made to unite us bodily, so that other edifice, which we ourselves are, is constructed for God to live there spiritually. . . . The visible building is dedicated today before our eyes, the other will be so at the end of the ages, at the coming of the Lord, when our corruptible body takes on incorruptibility.

Ruysbroek writes,

> Christ, the Son of God constructed for God Himself and for us
> an eternal ark and tabernacle; and it is none other than Himself
> and the Holy Church in every good man of whom He is the
> prince and the chief. . . . When a man desires wholeheartedly to
> obey God, he is freed and discharged from all sin, through the
> blood of Our Lord. He is bound and united to God and God to
> him; and he himself becomes the ark and tabernacle where
> God desires to dwell, not figuratively, but actually.

Likewise, commenting on the meaning of the three parts of the Jew-
ish temple, the court, the sanctuary, and the holy of holies, which
correspond in the Christian temple to the narthex and door, the
nave, and the sanctuary, the same author shows their spiritual
value:

> The court of the tabernacle is a life conforming to the moral
> law according to the outer man. . . . [The altar of holocausts]
> represents the unity of the heart and the recollection of sensible
> powers through distancing from earthly preoccupations. . . .
> [In the sanctuary] the virtuous life is 'repose close to God; at
> this stage the theological virtues are re-attached'. Finally, to the
> holy of holies corresponds the center of the being where one
> finds God who 'in me, is more myself than I.'

Thus each man, to the extent that he realizes the Divine Presence
in himself through participation in the God-Man, is the temple of
God. And we now understand better what was said above about the
role of the temple. If the latter is the image of the cosmos, and of
man the microcosm, it is because this last, in order to realize his
spiritual vocation, that is, effect his return to God, must recapitulate
and integrate in a symbolic 'center' all the elements of the visible
world together with their correspondences in himself, so as to tran-
scend them by 'sacrificing' them to God in such a way as to pass
'from this world to the Father'. As a mathematical image of the uni-
verse and as image of the Body of Christ, the temple is the fixation

of the spiritual presence in a material support. It thus symbolizes the process of the descent of God into man, the fixation of spiritual influence within corporeal consciousness.

Moreover, the analogy between the consecratory rites of the temple and the rites of baptism—blessings with water, exorcisms, and chrismations—has long been noted. Regarding this, St Bernard said

the rites of which these walls have been the objects should be accomplished spiritually in us. What the bishop did in this visible building is what Jesus Christ, the Pontiff of good things to come, performs each day invisibly in us. . . . We shall enter the house not raised by the hand of man, the eternal abode of the heavens. It is built with living stones, which are angels and men. . . . The stones of this building are joined together and bonded with a double cement, perfect Knowledge and perfect Love.

Again in the writings of the great Cistercian builder we meet the image of the living stones of the Church that is to be built. The construction of the material church thus symbolizes the Church in the making, both on the level of the community and of the individual. The whole Christian cycle unfolds in three acts. In the first, Christ comes to earth to *place the first stone* or foundation stone, which in the final analysis is He Himself. In the second, the temple is constructed upon this foundation, the substitute for which is Simon Peter. Finally, in the third, the building is completed through the placing of the true *cornerstone* or keystone. The whole edifice will then undergo a glorious transmutation, the stones becoming precious and resplendent, penetrated by the irradiation of the Divine Gold, which is its inward substance. Then the holy city will appear in all its splendor, which wrested these passionate words from Epiphanus of Salamis:

O paradise of the Great Architect, city of the holy King, fiancée of the immaculate Christ, Virgin most-pure, promised in the faith to the unique Spouse, you shine and glisten like the dawn!

8

BELLS AND BELFRIES

HAVING STUDIED THE MEANING of the temple as a whole, we are now in a position to examine the meaning of its different parts, which to some degree are all symbolic. To do so, however, would be a lengthy undertaking, going far beyond the compass of the present work. We shall merely examine then some of its more important parts, adopting the simplest approach which will consist in following the believer in his journey from the profane world to the house of God.

After saluting the familiar belfry, whose voice calls him to divine worship, he successively encounters the door, the font where he crosses himself, and the nave, which directs him to the altar, the center and aim of the whole building. In our account, we shall follow this order of discovery.

* * *

Belfries, which over time have assumed such importance, are not an original element of Christian architecture. The oldest known churches were without them: the towers encountered in the churches of Ravenna and Syria were not intended for bells, little being known of their purpose. It was only later that the custom of building towers equipped with bells became widespread.

The symbolism of belfries developed in two directions among mediaeval authors. Sometimes, taking up a very ancient theme (*Shepherd of Hermas*, Melito), towers were seen as an image of Mary and the Church, commonly called 'Tower of David' in the liturgy,

after the 'Song of Solomon' (4:4). More often, the 'moralizing' symbolism of the bell determined that of the belfry: both were likened to preachers and prelates who warned and instructed mankind. The often fastidious developments of a symbolism arbitrarily pushed to the minutest details in the case of Honorius of Autun or Durandus of Mende, are of interest only to the historian of ideas.

Should we then abandon the search for a meaning to the belfry? Certainly not! The fact that the tower was originally not used to house bells is important, for it immediately allows us to reject the facile objection of those who hold the 'utilitarian' thesis. Another thesis, equally to be rejected, maintains that the first church towers were 'purely decorative'. This 'explanation', so often advanced in respect of the parts or forms of our ancient religious monuments, and appearing as the last refuge of an ignorance that dares not speak its name, is unacceptable to anyone having even a summary idea of the true conception of traditional sacred art, where pure fantasy and the 'gratuitous' have absolutely no place. Those who assert the opposite deceive themselves by attributing to our ancestors their own modern concept of art and artist, which has nothing to do with the art of those times.

To us, the most interesting attempt to explain the belfry is that which links it to the cosmic symbolism of the temple in general. We have already alluded to this in Chapter 3, where it was pointed out that the shape of the belfry repeats the basic pattern of the temple itself: a dome surmounting a cube, the dome occasionally taking the form of a six or eight-faced 'pyramid', which is one of the phases of the passage from the sphere to the cube. Thus, all that has been said about the symbolism of the temple applies equally to the belfry.

But we can further add that the tower as such has a special, *ascensional* symbolism. With the pyramid and arrow reaching up above it, it rises to the assault of heaven, and is an image of the mountain, the Cosmic Mountain, about which we shall have more to say with regard to the altar. In certain religious traditions, the mountain served as model for the temple: Egyptian pyramids, Sumerian ziggurats, and the religious buildings of India are mountain temples. Now there is probably a kinship between these buildings and our belfries.

In addition, special attention should be given to the twin towers flanking the main façade of our great cathedrals. It seems likely that these have a definite solar symbolism connected with the symbolism of the oriented building as a whole, and perhaps a recollection of the more ancient solar 'columns' transmitted to the builders' associations. They will be the last manifestation of the original *indices* of which the purpose was to determine in practice the zone within which sunrises took place. This zone or band is the distance between the two extremes of the depth of winter and height of summer that are marked by two 'indicators' or 'pillars' that designate the relative 'solstitial' points situated with respect to the north and south, or, if preferred, to the right and left of the equinoctial axis, which latter was sometimes indicated by a *baetyl*. Certain menhirs in stone alignments found in Brittany and England have fulfilled this function, as have the obelisks and two pylons in front of the entrance to Egyptian temples (the analogy between the pylons and our twin towers being all the more striking in that both form part of the building), the two brass pillars of Solomon's temple, and the two columns of the façade of early Greek temples. Later, when the two columns were sometimes joined by a transverse beam, the result was the triumphal arch, which, in the first instance, was a 'sun-gate', a meaning later underlined by the motif of the Apollo's chariot placed above the arch. In due course we shall see how the door of the church with its analogous symbolism was integrated into the greater whole of these towers, between which the rising sun ascended to heaven after flooding the apse with its light.

* * *

We are familiar with the famous passage from the *Genius of Christianity* in which Chateaubriand analyses the 'poetry of bells':

> When, toward the harvest season, with the cry of the lark at dawn, the faint ringing of the bells of our hamlets was heard, it was said that the angel of the crops, in order to waken the

laborers, would sigh the story of Zipphora or Naomi on some
Hebrew instrument. . . .

This poetry is certainly not to be disdained: the bells which ring at
every hour of the day when we pray and at every stage of our life,
for the new-born, the newly wed, and the deceased, are like the
amplified voice of our joys and sorrows and, as such, have a 'moral
sympathy with our hearts.' But during earlier ages, when the reli-
gious spirit was still whole, these were certainly not the primary
sentiments that the sound of bells awakened in souls. They existed,
certainly, but in their place, which was definitely not the first. If we
want to know what bells signify in an authentically religious per-
spective, we need only read the ritual of their blessing, which in a
thoroughly biblical style develops the essential themes of their tra-
ditional symbolism.

The first thing to strike us is the sacred character conferred upon
a bell. Its baptism, analogous to that of a child and to the consecra-
tion of a church, incorporates it into the sacred domain and assimi-
lates it to a neophyte. The rite, in fact, comprises its purification,
first with blessed and exorcized water, then with incense burnt
under it, an anointing with oil, and the conferring of a name and
white robe.

There would be no justification for this profusion of very specific
rites if the bell were purely a utilitarian object, meant simply to call
the faithful to church. They rather point to its having a very marked
sacred character, which will be better understood once restored to
the religious category to which it belongs: that of 'sacred sound'.

Sound, generally produced by a metallic instrument, preferably
of bronze, nearly everywhere serves in the first place to indicate the
presence of the sacred, for example a sacred person, as is the case
among several African peoples. The Bangoras have a 'prophet' and a
priestess who, to this effect, wear a copper vestment with a fringe of
small bells. Among the Akambas, officiating priests wear similar
small bells. This fact can be compared with the prescriptions in
Exodus (28, 31ff.) regarding the high-priest's mantle, which bore
along its bottom edge a fringe of alternating pomegranates and
small bells; it was necessary that when the pontiff entered and left

the holy of holies, the sound of little bells be heard. In India, numerous ascetics shake hand-bells or iron rattles to announce their presence.

But the sound of these instruments is not limited to signaling a sacred presence, it also creates it, and by that very fact plays an important role of 'exorcism' against demonic influences. Again in India, copper mortarboards are struck around houses and in the precincts of temples to chase away the *asuras*; in several regions of Africa, hand-bells are shaken at moments of birth and death with the same intention; in Borneo a funerary gong with a sound very like that of our death-knell is used. But of more interest to us, understandably, are the customs of the Greeks and Romans, traces of which have been perpetuated in our countries. Among these peoples it was *bronze*, from which our bells are also made, that had a purifying and apotropaic or exorcising virtue. Apollodorus informs us that it was used 'for every purification and consecration.' Thus, for example, bronze instruments were struck to mourn a great person or to mark the moment of an eclipse, or to drive away specters—especially at the festival of the Lemuries—or in the rite of initiation called *thronismos*, where people danced around the neophyte in imitation of the Couretes around the newly born Zeus.[1]

Study of the ritual for the blessing of bells reveals a similar conception of the role of sacred bronze. The latter should not only summon the blessings of God, but repel demonic assaults far away from temples and dwellings, and in particular avert gales and storms:

> May this bell, like the lyre of David, call the Holy Spirit through the sweetness of its harmony.... When its voice ascends to heaven, may the protection of Angels descend thence upon thy Church....

says one prayer. Other prayers request again and again

1. Proclos (*Ad Remp.* 42 ii, 7) says bronze is the most sonorous metal and catches the creative humming of the World Soul.

that the sound of this bell ... repulse the ambush of the Enemy, with his deceitful ruses, that it avert hail, lightning, thunder, gales and all calamities. . . . May it crush the powers of the air. May these tremble on hearing its sound, may they flee before the sign that we have traced upon it.

Funeral knells especially have this function of driving evil spirits far away from the deceased.

To conclude, let us add that a formula of conjuration against lightning or storms, or an invocation like *Ave Maria* or *Rex gloriae veni cum pace* is often engraved on a bell. The idea is that the bell transmits the formula or invocation on the sound waves, and in this way fills, purifies, and sanctifies both air and space through the power of the sacred text. From this point of view, the bell plays for us a role similar to that of Tibetan *prayer wheels*. These objects and their use are very poorly understood in the West and for that reason, are unjustly decried. The wheels in question, containing rolls of parchment covered with prayers, are found at all street corners in the villages, where passersby turn them so as in a way to 'diffuse' the prayers into the air and thereby sanctify the space.

* * *

From the beginning of the tenth century, cocks were frequently placed on top of belfries. There was one on the Lateran Basilica, under Pope Pascal II (eleventh century). This involves not only a very old Christian symbol linked to St Peter's denial, but also a whole symbolic ensemble that accords perfectly with the meaning and role of the tower and bell. The cock, in fact, is a solar bird. It occupied an important place in the Mazdean religion where it was consecrated to Ahura-Mazda, himself the god of light. Its cult, adopted by the Pythagoreans, spread to Rome and Greece and was later incorporated into Christian tradition. Its fortune in the literature of the first centuries and the Middle Ages cannot otherwise be explained, for it is not justified by the Gospel text alone. In fact, this theme developed in the same two ways as it did among the Persians

themselves, for whom the role of the cock was to not only rouse the idle and summon to morning worship, but to drive away evil spirits, for it announces the light of the sun that dispels the nocturnal pestilence—*negotium perambulans in tenebris* (Psalm 90:6).

The cock even became an image of Christ in person: St Ambrose called Jesus: *gallus mysticus*, because, as vanquisher of the shadows and hell, He was resurrected at dawn and calls us to works of light. The 'Apostolic Constitutions' also invite Christians to pray, 'at the crowing of the cock that calls to works of light.' In the hymn *Aeterne rerum conditor* (*Office of Lauds*), St Ambrose again found beautiful poetic words to celebrate the spiritual role of the cock:

> Behold the chanting herald of day, awakener from the deep night.... At his cry, the Morning Star drives the shadows from the sky and the entire choir of luminaries abandons the ways of the world.... The cock awakens those abed, chides the sleepers, and accuses the faithless. At his crowing hope returns, the sick regain health, the robber hides his knife, and faith is reborn in the hearts of sinners....

But the most significant piece is Prudentius' hymn (*Cathemerinon*, I, 1), where belief in the bird's powers of exorcism is clearly expressed:

> For the foul votaries of the night
> Abhor the coming of the light,
> And shamed before salvation's grace
> The hosts of darkness hide their face.
>
> They know the cock doth prophesy
> Of Hope's long-promised morning sky,
> When comes the Majesty Divine
> Upon awakened worlds to shine.[2]

2. R. Martin Pope translation (*The Hymns of Prudentius*, London: J.M. Dent and Co., 1905).

This mysticism of the cock, symbolizing the vigilance of the soul awaiting the coming of the Spirit, the spiritual sun, was perpetuated throughout the Middle Ages by Raban Maur, Honorius of Autun, Hugh of St Victor, and Durandus of Mende. Thus it is obvious that the cock or Solar-bird is thoroughly at home on top of the belfry. Perched atop the solar tower as upon a lookout, he watches for the rising of the day-star. When it appears, his voice, assisting that of the dawn bells, exorcizes the demons of the night and announces the eternal resurrection of the Sun of Justice.

9

STOUP AND BAPTISTERY

A CHURCH IS NOT ENTERED as is a shop. The area it defines is a
sacred space, and therein lies the etymological meaning of the Latin
word *templum* and the Greek *temenos*, both of which derive from a
root signifying 'to cut', or 'to separate'. The precinct of a temple
clearly delimits a sacred domain reserved for the Divinity, separated
from the surrounding profane area. *Terribilis est locus iste.* . . . From
the vestibule to the sanctuary the believer follows the 'way of salva-
tion' that is, in a way, reproduced in the plan of the church: the
entrance and narthex together effect the transition between the two
domains; the nave, where the guiding Word of God resounds—'I
am the Way, the Truth and the Life'—is also the place of worship;
finally, the sanctuary, the impenetrable sanctuary, separated anew
by the chancel and centered on the altar, as moreover is the whole
building, is the place of the Divine Presence.

Before entering this sacred world of the temple, man must
undergo a lustration, that is, baptism; and he is invited to as it were
re-actualize this lustration each time he enters, by purifying himself
with the water in the stoup.

* * *

If the door, like the temple as a whole, is a solar symbol, the stoup
and baptistery are aquatic symbols. We shall see, however, that these
two types of symbols are not opposed to each other, and fall within
the same liturgical context.

It appears that the door should be studied before the stoup, since
the latter is situated inside the church. If we begin with the stoup, it

is not without reason, for, logically, it should be situated in front of the door, and we shall see that this was the case historically. This leads us to some interesting observations on the origin of the temple itself, which will throw a new light upon our exposition as a whole.

The first and natural temple, before man learnt the art of construction, was quite simply the world, which is the habitation of the Divinity, since it is written 'Heaven and earth are full of Thy Glory' (Isaiah 6:3). But since the world is too vast to be efficaciously enclosed in a ritual act, man reduced the universe to a familiar and meaningful landscape. The general and natural plan of a temple is the basic landscape composed of a hill (or tumulus) with its grotto, rocks, tree and spring, the whole circumscribed and protected by an enclosure announcing the sacred character of the place. Such, at the beginning, was the sacred grove, the *lucus* of the Romans and *alsos* of the Greeks.

When, later, architecture was born, the temple became a house and its mineral and vegetable components were transposed to constitute the very elements of the building. Whereas the virtual or rudimentary enclosure became the walls, the trees were transformed into pillars; the stone was the altar, the grotto gave birth to the niche of the apse and the ceiling was assimilated to the sky. Thus the temple appeared like a petrified landscape. In this new complex, the spring—and this takes us back to our subject—was channelled and became a fountain or, more often, was replaced by a basin for ablutions.

We use this last expression deliberately, for it accurately evokes the nature of the ritual gesture of the faithful, which involves purifying oneself before entering the sacred building. There were fountains near ancient churches built specifically for this purpose, like those built by St Paulinus at Tyre, the old Vatican Basilica, and Notre Dame in Paris (in the last instance, the fountains, which have since disappeared, were found in the enclosed court in front of the cathedral). The common practice was to wash one's face and hands therein, as is witnessed by a Greek inscription on the stoup of the abbey church of Saint Mesmin, near Orleans, expressed as follows: 'Wash here your sins and not only your face.' The stoup replaced and is a reminder of these fountains. At first it was placed outside, in front of the door, then under the porch, and finally inside right next to the entrance.

Like all ritual objects, the stoup conceals a general symbolism, which is made specific and completed by the particular meaning attached to its form.

The general symbolism is the same as that of the spring, of which the stoup is a substitute. If, in the natural temple, stone represented duration, the temporal reflection of eternity, the tree and spring, each in its own way, heralded life and regeneration: the tree renews itself each spring, and all life depends on water.

Among the fountains situated in front of old churches, the fountain that spouted in the baptistery was special. The baptistery, too, found its way into the church where it became the font (*fontis:* fountain). We cannot mention the stoup without relating it to the baptistery, for the former derives all its meaning from the latter. The Baptismal ablution is the only one that is real, and the small ablutions we make on entering the church are of value only because, in a certain way, they recall and re-actualize our baptism.

Essentially the stoup and baptistery are constituted by a tub of water that is either round, oval, or octagonal in shape. In the case of the stoup, the tub is often replaced with a scallop.

In traditional symbolism, every ritual tub represents the primordial Ocean, the 'Waters' of Genesis upon which the Spirit of God moved to bring about creation. And it is by reference to these waters that the baptistery or stoup possesses the power to regenerate.

The tub is often octagonal, which is most significant. Eight is one of the sacred numbers of Christianity: there were eight persons saved in the Ark, which is a figure of baptism and of the Church; there are eight beatitudes defining the Kingdom of Heaven; Sunday is the eighth day, etc. In his *Instructio pastorum*, Saint Charles Borromeo says that the most suitable shape for baptisteries is the octagon, for it is the mysterious emblem of perfection and eternal life. The saintly bishop of Milan thus echoed his illustrious predecessor, St Ambrose, who stated in a homily that 'the octave is perfection' (*Octava perfectio est*, Common of Several Martyrs, Lesson 3rd Nocturne). All the Fathers profess the same doctrine. The number seven is the number of the world (the seven days of Genesis), the perfection of the world. Eight, 7 + 1, is the passage to a new series, to a new world, and the return to the unity whence it arose. Thus, after the

seven planetary heavens, we reach the Empyrean of the eighth heaven, the symbol of Eternity. The whole of Dante's ascent in Paradise unfolds according to this plan. The seven colors dissolve and re-enter the eighth, white, which is also their unity and principle (note that the garment of the newly baptized is white). The eight branched star or compass rose has long symbolized the Spirit who breathes upon the original Waters. It is the *stella maris*, the star of the sea, the sign of the Spirit upon the Waters, the animal form of which is the octopedal medusa. Now, in early Christianity, this medusa was taken as a symbol of the soul regenerated by the waters of baptism and consequently, at a lower level, of the stoup.

With the large scallops from which stoups are often made, we retain the aquatic symbolism, to which every idea of purification and rebirth is linked. Like the egg, which we shall study later, the scallop is a universal sacred symbol both as a ritual utensil and as an ornamental motif. The scallop, more than the tub, recalls the womb, and especially the universal womb containing the original Waters and the seeds of beings. It strikingly evokes that obscure abyss of creative energy, which also explains how it became the emblem of second birth. Up to our day the scallop has remained a living baptismal symbol: the utensil used to lift the holy water and pour it over the forehead of the recipient is often a metallic scallop. Like the egg, the scallop not only serves as a funerary ornament, but also announces the other life and the resurrection. All this symbolism explains its use as a stoup, endowing it with a clearly baptismal character.

The meaning of the scallop is determined by the meaning of the spiral and the pearl. The spiral, another emblem of eternal life, in fact defines the scallop. It has been shown that the movement of vital growth reduces in one way to a spiral: the spirals of life, moreover, develop according to the mathematical laws ruled by the 'golden number', which both give them their harmony and are the signature of the Divine Geometer; whence the enormous importance of the spiral in sacred architecture.

As for the pearl, it was thought to be the product of light penetrating into the mussel: in a way, the pearl is the fruit of the union of Water and Fire. For St Ephraim the Syrian, the scallop and pearl recall respectively the baptism of water and the baptism of fire, the

birth of Christ in the soul through the baptism of fire. St Macarius speaks of the 'heavenly pearl', the image of the ineffable Light that is the Lord. Those who possess and wear the pearl live and govern with Christ in eternity. The mystery of baptism is likened to that of the pearl:

> The diver draws the pearl from the sea. Dive (by means of baptism) and draw from the water the purity found hidden there like the pearl from which the crown of the Divinity came forth.

As indicated above, the reflections of these holy authors show that the aquatic symbolism of the stoup and baptistery, and the solar symbolism of the temple in general, are not unrelated, and that they are even expressly related with regard to the two baptisms. At the end of the book, we shall emphasize the very rich liturgical theme of the baptismal water inflamed by the Christ Sun.

Thus the Sign of the Cross made with water is a rite of purification and sacralization: before crossing the threshold of the house of God, the believer must first be separated from the profane world and given a sacred character in harmony with the place he is entering. To a certain extent this gesture re-actualizes the seal of baptism, which makes the man a 'son of God'. The shape of the stoup, like that of baptismal fonts, emphasizes the efficaciousness of the rite: vat or cockleshell, it recalls the 'womb of generation' (which is what Denis the Areopagite called the Sacrament of Baptism) and the Fountain of Life, which feeds us spiritually. This source of life, *fons vitae*, is that which gushed forth in the middle of Eden and from the Temple at Jerusalem in the visions of Ezekiel (47:1) and Zechariah (13:1); that which was seen issuing from the Sublime Temple, from the Divine Body, at Golgotha (John 19:34); this fountain of water and blood—that is to say *fire*—gives us eternal life and transforms our very selves into a spiritual fountain for the world:

> If any one thirst, let him come to me and drink. He who believes in me, as the scripture has said, 'Out of his heart shall flow rivers of living water' (John 7:37–38).

10

THE DOOR

IN HIS VALUABLE LITTLE BOOK *Sacred Signs*, Romano Guardini writes that modern man needs to relearn the profound importance of gestures. The sign of the cross made with blessed water is more often than not a purely mechanical gesture. Perhaps an even more mechanical act is to 'enter the church'. And yet how much we miss, through lack of attention, in the apparently insignificant acts of 'crossing the threshold' and 'going through the door', for what is involved is the mystery of 'passage', whence the existence in traditional societies of all manner of 'rites of passage', and especially rites of hospitality. Passing through a door so as to enter an abode, be it ever so humble, constitutes something grave and solemn, which quite naturally becomes a rite.

The sacredness of the door and of the passage through it assumes its full importance in what concerns the temple, which is why 'threshold guardians', statues of archers, dragons, lions or sphinxes, semi-divine or even divine personages, like the Roman Janus, god of the door—*janua*—and of the first or 'opening' month of the year—*januarius*—are placed at the entrances of sacred buildings. The role of these threshold guardians is to remind those wishing to enter of the fearful nature of the step they are about to take by passing into a sacred domain. 'You who enter, turn yourself towards heaven,' says an inscription above the door of the church at Mozat.

In the sacred wall separating the holy place from the profane world, there is this void, this caesura, which is something prodigious: by its means we pass from one world to another.

All visitors to Romanesque and Gothic churches have been struck by the great importance given to the decoration of doors, the main door in particular. This is explained the moment we notice that the

different, carefully arranged ornamental motifs aim at emphasizing and expressing the fundamental symbolism of the door. We hasten to add that this symbolism exists even in the barest of doors, so that all we are about to say applies to every door of the church.

If the temple is an image of the world, it can from another angle be considered an open door onto the Beyond, according to the word of Scripture applied to it by the holy liturgy: 'How awesome is this place! This is none other than the house of God, and this is the gate of heaven.' (Gen. 28:17). Now, it has been shown[1] that the door itself is a summary of the whole temple. In fact, it is presented as a niche with rectangular base surmounted by a semi-circular or pointed arch, which is to say that it quite simply repeats the choir of the church, which itself is a large niche sprung from the original sacred cavern—in turn a symbol of the Cosmic Cavern—of which we find still living forms in the sacred niches of India and Islam (the *mihrab* of mosques). The sanctuaries of Byzantine and Romanesque churches with their vaults in which Christ the Pantocrator is enthroned, as in the tympanum of the portal, clearly have this air of a sacred cavern. It will be noted, moreover, that the contours of the niche and the door reproduce the very plan of the whole building: the rounded part, like the vault and the cupola, represents heaven; the rectangle, like the nave, represents earth. The door is thus, in its turn, a cosmic symbol.

But it is also a mystical symbol. Since the temple represents the Body of Christ, the door, as summary, should also represent Christ. He Himself, moreover, very clearly said as much: 'I am the door of the sheep. . . . I am the door; if any one enters by me, he will be saved' (John 10:7–9). The church door effectively becomes this mystical and Christic door through the rite of consecration, in the course of which the bishop anoints each jamb with holy oil, while saying:

> May this door be blessed, . . . may it be an entrance of salvation and peace; may it be a door of peace, through the intercession of Him who is called 'The Door', Our Lord Jesus Christ.

1. T. Burckhardt, *I am the Door* (see bibliography), which is our principal source of inspiration for this chapter.

Since the Christian temple is also the figure of the Heavenly Jerusalem, that is, of the world renewed and transfigured, of Paradise regained, it is through the Christ Door that we enter therein.

All portal ornamentation develops these two symbolisms, cosmic and mystic, which support and complete each other. It comprises fundamental elements that are nearly always the same. The tympanum is occupied by the figure of Christ in Majesty or Glory, the scene represented being in general that of the Last Judgment, or the vision of heaven opened, according to the Apocalypse, and sometimes the Ascension or Transfiguration. In every case it is a question of a glorified Christ, that is, the figure of the Pantocrator, the Master of the Universe. He appears in an almond shaped halo of glory, seated on the throne, one hand raised, the other holding the Book of Life, surrounded by four animals. Flanking Him are the twelve Apostles and sometimes the twenty-four elders of the Apocalypse or the angelic choirs. In this scene, we may also encounter on the tympanum or its peripheries the two Saints John, St Michael, and the episode of the wise and foolish virgins. The archivolt, which surrounds the tympanum, is often decorated with a vegetable frieze, generally a vine. Another ornamental element is the zodiac with the seasonal labors corresponding to each sign, and therefore to each month; it is depicted either on the archivolt, doubling up the vegetable frieze, as at Autun and Vézelay, or in two vertical bands to the left and right on the door-jambs.

The representation of the zodiac is particularly important. It embodies the celestial cycle, the movement of heaven, that is, the activity of the Word in the world. Whereas the Eternal Word, the Second Person of the Trinity, who is the Lord Himself, reigns motionless at the center of all, holding the Book of the Law or of supernatural Revelation, the Cosmic Word, who is the creator, always in action, effects a natural Revelation that is none other than the world itself. The world is a cyclical revelation of God in time and space. The sky represents the movement of life, a circular movement around the Divine Sun, like the planets and zodiacal signs around the visible sun.

The circle of the zodiac is divided into four parts according to the axes passing through the equinoxes and the solstices, these latter

determining the seasons. Now, the equinoxes and solstices have been called 'celestial doors', because they are the points at which one season passes into another, that is, from one 'timeframe' to another. The two solstices constitute as it were the two poles of the annual cycle, and therefore, also, of the temporal world in relation to space, since there is a correspondence between the four points of the year and the four cardinal directions: north and south correspond to winter and summer solstices, and east and west to vernal and autumnal equinoxes respectively. These correspondences between seasons and cardinal points, between time and space, define the two essential characteristics of the world and existence.

The connection with the door is obvious. The main door of the temple is viewed as a synthesis of the celestial doors and above all the solstitial doors, which are the cosmic image of the Door of Heaven, which is none other than Christ Himself. We saw above, regarding belfries, how this synthesis can be envisaged starting from the solar *indices*. When found on the right and left sides of the door, the zodiac is generally arranged in such a way as to make perceptible the division of the annual cycle into its two halves, the one ascending, from the winter to the summer solstice, the other descending from the summer to the winter solstice. The temporal aspect of the Revelation of Christ, the Sun of Justice, corresponds to these two solstices, the 'turning points' of the sun, the two extremities being marked by the Forerunner, who announces His birth, and the beloved Apostle, who evokes His glorious return in the Apocalypse. This is why St John the Baptist and St John the Evangelist, whose feasts are situated precisely at the two solstices (June 24th and December 27th, respectively), are often depicted on the uprights to either side of the Christ on the tympanum. Just as they 'open' the two periods of history marked by the two advents of the Savior, so likewise, on the cosmic plane, they 'open' the two phases of the annual cycle, which is the condensed symbol of the universal cycle of time and history; and in this role, by so to speak duplicating him, they replaced Janus of the two faces, whose feast the *Collegia fabrorum*, the ancestors of those who built the cathedrals, celebrated at the two solstices.[2] A curious window at Rheims (Church of St Remy) shows what could be called a 'synthesized' St John, a single

figure embracing both the Forerunner and the Evangelist, a fusion emphasized by the presence above the head of two sunflowers pointing in opposite directions (= the two solstices), in sum a sort of Christian Janus. This division of the annual cycle is related to the scene on the tympanum depicting the Last Judgment, which closes history or temporal Revelation; and there is an easily understood correspondence between the two phases of the year and the division of men into the *chosen, rising* to heaven, and the *damned, descending* to hell. This symbolism of the temporal cycle is expressed again in the number of twelve Apostles, related, as we shall see on many occasions, to the twelve signs of the zodiac grouped around Christ the Sun, both in the scene of the wise and foolish virgins, whom Christ awaits on the threshold of the *door,* and finally in the vision of Christ in Glory who, with history completed, shines in the timeless City of Heaven.

If now we consider not the great portal alone, but all the doors of the church together, we will notice that they are divided according to the four cardinal points, and thus according to the axes of the solstices and equinoxes. In principle, each side of the church has three doors, that is, twelve in all, in the image of the Heavenly Jerusalem. In practice though, even in the large buildings, only the west, north and south façades have three doors each. In the eastern façade, the doors are replaced with other openings: the great stained glass windows of the apse, which are hit by the rising sun and are thus perfect 'solar doors'. Each of the twelve openings corresponds to a sign of the zodiac, and each group of three to a season. The central or principal openings of the four groups correspond exactly to the cardinal axes.

The zodiacal number twelve is found again in the traditional twelve pillars of the nave, which, marked during the consecration with twelve crosses, represent the Apostles, the spiritual columns of the Church; but, as we have seen, the twelve Apostles, like the twelve

2. In the old operative lodges, called 'lodges of St John', these were the two principal solemnities. Once again, then, we find ourselves face to face with an ancient heritage that was Christianized, and could be, because it represents an eternal value.

tribes, are related to the twelve signs of the zodiac: just as the latter surround the sun, so the Apostles surround Christ the Sun, King of the world.

These observations will give an idea of how the ages of high intellectuality took care to make perceptible the harmony existing between the sensible and spiritual worlds.

But that is not all. We mentioned a plant frieze, generally a vine, sculpted on the archivolt or the uprights, parallel to the zodiacal frieze. It, however, always occupies an 'inner' position, at the back of the splays of the niche, whereas the zodiac is situated on the 'outer' edge. This is because the frieze in question is nothing but a stylized Tree of the World, like the niche an ancestral symbol of humanity, and often lines the inside of the latter.[3] In the Christian temple, this tree is a vine because Christ likened Himself to one: 'I am the true vine' (John 15:1 ff.)—once again, a happy coincidence between eternal sacred symbolism and properly Christian symbolism.

Another ornamental motif is the wheel. In the oldest monuments and up to the Carolingian age, this wheel was a cross in a circle, or more often, the monogram of Christ also inscribed in a circle:

This sign is analogous to the cosmic wheel, which is none other than the diagram of the world itself envisaged in its cyclical movement. The six directions marked by the down strokes of the deliberately fused letters X and P, correspond to the directions determined by the two cardinal axes along with the polar axis, projected on a plane. Moreover, monograms without the loop of the P, and thereby directly revealing their cosmological character, are widely attested.[4] We see immediately that this figure reproduces in plane geometry the three-dimensional cross mentioned in the text of Clement of Alexandria.[5] Here again, the cosmic and theological symbols 'hang together' perfectly. This

3. In India, a sacred niche must contain a representation of either the tree of the world or the divinity.

4. There are beautiful specimens at the Vienne Museum (Isére).

5. See Chapter 5, 'Ritual Orientation'.

figure is the abstract image of the Divine Word under His double aspect of Cosmic Word and Natural Revelation, and of Incarnate Word bearing the name of Christ, which is magnificently expressed by the letters that blend with the Space-Time diagram. This symbol, engraved on the lintels of the very sober doors of Carolingian churches, clearly expressed the assimilation of the door to Christ. Now, this figure in combination with the oriental *oculus* gave birth to the rose window, of which the character of *cosmic wheel* is attested by the fact that it very often has *twelve* radii plus the signs of the zodiac or the twelve Apostles depicted in medallions on the circumference, whereas the center, the motionless hub, is occupied by Christ in Glory. After becoming rose window, the cosmic wheel was raised from the lintel to its situation above the door. Finally, in the Gothic period, the three doors with the rose window were surmounted by a large string-course, which, as Hamann McLean has shown, was inspired by the Roman triumphal arches, which also had three openings.[6] It is known that these edifices had a sacred character and were *puerta del sol*. The particular beauty of the triumphal arch belongs to the fact that it is a door to the state of purity, a door that opens onto the void; but this void is in reality the world itself and all the space of heaven. A more adequate symbol of the 'heavenly door' cannot be imagined. When the rose window was placed in the middle, the great portal, transformed into a triumphal arch, became an even more striking image of the *janua coeli* through which the divine sun shines.

To conclude, let us mention another motif, widely known for its importance and frequent appearance, the Tetramorph, which designates the mysterious 'Four Animals' surrounding Christ in Glory. In this context the term 'animal' is rather ill chosen; it is a too literal translation of the Latin *animalia*, the meaning of which is wider than that of the English word, designating as it does all 'animated being'. It would be better, therefore, to say the 'Four Beings', since even if three of them, the eagle, the bull and the lion, are indeed animals, the fourth is a man. The four figures surrounding the Son of

6. *Cahiers de Civilisation médiévale* (Université de Poitiers), April–June 1959, pp 157–175.

Man are a modeled transposition of Ezekiel's vision (1:5–14), as well as St John's:

> And round the throne, on each side of the throne, are four liv-
> ing creatures, full of eyes in front and behind: the first living
> creature like a lion, the second living creature like an ox, the
> third living creature with the face of a man, and the fourth liv-
> ing creature like a flying eagle (Apoc. 4:6–7).

These figures are usually regarded as symbols of the evangelists, which is true, but, to grasp their full significance, it is useful to know that they have another meaning. They are the four 'cherubim' form-ing the living and square Chariot (*merkabah*) upon which the Eter-nal appeared to Ezekiel and the glorified Christ to St John. These four beings should be envisaged simultaneously in their cosmologi-cal and theological, that is, natural and supernatural, senses.[7] In the natural sense, they represent the four 'corners' or 'pillars' of the world, that is, the four constituent elements of the physical world, or, more exactly, the supernatural powers that rule these elements, powers issued from the creative Breath of the Word. They are also related to four main constellations of the zodiac, the Man corre-sponding to the Water Bearer and the Eagle sometimes being substi-tuted for the Scorpion.[8] The Jewish tradition has each of the four letters of the great Divine Name YHWH correspond to one of the beings: Y corresponds to the Man, H to the Lion, W to the Bull, and the second H to the Eagle. This chariot symbolizes the divine opera-tions in the world; it is another expression of the natural or cosmic Revelation, the Will of the Word acting upon the sensible as upon

7. 'The four animals are the ideal representation of the whole of living creation,' says Crampon (*Nouveau Testament*, p311), without, however, understanding the full importance of his assertion.

8. Given the analogies linking the zodiac to the tribes of Israel, it will not be without interest to learn, through a targum of the *Pseudo-Jonathan*, that the tribes are grouped in threes, with each group having its own emblem. There were thus four emblems, which were precisely those of the Tetramorph: Issachar, Zabulon, Judah: LION; Ruben, Simeon, Gad: MAN; Ephraim, Manasseh, Benjamin: BULL; Dan, Aser, Naphtali: EAGLE.

the supernatural world: it establishes and preserves everything. The fact that each being corresponds to a letter of the ineffable Name signifies, first, that the sensible world is the image of the spiritual world, revealing it to those who know how to see it with the 'eye of the heart', and then that Jesus, being the Lord, is the fullness of all cosmic reality, the bond that is 'to unite all things in him' (Eph. 1:10), the center and passage from this world to the next.

In supernatural Revelation, the four evangelists correspond to these 'cosmic pillars'; they are also the pillars (the principal four among the twelve mentioned above) or corners of the Church. They are the earthly supports of the supernatural Revelation of the Word through the Church, which latter is already the first fruit of the regenerated *future* world. In certain ancient domes, Christ is shown in the center of the cupola supported by the Evangelists or their symbols, which are depicted in the pendentives at the four corners; occasionally, as at St Sophia in Edessa, it was four cherubim; St Maximus the Confessor likened them to those of the Ark of Moses, which, he said, represented the 'form of the universe', that is, the four cosmic pillars. Here again, we grasp the harmony uniting the cosmic and natural order to that of the spirit.

Thus, by means of its symbolism, the door of the temple is in itself truly a sacred site. Like the sanctuary centered on the Stone of the Altar and the Cross, the portal, with its celestial tympanum centered on Christ in Majesty, is the place of a theophany, a manifestation of the Lord in His Glory. *In His Glory*—we believe it right to dwell on this point, as it provides the key to all this symbolism, making it possible to reveal a mysticism of the door.

In our opinion, the portal (particularly the Romanesque), which is a representation in stone of that vision of heaven opened, that 'door opened in heaven' foreseen by St John (Apoc. 4:1), constitutes the most striking plastic expression of the very spirit of Christianity: the eschatological sense, the expectation of the Parousia, the Lord's Return; a spiritual tension in the Body of the Church, and, for the believer, an attempt to inwardly actualize that instant which will be 'the fullness of time' and the 'day of the Lord'. This extraordinary apparition set in stone seizes the believer as he enters the temple, and offers him in brief the entire meaning of the world,

something that simultaneously expresses and anticipates 'He who was and is and is going to come', which is an invitation to 'watch and pray', 'for you know neither the day nor the hour when the Son of man is to come' (Matt. 25:13).

In passing through the church door, the believer should be aware of making a sacred gesture, of 'passing from this world to the Father', as this beautiful prayer of William of St Thierry suggests:

O Thou who didst say: 'I am the Door', show us the habitation whose Door Thou art, and when and to whom Thou dost open it. The House, whose Door Thou art, is Heaven where Thy Father dwells.

11

LABYRINTHS

AT FIRST GLANCE, the question of the labyrinths traced on the floors of certain churches may appear somewhat secondary and, as such, not worth examining in a work that intends to stick to essentials. If we do include it, this is not only to satisfy the legitimate curiosity of art lovers who visit our ancient religious buildings, but rather, and above all, because the study of the nature and purpose of labyrinths can throw new light on the meaning of the temple itself.

* * *

Labyrinths seem to have been commonly used, at least in certain countries. In France, there remain those of St Quentin, Amiens, Bayeux, Chartres, Poitiers and Guingamp, although many more, such as those at Arras, Auxerre, Rheims and Sen, have now disappeared, and examples can also be found in England and Germany, and at Pavia, Piancenza, Cremona, Lucca, and other places in Italy. Their origin is certainly remote, as one has been found in the remains of the ancient Christian basilica of Orléansville (*Castellum Tingitanum*), and their at least 'literary' connection to the famous labyrinth of Crete is certain, as is attested by some inscriptions and representations we shall soon consider. But should we go further and seek the historical origin of our labyrinths in this direction, noting, with Evans, the fact that buildings of the 'basilica' type could well have originated in Crete? This remains in the domain of supposition. We should also mention Autran's interesting observation that the distribution of labyrinths in the churches of Europe coincides

with the distribution of megaliths. Furthermore, labyrinths have been found engraved on megalithic stones, like the one in the Dublin Museum. The hypothesis of a transmission by way of megalithic civilization is therefore not to be excluded. But rather than spending time on these historical considerations, which have no direct bearing on our perspective, let us immediately proceed to the study of labyrinths as such.

Some labyrinths are located in the nave at the crossing of the transept, but the majority are laid out at the start of the nave, where the faithful immediately encounter them on passing through the door. A labyrinth is made up of a series of concentric circles, or, amounting to the same thing, concentric octagons, as at Amiens; the center is clearly defined and sometimes filled with a figured scene or geometric motif; finally, the center is the point of intersection of two perpendicular axes, defining a visible cross spanning the often very sinuous folds of the circled lines. What is the meaning and purpose of these figures?

Obviously, for the reasons already given in connection with belfries, we reject the thesis of those who see in them nothing but ornamental motifs. Besides, apart from these very general reasons, there is an altogether decisive one for not holding to this false explanation: we expressly know that labyrinths were used in devotional exercises, to which certain indulgences were attached. But before examining what this involved, which is properly the heart of the matter, let us mention a preliminary explanation of these mysterious patterns. People have wished to see in them the collective signature of the associations of freemasons, which is all the more probable because in certain cases, as at Amiens for example, the master builder was depicted in the center; moreover, the labyrinth is formed of a continuous line, which makes it similar to the 'string of knots' or 'love knots', well-known symbols of craft corporations, depicting, among other things, the bond uniting the members of these organizations. But, to affirm the labyrinth's role as signature is only to postpone the true explanation, which belongs to the very nature of the object and justified its adoption by the trade corporations.

We are given a first approximation by the known fact that labyrinths were used in antiquity to protect towns and houses against

evil influences. This was shown by Knight in his book *Cumean Gates* (1936), especially with regard to the miniature archaic Greek houses found at Corinth, on the outside walls of which labyrinths were engraved (in this regard, let us observe that archaic Corinth was very likely subject to a Mycenian and, by way of it, Cretan influence). Let us also note in this regard the position of English labyrinths, which are small monuments erected outside and near to churches. The possibility, then, that labyrinths played an 'exorcistic' role with regard to evil powers cannot be excluded. Within the same order of ideas, the moats and walls of towns of the Middle Ages were ritually consecrated against the assaults of the devil, sickness, and death. In such cases, the place of labyrinths near the door of the temple is fully justified.

Ultimately, however, this apotropaic role is not proven with regard to our cathedrals, and in any case it is not the essential. The purpose of labyrinths was above all spiritual, which is demonstrated as much by tradition as by their very structure, as mentioned earlier. If we consider the circles of this structure along with their windings and the axes superimposed on them, we are stuck by the similarity with the spider's web, the natural model of weaving, wherein the four branches of the cross constitute the warp of the cloth, and the concentric lines and their windings represent the weft. In universal symbolism, weaving represents the world or existence, sometimes conceived as the construction of the cosmic Spider, the image of the supreme Artisan. What is apparent in the labyrinth from this viewpoint is the complication of the weft, the difficulty of again finding oneself in its turns and windings, and the figure represents human existence, life with its vicissitudes of every order, the consequences of the human state and its immersion in the world. Entering the labyrinth is birth, and leaving it, death. In this regard, we read the following in a mediaeval hermetic manuscript preserved at Saint Mark's:

In seeing these thousand spirals, from the inner to the outer, these spherical vaults which hither and thither turn in upon themselves, recognize the cyclical course of life, revealing to you in this way its slippery turns and tortuous paths! It unfolds

concentrically and subtly rolls up in compounded spirals, just as, in its coils, the Great Serpent of Evil crawls and insinuates itself in broad daylight and in secret. . . .[1]

Left to himself, man is incapable of knowing himself; like Dante, he is lost in the 'dark forest'. To find himself, he needs 'Ariadne's thread', which is none other than the concentric windings themselves, the entanglement of which is only apparent, since they are in fact made up of a continuous line, the 'thread of existence'. In Christian language, the 'thread' allowing man to 'find himself', is Divine Grace. Is it rash to see in the inscription engraved on the labyrinth of the Dome of Lucca, the Myth of Theseus interpreted in this sense? 'Behold the labyrinth of Crete constructed by Daedelus, from which nobody, once having entered, could escape except Theseus, *graciously* aided by the thread of Ariadne,' *Theseus gratis Adriane* (sic) *stamine jutus.* Let us pay attention to this word *gratis,* the same as *gratia,* Grace. Ariadne is the divine grace that helps Theseus in his struggle with the monster, that is, man in his combat with evil. This allegorical exegesis of an ancient myth in a Christian sense is altogether in the line of thought of the first centuries and the Middle Ages. In the past, moreover, the scene of Theseus' combat was also represented at the center of the Chartres labyrinth, which is a strong presumption in favor of the exegesis we are proposing.

We have just mentioned the center of the figure, and this leads us to the second way of envisaging it. No longer do we consider the windings and their disorder, but the four branches or axes whose intersection coincides with the center of the figure. And, let it be noted, we are now faced with a diagram similar to that used at the founding of the temple: a cross within a circle. In addition, the existence of square labyrinths, such as the one at Orléansville, clearly shows that here we are dealing with the same symbolic domain of the circle and its quadrature. Thus, the labyrinth clearly appears to be a cosmic symbol, a microcosm, an 'image of the world', in which the cardinal cross, the emanation of the center, organizes the 'chaos'

1. Published in *Cahiers du Sud,* 8–9, 1939.

—at least apparent—of the windings.[2] What counts in the figure, therefore, is the center, identified with the Center of the World, to which the lines lead; and this is why in the Middle Ages labyrinths were called 'roads to Jerusalem', the holy city necessarily being situated, at the center of the world, as we have already said. In certain cases, the walking of the labyrinth took the place of the pilgrimage to Jerusalem, and indulgences were attached to this practice, proof that it was taken very seriously. It involved nothing less than what is called the 'journey to the center', or the 'spiritual orientation' of the being, of which pilgrimage is only an outward aspect. As a course directed to a consecrated center, pilgrimage is a victory over space and time, because its goal is ritually identified with the supreme Goal, the supreme Center, which is not other than God, and, at lower levels, with the Heavenly Jerusalem and the Church. Thus, at the center of the Orléansville labyrinth, we find a 'magic square', the letters of which form the words *Sancta Ecclesia.*

A confirmation of what we are saying is to be found in the concept and usage of the Hindu *mandala,* a diagram in the form of concentric circles inscribed in a square, which, in the Hindu tradition, is expressly presented as an *imago mundi.* In initiations, it is traced on the ground and the neophyte, in order to reach the center, successively traverses its different zones. Ultimately, this journey to the center is identical to the ascending procession of the Hindu faithful, who, by means of ladders on the flanks of the temple, climb to the chapel at the summit, which is situated on the vertical axis and identified with paradise. The *mandala* can be viewed as the plane projection of the spirals of approach on the sides of the temple, the image of the ascension of the cosmic mountain of paradise. Exactly the same goes for the labyrinth: similar to the cruci-circular figure of the foundation rites, it is, within the temple, like the essential diagram of the temple itself insofar as it is an image of the cosmos and of the Spiritual Center.

From this we can measure the importance and regained meaning that the walking of this mystical maze by the mediaeval faithful

2. The church of St Foy in Saverne possesses a labyrinth in the corners of which are depicted the four rivers of Paradise.

assumes within this perspective. It was in no way 'a simple diver-
sion, in turning to which those who had nothing to do passed their
time,' as Cisternay, canon of Chartres, rather thoughtlessly asserted.
The eminent dignity of this 'pilgrimage', as moreover of any pil-
grimage, derives from the fact that it symbolizes the true pilgrim-
age, the true 'journey to the center', which is an 'inward' journey in
search of the Self. The Self of man is identified neither with his
body, the domain of sensations, nor with his soul, the domain of
feelings, nor with his mind, the domain of ideas and reason, but
with his *spirit*, or to use traditional language, his *heart*. According to
the spiritual schools, this spirit or *heart* is also called the 'depths', the
'interior castle', the 'fine point', or 'summit of the soul'. It is there
that the human essence resides, 'the image of God in man', it is there
that the center of his being is found. In all spiritual work, the
unique goal of life, the *unum necessarium*, is to 'realize' this Self, that
is, to become consciously aware, not discursively, but, by the grace
of God, vitally and ontologically, that this alone is our true being,
such that all the other envelopes of the individual are reabsorbed
into this luminous and living center, which is the 'Kingdom of God
within us' and which, by virtue of the analogy between the macro-
cosm and the human microcosm, is identified with the Center of
the World. The man who, through the grace of God, is established
in this center, sees everything, the world and self, with the very eye
of God.

In the long and difficult effort of concentration upon itself that it
must make in order to effect this piercing through to the center, the
spirit needs the assistance of external supports that channel sensible
and mental currents and cause them to enter into the perspective of
the goal, thus helping man to find his own center. This is the func-
tion of images, whatever they may be. From the start, there have
also been, apart from the holy icons, figures of an abstract, geomet-
rical type, constructed in such a way as to emphasize the central
point engendering them. It is probable that the labyrinth was one of
these. It certainly falls into the category of *yantras*, the Hindu word
designating any figure serving as a support for meditation and con-
centration. The *mandala*, we have seen, is a *yantra* for ritual use.
Now the similarity between the *mandala* and the labyrinth is too

obvious for the spontaneous idea of a similar use for the second not to arise.[3]

We believe we can give an idea of what the labyrinth meant for mediaeval man by an example that has the double advantage of being not only current and thoroughly alive, but of having emerged, at least in part, in a Christian milieu. Fr. Dournes has published some remarkable pages on the art of the Sre, a people of the central highlands of Vietnam. Among all the subjects he deals with, we shall concentrate on what he teaches about the decorative motifs of the Sre's basketwork.

Each piece of work begins with a crossing of strands, defining a center called *nus* (heart), which is multiplied and propagated in concentric squares to form the work. This 'stitch' of the basketwork is called *guung nus*, that is, the 'way of the heart'. The initial square brings together the lines of construction; it is the essential figure, catching the attention. Attentive observation of the *guung nus* naturally leads the eye to look for the center and concentrate upon it. A Christian Sre, given a cross to decorate, inscribed a *nus* at the center, and, on the four branches, a series of chevrons pointing to the center, all of which constituted a veritable Sacred Heart. Another defined the *nus* as the primordial stitch whence everything flows (= the center of the world), and said that through it, the Christian is brought to look upon the Heart of Jesus as the model to follow, the 'stitch' to continue with in order to 'weave' the community of men (*L'Art Sacré*, 7, 1955).

This notion of center is absolutely essential to spiritual work and, consequently, to the objects that are in any way its 'tools'. We have already established that this notion presides at the foundation of the temple, the 'tool of meditation', and have just discovered it again in the labyrinth. We shall now see how the 'way of the heart' arranges the internal structure of the temple around the Altar.

3. In order to elucidate the role of the labyrinth more completely, it would be necessary both to study why it was used in the performance of certain ritual dances, and to consider its position inside the church, either at the center thereof, like the *omphalos* of the Byzantine church, or towards the lower end of the nave, and the relationship between this position and the parts of the human body. These, however, are very complicated matters that we cannot consider here.

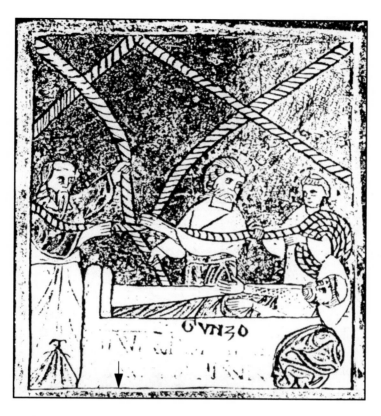

Saints Peter, Paul, and Stephen appear in a dream to Abbot
Gunzo and unwind cords to indicate to him the plan of the
future basilica of Cluny (miniature of the life of Saint Hugh,
Bibliothèque National, twelfth century)
(Chapter 2: 'The Celestial Origin of the Temple')

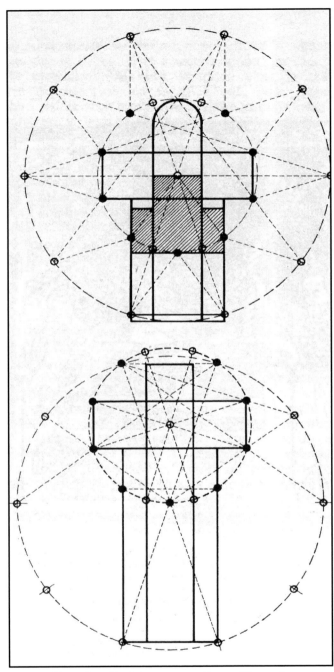

Typical gothic layouts according to Moessel
(division of the guiding circle by ten)
(Chapter 3: 'Temple and Cosmos')

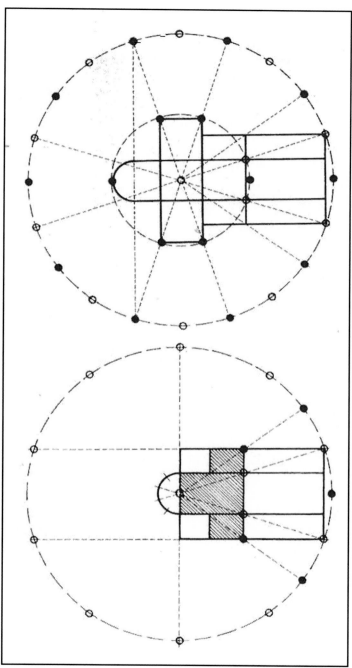

Typical floor plans according to Moessel. On the left: a early
Christian basilica. On the right: a gothic cathedral
(Chapter 3: 'Temple and Cosmos')

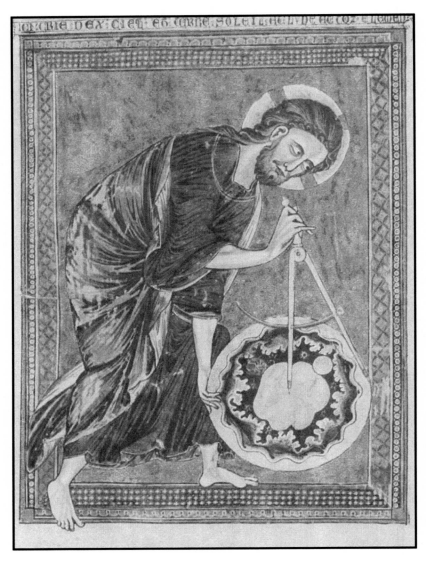

God represented as the architect of the universe.
(Moralized Bible, Vienna)
(Chapter 3: 'Temple and Cosmos')

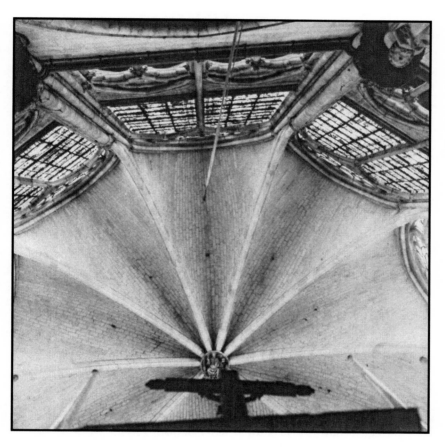

Troyes Cathedral. Key of the vault of the apse,
bearing the figure of Christ, rises 88 feet, 8 inches
(888 is the gematria of the name of Jesus in Greek)
(photo Tetraktys Ch.-J. Ledit).
(Chapter 4: 'Numerical Harmonies')

The figure above combines indications from two great medieval sym-
bolists: Saint Hildegard of Bingen and William of Saint-Thierry.
According to Saint Hildegard, man in his length and width, with arms
extended, is inscribed within two equal and perpendicular series of
five equal squares (five is the number of man) and lastly in a perfect
square. For his part, William of Saint-Thierry remarks that man is
equally inscribed in a circumference with the navel at its center.

The above synthetic diagram enables us to understand how the com-
bination of circle and cross, in temple construction, expresses the
mystery of the relationships between man and universe, as well as the
theanthropic mystery of the Church, which brings earthly man—the
square—to participate in Divinity—the circle.

(Chapter 4: 'Numerical Harmonies')

Diagram drawn from the journal 'Compagnonnage'
(July–August 1961)
(Chapter 6: 'The Temple, Body of the God-Man')

The Body of Man within the Temple
(Chapter 6: 'The Temple, Body of the God-Man')

(Chapter 6: 'The Temple, Body of the God-Man')

Notre-Dame de Paris, the great bell
(photo CAP Roger-Viollet)
(Chapter 8: 'Bells and Belfries')

Trêves (Maine-et-Loire)
Stoup (photo Hurault-Viollet)
(Chapter 9: 'Stoup and Baptistery')

Poitiers (Vienne)
The Saint John baptistery (photo Hurault-Viollet)
(Chapter 9: 'Stoup and Baptistery')

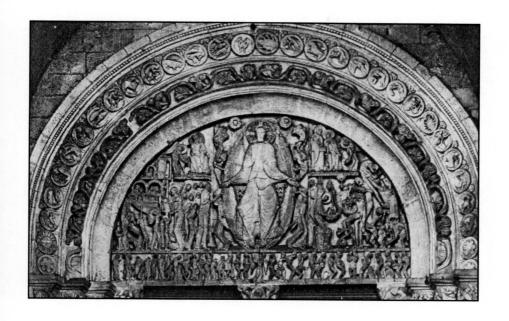

Autun
The grand portal of the Saint-Lazare Basilica at Autun
On the tympanum, the Last Judgment;
exterior coving: the zodiac and the labors of the months;
interior coving: a vegetal frieze, substitute for the cosmic tree
(Chapter 10: 'The Door')

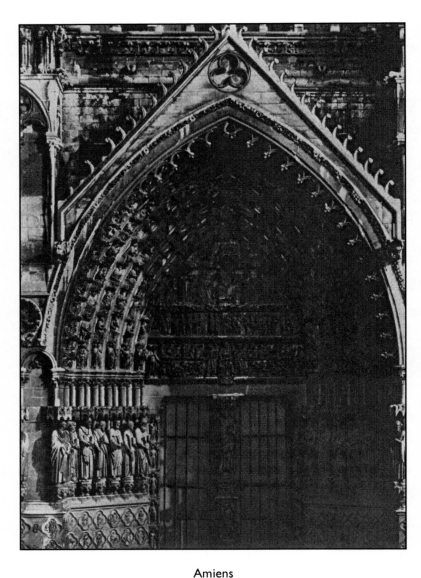

Amiens
Cathedral of Notre-Dame d'Amiens: the Saint-Sauveur doorway
On the tympanum, the Last Judgment; on the archivolt, the heavenly
Hierarchies; on the trumeau, the 'Beau Dieu'
(Chapter 10: 'The Door')

Limoges
Sculpture of the cathedral's central doorway
(photo Roger-Viollet)
(Chapter 10: 'The Door')

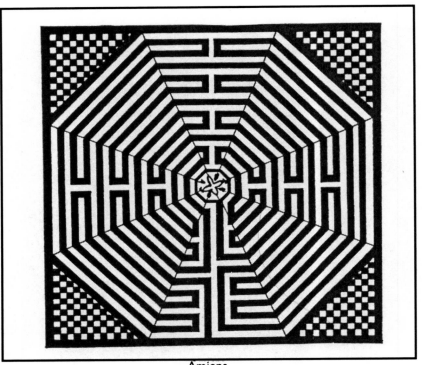

Amiens
The great labyrinth of the nave

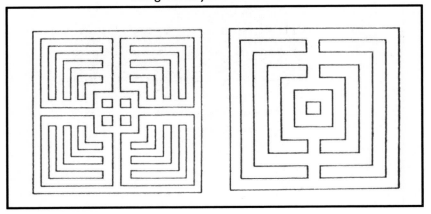

Amiens

The Labyrinth
beside the principal alter

The Labyrinth
beside the entry to the choir

(Chapter 11: 'Labyrinths')

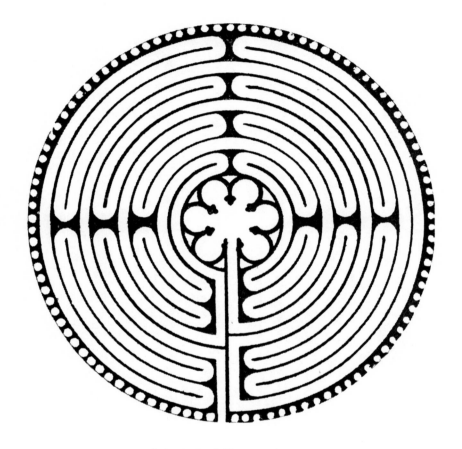

Labyrinth of Chartres cathedral
(Chapter 11: 'Labyrinths')

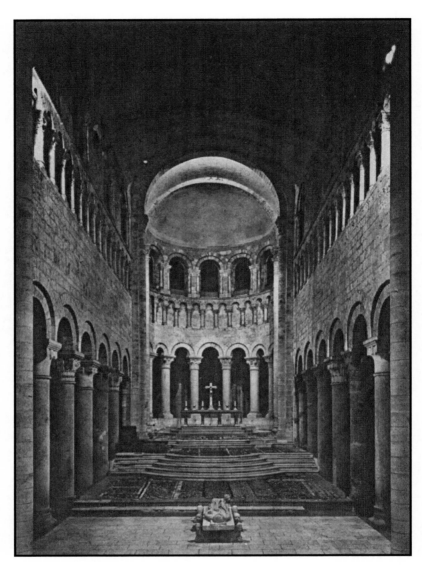

Romanesque catharsis! The basilica of Saint-Benoît-sur-Loire
(Chapter 12: 'The Altar and Christ')

A structure evoking the cosmic mountain
The church of Vouvant (Vendée)
(Chapter 13: 'The Altar: Lights on the Holy Mountain')

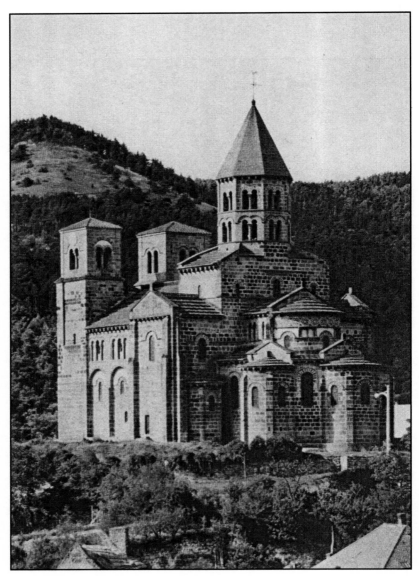

A structure evoking the cosmic mountain
The church of Saint Nectarius seen from the south-east
(photo G. Franceschi)
(Chapter 13: 'The Altar: Lights on the Holy Mountain')

12

THE ALTAR AND CHRIST

WHEN, AFTER CROSSING THE THRESHOLD, we penetrate into the cathedrals, or even the most modest churches of former times, we are as if fascinated and overcome by that 'sober drunkenness' spoken of by Cistercian mystics. The temple acts like a charm, for in it we can feel the throbbing of a harmonious soul, whose rhythm, coming to meet us, prolongs, transcends, and sublimates our own living rhythm and even the rhythm of the world in which it floats. This 'magic' derives from the existence of a center from which lines radiate, engendering and extending with unreserved joy and according to the golden mean, forms, surfaces, and volumes, to a skillfully calculated limit, which arrests, reflects and returns them to their point of origin; and this twofold current in a way constitutes the subtle 'breathing' of this body of stone, which, after expanding outwardly to fill space, gathers itself into its origin, into its heart, which is pure inwardness.

This center, from which everything radiates and towards which everything converges, is the Altar. The Altar is the most sacred object in the temple, the reason for its existence, and even its essence, for while in cases of necessity, the Divine Liturgy can be celebrated elsewhere than in a church, it is absolutely impossible to do so without an altar of stone.

Introibo ad altare Dei... 'I will go to the altar of God.' This verse of the psalmist which opens the Mass, places us from the outset of the holy office before this amazing cult object. The altar is the table, the stone of sacrifice—that sacrifice which, for fallen humanity, is the only means of making contact with God. The altar is the place of this contact: by means of the altar God comes to us and we go to Him. It is the holiest object in the temple, since we bow before it,

kiss it, and cense it. It is a rallying point, the center of the Christian congregation, and to this outer gathering corresponds an inner gathering, not only of souls, but of *the* soul, the instrument of which is the symbol of stone itself,[1] one of the most profound of symbols, like the tree, water, and fire, reaching and touching something primordial in man.

* * *

The Christian altar is the successor and synthesis of the Hebrew altars and derives its sublimity from its conformity to its celestial archetype, the Altar of the Heavenly Jerusalem, where rests the Lamb 'slain from the beginning of the world.'

There is a striking correspondence, for example, between the altar of Moses and our own. Moses built an altar at the foot of Sinai, offered sacrifice, and divided the blood into two parts. One part was given to the Lord (or, more precisely, was poured over the altar representing Him) and the other to the people who were sprinkled with it. Thus was sealed the pact between the Lord and His people, the First Covenant (Exod. 24:4–8). Likewise, on the Christian altar, the blood of the New Covenant is poured out, offered to the Lord, and then distributed to the people, sealing the reconciliation of the sinner with God.

In the temple at Jerusalem, there were several altars. Between the courts and the Sanctuary was the altar properly so-called, the altar of holocausts, where each day the sacrifice of the lamb was offered. The altar of incense was to be found in the Sanctuary, together with the seven branched candlestick and the table of the showbread, that is, the bread of offering (these loaves, numbering twelve, were renewed each Sabbath). Finally, in the Inner Sanctuary or 'Holy of Holies', there was not an altar, properly speaking, but a particularly

1. The altar is indeed not only a *table*, but also and in the first place a *stone*. The altar, in the strict sense—what is called the 'fixed altar'—is a single natural stone resting on a base, or at least four feet or uprights, of stone. In wooden 'altars', only the stone fitted into the center of the table merits the name of altar, but, properly speaking, this is a 'movable altar'.

sacred stone, the *shethiyah* stone upon which the ark rested and about which we shall speak at length.

In the Christian temple, which replaced that of Jerusalem, the main altar is the synthesis of these different altars. First, it is the altar of holocausts where the 'Lamb of God' is sacrificed, and at the same time the table of the showbread, that is, the Eucharistic bread. Secondly, it is the altar of fragrance where incense is burned, as is clearly brought out in the Roman ritual; for, when a bishop consecrates the altar, he lights incense on the five crosses engraved in the middle and at the corners of the stone, while the anthem, 'From the hand of the Angel, the smoke of incense rises to the Lord,' is sung.

Finally, the main altar plays the role of the *shethiyah* stone supporting the Ark, in the sense that it supports the tabernacle. Among the Hebrews, the word tabernacle, signifying tent, designates the ensemble formed by the Sanctuary and the Holy of Holies, and, from this perspective, the actual tabernacle can be seen as the temple in miniature. But, above all, it recalls the Ark (*arca*: chest), as much by its restricted dimensions as by its role. The Ark contained the Tables of the Law, the Rod of Aaron, and a measure of manna. There the *Shekinah*, the 'Glory' or Divine 'Presence', was manifested between the Cherubim. And there in the Christian tabernacle rests the true Manna, the 'living Bread descended from Heaven.' In certain churches, a symbolic materialization of the 'glory' of the *Shekinah* can be seen in the form of a radiating triangle bearing the Divine Name YHWH at its center. Finally, the little curtains hanging in front of the tabernacle recall both the tent of the desert and the veil hiding the Holy of Holies.

If we have dwelt somewhat upon this parallel between the Christian and Hebrew sanctuaries, it is first of all in response, once again, to those who deny all parallels of this kind and claim to demonstrate the absolute originality of the Christian sanctuary. Moreover, at a time when people have become forgetful to the point of familiarity, or even neglect, we do not consider it useless to remember the *sacred* and *fearful* character of the sanctuary and altar, where the Divinity is really enthroned 'behind the veil'. At the oratory of Germigny-des-Prés (ninth century) there is a Byzantine mosaic embedded in the sanctuary vault, representing the Ark of the Covenant

with the angels and the Hand of God. Below it runs a Latin inscription worded as follows:

> Gaze upon the Holy Oracle and the Cherubim, contemplate the splendor of the Ark of God, and, at the sight of them, think of touching with thy prayers the Lord of Thunder.

The great preface of the Roman Pontifical chanted at the moment of the consecration of the altar, ritually connects the Christian altar to all the Hebrew altars, those of Moses, Jacob and Abraham; better yet, it connects it to all the altars of humanity *ab origine mundi*, from the altar of Melchizedek to that of Abel. It is can thus be seen to what a venerable tradition the Christian altar, through an uninterrupted transmission, is heir; it concretizes, so to speak, the whole religious history of the world.

But there is more. The earthly altar derives its sublime and sacred character from its conformity to its archetype, the heavenly altar. For our temple altar is only the earthly symbol of this heavenly archetype, just as the earthly liturgy 'imitates' the heavenly liturgy described in the Apocalypse. The *Sursum corda* is an invitation to contemplate the eternal archetype of the visible liturgy. Regarding the Eucharistic sacrifice, Theodore of Mopsuesta says that

> since these are the signs of the realities of heaven that it accomplishes symbolically, it is thus necessary that it should also manifest them; and the pontiff creates a kind of image of the liturgy that takes place in heaven.

The officiant, therefore, reproduces the service celebrated by Christ the Pontiff who, adorned with His own Blood, penetrates into the Tabernacle that has not been made by human hands. In the canon of the Roman Mass, the priest beseeches God Almighty, 'to cause these offerings to be borne on high by the hand of Thy holy Angel, to Thy sublime Altar in the presence of Thy Divine Majesty....' And at the introit of the Syrian Mass, the priest prays: 'Receive from my sinful hand, O Holy Trinity, this sacrifice which *I offer on the heavenly altar of the Word.*'

* * *

Till now, we have only described the altar from the outside, as it were. To understand its full meaning, we shall have to go further and grasp its symbolism from within.

The essential fact from which to start is Jacob's anointing of the *Bethel stone* (Genesis 28:11–19). Jacob, en route to Mesopotamia, set up camp after the day's march and slept directly on the ground, using a stone as a pillow. While asleep, he saw in a dream heaven opened and joined to the earth by a ladder, upon which angels ascended and descended; at the top stood the Eternal. On awakening, Jacob cried, 'How awesome is this place! This is none other than the house of God, and this is the gate of heaven.' And he poured oil upon the stone, thus making an altar of it to commemorate his vision.

In the ritual of consecration, the bishop, pouring the holy oils over the stone, repeats the patriarch's gesture. The anthem, 'Jacob made an altar of the stone by pouring oil on it,' is sung, then the prayer, 'May Thy Holy Spirit, Lord, descend upon this altar, so as to there sanctify our offerings. . . .' is recited. Thus the altar stone is ritually assimilated to the stone of Jacob.

Nor is the importance accorded the stone of Jacob in Christianity and, of course Judaism, foreign to the Islamic tradition. This latter tradition asserts that the stone was transported to the Temple of Jerusalem and can still be seen today in the Mosque of Omar, built on the site of the Temple. It is venerated under the name of 'al sakhra' (the rock). It is pierced with a circular hole, giving access, it is said, to a cistern that the Muslims call 'bir-al-arwah' (the well of souls), for, according to them, the souls of believers gather there twice a week to pray to God. In a travel journal, Jamal-ad-Din recounts that he saw Christian priests placing phials of wine on this stone. It is not clear to what this latter action alludes: was it a question of wine intended for the Holy Sacrifice? Did priests have the opportunity of celebrating Mass in this place? Whatever the case, it seems indisputable that Christians venerated this rock as sacred. For it is the rock of Orna, where the Angel of the Lord appeared to David, and which the holy king chose as the place to set up an altar

before the tent of the Covenant. Solomon erected the altar of holocausts on it, and it is thought that the latter was situated just above the upper part of the rock.[2]

If the stone of Jacob is surrounded with such veneration, it is because it conceals a great mystery, that it is situated at the 'center of the world'. We have seen that the notion of the 'center of the world' forms the basis of architectural symbolism, and also governs the symbolism of the cross. This 'center of the world' is not a geographical center in the modern scientific sense, but a symbolic center (which does not mean imaginary—quite the contrary), based on geometric symbolism. With the universe being represented by a sphere or circle, and the center being the most precious point, since it engenders the whole figure, in the spiritual sense every sacred object and place which allows an entering into contact with the Spiritual Center, that is to say God Himself, Who is the center, the beginning, and the end of the whole sphere of creation, is symbolically situated at the 'center of the world' and upon its 'axis'.

The altar of Jacob is situated at the 'center of the world', as we are given to understand by the sacred text when it speaks of the 'angelic ladder'. This ladder represents the 'world axis', the base of which rests upon the earth and the summit constitutes the 'door of heaven'. It is the natural path of angels as 'messengers' of Heaven on earth and executors of the heavenly Will. The altar embodies the point of intersection of the axis with the earthly surface.

Thus, through the rite of consecration, the Christian altar, like that of Jacob, becomes the 'center of the world' and is situated on the axis of Heaven and earth, which qualifies it to become the site of a theophany, of a divine manifestation, the place where the heavenly and earthly worlds make contact with each other. This is the place where the Son of God chose to offer Himself for us, as it is written in the Psalms: 'But God is our King before the ages, working salvation in the midst [the center] of the earth' (Psalm 73:12). Through this sacrifice, He re-establishes axial communication with God, re-opens the 'door of Heaven' and makes the temple a *bethel*, truly a 'house of God'.

2. See Ch. Ladit, *La mosquée sur le roc*, 1966.

If the rock of Orna along with the high altar represented the 'center of the world', there was another stone in the temple at Jerusalem that represented the center even more directly, the *shethiyah* stone, on which lay the Ark in the Holy of Holies. This stone still existed in Herod's time, but the Ark had disappeared. Upon it, the High Priest placed the censer, as required by the ceremony. Some hold that this stone, too, was not other than the stone of Jacob. This does not contradict the other tradition that makes the rock of Orna Jacob's stone, except for those who see things solely from an 'historical' and 'outward' point of view. Actually, what we are about to say will show that the two traditions express the same spiritual reality.

The Hebraic tradition has it that at the creation, God, from His Throne, threw a precious stone into the abyss; one end sunk into the depths while the other emerged from the chaos. This end formed a point, which began to extend itself, thereby creating space, and the world was established upon it, which is why this stone is called the *shethiyah* stone, that is to say, foundational stone. This point, formed by the stone, is the center of the great cosmic circle alluded to above; and this is why the Holy of Holies in Jerusalem and, therefore, the entire holy city, was situated at the 'center of the world'.

At this point, it will be useful for what follows to specify the exact meaning that should be given to the usual designations of foundation stone and corner-stone, which we have already mentioned (Chapter 7), as the ideas corresponding to these expressions are not always very precise. Now, foundation stones are the cubic stones placed at the four corners of a building. Generally, the first stone to be laid, which is referred to as *the* foundation stone, is the one at the northeast corner. The *foundational stone* or *shethiyah* stone is the one found at the center of the building's base. Finally, the *corner-stone*—also known as the 'peak stone' or 'summit of the angle' or 'keystone', etc.—is properly the stone that, at the opposite extreme of the same vertical axis to the *shethiyah* stone, constitutes the key of the vault. However, long-standing confusions affect these designations. Thus foundation stones are confused with the foundational or central stone, and very often the first stone or foundation stone of the northeast corner, and even the *shethiyah* stone, is called the corner-stone. These confusions can be explained and even justified

by the fact that, in reality, all the stones in question refer back to the corner-stone, which is as if their essence, and which is, in any case, the 'principle' of the building, the 'logical' principle, obviously, and not the 'chronological', for, from the chronological point of view, the cap stone is the 'last stone'. The *shethiyah* stone is like the horizontal projection of the corner-stone on the plane of the base, and is also reflected by the stones of the four corners, although less directly. Moreover, these four stones could very well be called corner-stones, since they constitute the corners of the square of the base, precisely, and in these positions play the same role as the cap stone, which consists in bringing together and uniting two walls or the two sections of an arch. But these stones, like the *shethiyah* stone, are cubic, whereas the corner or peak stone has a special and unique shape, such that it cannot find its place during the course of construction, so that 'the builders reject it'. Only those builders who have graduated 'from the set-square to the compass', that is from the square to the circle, therefore from earth to heaven—the 'pneumatics'— understand its purpose.

The position of the *shethiyah* stone corresponds to that of the altar. In circular churches like San Stefano Rotondo (Rome) or Neuvy-Saint-Sépulcre (France), this is rigorously exact. But it finally comes to the same thing in churches of basilical or cruciform design. The altar is placed at the crossing of the transept or at the center of the semicircle of the sanctuary. In the first case, the altar occupies the center of the principal governing circle of the building, and in the second, the center of a secondary governing circle, which is a 'reflection' of the first. This center, marked by the altar, is the true center of the building, and the altar is clearly at the place of the *shethiyah* stone, the center point, the omphalos of the world.

The five crosses engraved on the altar stone, one in each corner and one in the middle, recall the basic pattern of the building constituted by the four stones at the corners and the one in the middle. According to Durandus of Mende,

the four crosses signify that Christ redeemed the four quarters of the world. . . . The cross in the middle of the altar signifies

that the Saviour accomplished our redemption at the center of the world, that is, at Jerusalem.

The symbolism of the dome, cupola, or vault, which 'covers' the sanctuary on high, completes that of the altar stone. The round vault symbolizes heaven, while the square stone of the altar symbolizes the earth. The corner-stone or key of the vault, or 'summit of the angle', up above in the vault, corresponds to the *shethiyah* stone (altar) below. As we have said, the two stones are situated on the same vertical line, which is the 'axial pillar'; this pillar is 'virtual', in the sense that it is not embodied (except in the case of pendative vault keys, which constitute the beginnings of materialization), which does not prevent it from playing a primordial role, for the whole building is arranged around it. It represents the world axis.

Finally, the ciborium or baldachin repeats and further clarifies all this symbolism. The baldachin is a structure made up of four columns supporting a dome that, in principle, covers the main altar. (Many churches still adhere to this rule of the baldachin.) The diagram of the baldachin is a cube (the four columns) surmounted by a hemisphere, that is, a diagram of the sanctuary itself, the whole temple and the universe (heaven above earth). There is no better way to suggest that the altar is at the center of the world.

* * *

The architectural symbolism of the altar and sanctuary serves to clothe and express a theological doctrine. As we have seen, St Maximus the Confessor developed the idea that the temple is the image of the universe, of man, and of God. The Holy of Holies is the noblest part, and all is summed up in the mystery of the altar. The latter is truly the center and 'heart' of the building. Now, the mystery of the altar is that it *is* Christ.

All the Fathers agree on this point. St Ignatius of Antioch wrote, 'Run together, all of you, to unite in the same temple of God, at the foot of the same altar, that is, in Jesus Christ.' St Cyril of Alexandria taught that the altar of stone mentioned in Exodus (20:24) is Christ. For St Ambrose, the altar is the 'image of the Body of Christ,'

while for Hesychius of Jerusalem it is 'the Body of the Only Son, for this Body is truly called an altar.'[3]

This identification of the altar with Christ seems to be firmly based on a passage from Scripture that, in speaking of Christ, says, 'We have an altar'[4] (Heb. 13:10), and this passage should be compared with the celebrated verses from the First Epistle to the Corinthians (10:1–4):

> I want you to know, brethren, that our fathers were all under the cloud, and all passed through the sea, and all were baptized into Moses in the cloud and in the sea, and all ate the same supernatural food and all drank the same supernatural drink. For they drank from the supernatural Rock which followed them, and the Rock was Christ (*petra erat Christus*).

This assertion by St Paul is based on the most authentic Hebrew tradition. The Lord had long been likened to the stone and rock, and it was said the Israelites had been drawn from Him: 'You were unmindful of the Rock that begot you, and you forgot the God who gave you birth' (Deut. 32:18). 'Look unto the rock whence you were hewn, and to the quarry from which you were dug out' (Isa. 51:1). The symbolism of the stone is also related to the Messiah. In conformity with rabbinical interpretation, that of Rabbi Solomon Yarhi, for example, the text from Isaiah,

> Behold, I will lay a stone in the foundations of Zion, a tried stone, a corner-stone, a precious stone, founded in the foundation. He that believeth let him not hasten (28:16),

was applied to the Messiah by both St Peter (1 Pet. 2:5–6) and St Paul (Rom. 9:33). The 'spiritual rock' of the desert is the same stone, and thus the Messiah, as is proved by the witness of Philo. According to him,

3. See the complete citations with references in *La Maison-Dieu*, no. 29.
4. Cf. the expression 'heavenly altar of the Word' from the Syrian Liturgy (above).

Moses, by this stone, meant the *Wisdom* of God which nour-
ishes, cares for, and tenderly raises those who aspire to incor-
ruptible life. This stone, become like the *mother* of all men on
earth, offers its children nourishment which it draws from its
own substance.

And Philo further specifies that 'this stone is the manna, that is, the
Word, the Logos, more ancient than all beings.'

This doctrine is enacted in the Syrian Liturgy, when, before the
consecration, the priest shakes the great veil above the offerings of
bread and wine while saying, 'You are the hard stone that was split
to let twelve rivers of water escape to give drink to the twelve tribes
of Israel.' Always in rabbinical tradition, the stone of the Rock of the
Desert, the stone of Jacob, the *shethiyah* stone, and the *corner-stone*
are one and the same reality, designating the Divine Word, the Mes-
siah. In the book of Genesis (49:24) Jacob recalls the help of 'the
mighty one of Jacob: thence he came forth a shepherd, the *stone of
Israel*'; and Rabbi Moses Nahmenides, commenting on this passage,
says that the 'Shepherd, the *stone of Israel*' is none other than the
'chief stone' of Zechariah (4:7), 'which became the head of the cor-
ner through the will of the Lord' (Cf. 1 Pet. 2:4–8; Acts 4:10–11). By
pouring oil over the stone, Jacob literally made it an *anointed* thing,
that is, a *Christ* (this is the meaning of the Greek word *christos*, cor-
responding to the Hebrew *messiah*), and this is why he said, 'This
stone . . . shall be God's house, *Beth-el*' (Gen. 28:22): *Bethel*, 'house'
or 'temple of God', which is precisely Christ. And it would be inter-
esting, in this regard, to examine the correspondences pointed out
by Philo, between the stone that is the *messiah*, and the *bread* or
manna, correspondences symbolized by the assonance between
Beth-El, the 'house of God' and *Beth-Lehem*, the 'house of bread',
exactly where the Messiah was born who would declare Himself 'the
bread descended from heaven.' The likening of the Messiah to the
different stones we have been studying is perfectly justified, for
these stones can, at different degrees, be regarded as symbols of the
Divine Word. If Christ is the rock from which the water of immor-
tality gushes, it is because He is God, and, as such, is also the Center
of the World, the Universal Axis upon which are situated the stone

of Jacob, the corner-stone, and the *shethiyah* stone.[5] The rabbinical tradition also asserts the identity of the stone of Jacob and the foundational stone. God, according to the *Midrash Yalkouth*, 'buried the stone of Jacob in the depths of the abyss and made it the foundation of the earth. This is why it is called *shethiyah*.' According to the Talmud (Thaanit treatise), the *Midrash Yalkouth*, and Rabbi Solomon Yarhi, it was this stone that was given to the Israelites in the desert by Mary, Moses' sister. Finally, the stone of Jacob, say the rabbis, is the same as both the stone 'cut out' from the mountain (Dan. 2:34–35), which designated the Messiah descended from Heaven, and the 'stone with seven eyes' spoken of by Zechariah (3:9; 4:10). Thus, in venerating the stone of Bethel or *shethiyah* stone, the Messiah is mysteriously honored in the Holy of Holies at Jerusalem. In addition, there is an interesting comparison to be made between the vision of Jacob's ladder, on which the angels ascended and descended, and these words of Christ: '[Y]ou will see heaven opened, and the angels of God ascending and descending upon the Son of man' (John 1:51); and elsewhere, He says, 'I am the door [of Heaven]; if any one enters by me, he will be saved' (ibid., 10:9).

Of all these parallels, we shall at present only consider that of the *shethiyah* and corner-stones, which we touched upon earlier, and we shall see how the preceding remarks drawn from rabbinical teaching shed light on the matter. Christ Himself is defined as the Corner-stone; but He is also the Foundational or *Shethiyah* Stone (cf. above Isa. 28:16; 1 Pet. 2:5–6 and Rom. 9:33, confirmed by Rabbi Solomon Yarhi). 'Christ,' says St Augustine, 'is simultaneously the *foundation*, for by Him we are governed, and the *corner-stone*, for in Him we are reunited.' The foundational stone, we have seen, is the 'reflection' of the corner-stone on the earthly plane, at the lower extremity of the vertical axis that connects the two. Now, in architectural traditions, the *shethiyah* stone is often called the 'stone fallen from heaven'; and the expression 'stone fallen from heaven' applies perfectly to the Messiah, with reference to the 'stone

5. One finds it confirmed in gematria. The expression *eben shethiyah*, when the initial aleph is 'fully' read (= 111), gives the number 888. This is, as we have seen, the number of the word IHCOVC (Jesus) in Greek.

detached from the mountain' and, parallel with this, 'the bread descended from heaven'. This 'stone fallen from heaven' is also called *lapis exilis* (*exilis* for *exsul*), for it is as though 'in exile' on earth; in the architectural mystical traditions, however, it must 're-ascend' to heaven. In fact, the 're-ascended' stone is the cornerstone, the key of the vault. In sum, it can be said that the cornerstone represents the Eternal Word, which resides in heaven, whereas the *shethiyah* stone represents Christ, the Word descended on earth. And this accords with the traditional concept, which sees in the stone of the altar an image of the *humanity* of Christ more particularly (Durandus of Mende). The axial pillar connecting the two Christic stones is the path of salvation, *via salutis*, which opens onto heaven; the key of the vault is the 'door of heaven', *janua coeli*, like the summit of Jacob's ladder. Cosmologically, the axis is the axis of the world, and theologically, it is the Way, that is, Christ Himself, who said, 'I am the Way.'

<p style="text-align:center">* * *</p>

At first sight it may appear surprising for Christ to be represented by a stone. However, it should not be forgotten that the stone has been always and everywhere a symbol of divinity.

In ancient Greece, according to the witness of Pausanias, the gods were venerated in the form of rough stones that were later shaped and ultimately became statues. At Delphi, the famous white stone, the navel of the earth, marked the religious center of the Hellenic peoples. Aphrodite of Paphos, Zeus of Kasios, Hera of Argos and Artemis of Patroa were *baetyls*.

However, it is in Asia that the cult of stones was particularly developed. The most celebrated stone of Antiquity, the black stone of Pessinont representing Cybele, the 'mother of the gods', was taken to Rome from Phrygia, its place of origin. Mithras, who was said to be 'born from stone', came from Persia. The famous black stone embedded in the Kaaba at Mecca is a legacy of the ancient cult of the pre-Islamic Arabs, for—and this is of particular interest to us— the cult of stones was especially developed among the Semitic peoples, notably among the Canaanites, the immediate neighbors of

the Jews. Moreover, the word *bethel*, which became *baetyl*, and which served to designate a sacred stone, is in the first place a Canaanite word. Likewise, when the bishop, in consecrating the altar stone, pours oil on it, he is perpetuating an immemorial rite, of which the gesture of Jacob is only one proof among others. In Greece, stones at crossroads, most often representing the god Hermes, were anointed with oil; at Benares, the black stone image of Krishna is anointed daily, and the rite was attested to hundreds of times in the land of Canaan, where the oil was moreover mixed with blood. This anointing is evidently an 'animation' or 'vivification' rite, for the oil symbolizes the Spirit penetrating matter.

Underlying the symbolism of stone is a primordial intuition of the human soul. Stone amazes us by its strength and hardness. Its size and power is both admired and feared. It also amazes us by its permanence: it 'exists' firmly and is always there; there is something in it that transcends the precariousness of human life. Thus, the mineral, although it represents the last state of being, the lower limit of creation, is nevertheless best able in our world, through an inverse analogy, to represent divine Power and Eternity. From another perspective, stone—and here we are thinking of the altar stone—through its 'anonymity', through the absence in it of every figurative element, is one of the most accurate signs of the a-formal character of God, an 'aniconic' image of the Divinity. It is the sobriety of such a symbol that makes for its grandeur and efficacy.

The moment stone acquired a superhuman character and was regarded as the abode of the Divinity, it also inherited the attributes of the Divinity, in the first place, Its creative power. Traditions abound in which it is said that mankind was born from stone. So it was for the Greeks, that, after the flood, the new human race came forth from stones thrown on the ground by Deucalion. Mithras was 'born from the rock'. We saw above that this idea is not foreign to the Hebrews, since the Lord is invoked under the name of 'the Rock' that gave birth to the Israelites. Likewise, Christ was born in a cave dug into a mountain, in accordance with the prophecy of Daniel announcing that the Messiah was the 'stone taken from the mountain', and He rose by issuing forth from a tomb dug into the rock. Now, if stone can create, it can *a fortiori* fecundate. This is why in many places one finds

fertility stones: at Locronan, in Brittany, sterile women go to sit on the 'Stone Mare' or 'Chair of St Ronan' and pray to become mothers. The same custom is found in India. Stone not only has generative but also curative power: near Mériadec and Sainte-Anne d'Auray, peasants afflicted with certain ills go and lie on a megalith hollowed out like an enormous cup. The Church has almost always 'integrated' these customs and sometimes in a very characteristic way: at Puy, the pre-Christian 'fever stone' which played the same role as the Breton megalith, is embedded in the broad flight of steps leading up to the basilica, opposite the central portal.

By placing it within this total religious context, we will better understand the concept of the 'rock in the desert', of the altar stone that begets us to spiritual life, nourishes and refreshes us, and is the source of every grace. It will become even clearer by means of comparison with one of the last avatars of the spiritual stone, the Grail, which, as described in the romance of Wolfram von Eschenbach, is a Eucharistic symbol. In the book, the Grail is portrayed as a stone that feeds the Templars; it consumes and revives the phoenix, arrests old age and restores youth. On Good Fridays, a dove places a host on it, which is the source of all its power.[6]

<p style="text-align:center">* * *</p>

In the Judaeo-Christian tradition, however, this universal symbolism of the stone is coupled with a special and more secret symbolism. 'Stone', in Hebrew, is *aben* (pronounced *eben*): but *aben* is also the emphatic form of the word *ben*, that is, son. These two words come from a root signifying to build, or to create. Thus the word 'stone', seen from and through the Hebrew, constitutes a cryptogram of Christ expressing the mystery of His filiation. This manner of thinking through cryptograms is obviously related to the applications of gematria to architecture pointed out earlier.[7]

6. Wolfram von Eschenbach, *Parzival*, 469–470.
7. Let us again point out a confirmation by gematria. The number of *eben* ('stone') and that of *dabar* ('Word'), obtained through reduction are the same: 8.

We are now able to render a more accurate account of the importance and special role of the altar in the temple. If the temple of stone is the image of the Heavenly Jerusalem, or the Kingdom of Heaven, or the true spiritual Temple formed from 'living stones' united among themselves by the 'Corner-stone', which is Christ, then the universal Church is already virtually this Jerusalem on earth and, at a lower degree, as much could be said of the congregation assembled in the visible temple for the divine sacrifice. Now, the spiritual center of this congregation is the altar stone, for it is the ritual figure of Christ invisibly but really present among the believers.

Moreover, if the altar is Christ and the Body of Christ, this last expression needs to be understood in all its fullness: it also designates the Mystical Body. Such is the meaning of the obligatory relics inserted in every altar stone. Whatever the origin of this rite, what interests us is the meaning that it assumes, indicated by the ritual of consecration. The latter is based on a text from Revelation saying that the souls of the saints are placed under the altar of God (Apoc. 6:9), and which furnishes the following anthem:

> You have taken your place under the altar of God: O Saints of God, intercede for us. The saints will leap in glory and rejoice in their dwellings. . . .

Origen comments on this passage as follows,

> Blessed are those souls that Scripture shows placed under the altar of God, who have thus been able to follow Christ even to reaching this altar where the Lord Jesus Himself, the High Priest of future blessings, is present.

In this rite, we can also see an application of the words of the Apostle, '[Y]our life is hidden with Christ [Altar] in God' (Col. 3:3).

This is truly a Christic number, since, as has been seen, its triple repetition (888) is the number of IHCOVC.

* * *

But the tradition goes further in interiorizing the symbol of the altar in conformity with its place in the temple. The altar is not only the Body of Christ; more inwardly still, it is His Heart.

Its placement corresponds to that of the wooden cross, placed, for the blessing of the first stone, below the triumphal arch, at the point of intersection of the arms of the transept and the nave. 'The heart is situated in the center of the body, as is the altar in the middle of the church' (Durandus of Mende). Christ is likened to a center, to a living heart, which, through its blood, infuses life into all the members. The heart of Christ is at the same time the place of His infinite love and the ontological center of His Person and of the whole Body. Nicholas Cabasilas also identifies the Heart with the altar:

> The power of the holy table draws to us the true life from that blessed Heart. . . . As He is the Head and the Heart, we depend on Him for moving and living since He possesses life . . . since He Himself has life by nature He breathes it into us, just as the heart or the head imparts life to the members. (*The Life in Christ*, Fourth Book, § 8)

Thus, the Altar unites the members of the Mystical Body in their true center, the Divine Heart, which is the Heart of the World. In the microcosm of the temple, the altar represents this Heart of the World, which is the Heart of God, whence the Lord has made His creative action felt in the six directions of space, according to the passage from Clement of Alexandria already cited. This is why, as was said at the beginning of this chapter, the altar is the true center of the sacred building, the focal point from which all its architectural components should radiate. Here, too, the cosmic sustains the mystical symbolism.

The central position of the altar at the very place of the heart also determines its role in the spiritual life of the individual as in that of the community. The altar is likened to the heart of man, and it is upon this altar of the heart that man needs to enact the great sanctifying sacrifice. 'The altar is our heart upon which offerings must be

made,' says Durandus of Mende. And, again, 'The altar is the figure of the mortification of the heart, in which all movements of the flesh are consumed by the fervor of the Spirit.' This last trait is an allusion to the perpetual fire that should burn on the altar, according to Leviticus (6:9–12). In a commentary on the book, Procopius of Gaza (sixth century) tells us that the holocaust is lit in our hearts through the perpetually preserved fire, which is the fire brought to earth by Christ. On the altar of the heart, the pneumatic immolates his separate self, and, deified, is identified with the Heart of Christ. He is then established at the center of all the worlds, he is fixed at the center of Being, 'guarding the motionless Intellect, as motionless as the axis of the heavens; gazing, as towards a center, upon the abyss of the heart' ('Spiritual Centuries' in the French *Philokalia*). To return to the language of architectural symbolism, we could also say, that, as with the builders 'who have been promoted from the set square to the compass', he has ascended, following the 'axial pillar', from the foundation stone to the keystone, that is, to the point where the whole inward order of the building is 'understood' and where the entire world is seen with the eye of God. 'Just as there is this unique point at the center of the circle,' says St Maximus the Confessor,

> where all the lines that part from it are still undivided, so likewise in God, he who has been judged worthy to arrive there, knows with a simple knowledge, and without concepts, all the ideas of created things.

13

THE ALTAR:
LIGHTS ON THE
HOLY MOUNTAIN

DESPITE THE CAPITAL IMPORTANCE of what we have just said, if we go no further, we shall obtain only a partial view of the meaning of the altar. Although in itself the stone has all the value indicated, since *Petra erat Christus*; nevertheless this value is further emphasized by the obligatory presence of two other elements: the steps leading up to the altar and the lights placed upon it.

* * *

The steps, which, as we have said, are required in the raising of an altar, are themselves also symbolic. They remind us that the altar is raised on a 'Holy Mountain', which is an image of the world and of paradise, its significance joining and reinforcing what we already know of the altar.

Enemies of symbolism will be quick to object: 'Quite simply, the steps and platform exist so that the altar, thus raised, may be more visible to the congregation.' But this reasoning lacks vision. The undeniable fact that the altar has been raised so as to be more visible does not prevent what we are saying from being rigorously exact. First, because every object, whether we like it or not, is symbolic, for symbolism is in the very nature of things, since there is, as they say, 'a cipher to things'. Furthermore, this symbolism is super-added to the utilitarian function of the object without suppressing the latter. Second, because the liturgy, the witness of which no one

can deny, expressly suggests that the altar is situated on Mount Zion, since it has the priest recite at the foot of this very altar, which he is about to 'climb', the psalm *Judica me* that the Israelites chanted while climbing Mount Zion to go up to the Temple:

> Send forth Thy light and Thy truth: for they have led me and brought me to Thy holy mount, and into Thy tabernacles. And I will go into the altar of God. . . .

Finally, and above all, because the altar where the perpetual sacrifice of the Messiah is celebrated, is, accordingly, raised upon a new holy mountain, Golgotha, where this sacrifice took place in an historical form. And if this sacrifice took place there, this necessarily has a meaning, itself linked to the spiritual meaning of the mountain.

The image of the Holy Mountain is to be found everywhere in the Bible, especially in the Psalms, where it constitutes an essential element of the 'landscape' of these inspired hymns. But it is not a peculiarly Judaeo-Christian image; found almost everywhere, it belongs to the category of those great universal sacred symbols that constitute the natural, and at the same time supernatural, language of all sacred activity, of every type of liturgy. Christianity is in no way diminished, let it be repeated, by pointing out elements in it that do not belong to it alone, but to all religious forms. Quite the contrary; there is in this a supplementary proof of its 'catholic', that is, universal, character, and a sign of its mission, which is to unite all in Christ.

The mountain as sacred 'object', is therefore to be found in all traditions. Through its sheer size, its height, and majesty, it is imposed upon man as a sign of Divine Power. Vertical, with its summit raised towards heaven, it invites ascension to God; the water that gushes out and falls from it to form the rivers upon which physical life depends, is the image of heavenly blessings. Reduced to its shape, the pyramid, it is a volume arranged around an axis, a volume that is sufficient unto itself and thus offers a résumé of the world; rooted in the earth, resting on the surface, touching heaven to which it is also mysteriously linked by lightning, it joins together by way of its axis the three 'tiers' of the world: hell, earth, and Heaven. This axis

of the mountain is identified with the axis of the world, which we have already discussed above regarding the altar.

Herein lies the explanation of the various stories relating to holy mountains, which are nearly always identified with the earthly Paradise. In Iran, Mount Alborj marks the center of the world. Around it move the sun and planets, and from it came forth all humanity. From it, too, gushed the fountain of life, forming a lake, in the middle of which the tree of life sprang up, and from which water descended in four rivers to the four regions of space. This is paradise, the abode of Ahura Mazda. Mount Meru in India is the highest point on earth, reaching Heaven. It is the center of all, and the North Pole, that is, the fixed pole of the world. On Meru, as on Alborj, is found a lake where the water of life collects, together with a garden of delights and the Tree of Beatitude, an apple-tree. In China, the holy mountain is Jade Mountain, where grows the peach-tree of immortality. Among the Arabs it is Mount Qaf, which has as its foundation a stone made of a single emerald, and which encompasses the whole earth. Similar traditions are to be found in Pamir, Mongolia, Mexico, and other places. It should be added that nearly everywhere the Holy Mountain is the place where the ark of salvation came to rest after the flood; for example, Noah's ark came to rest on the summit of Ararat, and it is from this summit that the re-creation of humanity began.

Determining as it does the axis of the world, the transcendent place where earth is joined to heaven, the mountain plays a symbolic role in religious rites analogous to that of stone and tree. To be sure, temples, high places, and altars[1] were initially constructed at the summit of mountains so as to situate them symbolically on the axis of the world—the original paradise, the place that escapes the flood. Where there were no mountains, artificial hills were constructed, and temples were even built in the form of mountains. Thus, at Babylon, the ziggurat was a conical tower of seven tiers representing the seven heavens. The priest would climb to the top and there celebrate the cult. Likewise, as we have seen, the Hindu temple is modelled on Mount Meru; flights of stairs allow one to ascend

1. The word altar comes from *altare*, the root of which is *altus* (high), and which more or less signifies 'high place'.

right to the top, and the faithful who climb them ritually ascend to heaven, identified with the summit, since the original paradise was situated on top of the cosmic mountain.[2]

The symbolic value of mountain or hill is such that its ritual use remains alive nearly everywhere in Christian lands. Whenever possible, churches are built on high ground: Rocamadour, Mont Saint-Michel, Montmartre, etc. From this point of view, the most impressive holy city is without doubt Le Puy, with its sanctuaries built on the heights, and above all the extraordinary chapel of Saint-Michel-d'Aiguille at the top of a volcanic spur thrusting towards heaven.

Numerous holy mountains are mentioned in the Bible, each stage of revelation having taken place on a mountain where God spoke to a prophet. It was on Sinai that God handed down the Law and where Moses saw the celestial prototype of the Ark. It was on Carmel that Elijah met the Eternal, and to this day, it has remained the inspirational image of the soul's ascent to God in Carmelite spirituality. It was on Mount Gerizim, the holy place of the Samaritans, that Jacob built an altar (Gen. 33:20), and that God wished His Name to be worshipped (Deut. 12:5–12). It was called 'Mountain of Blessings' (ibid., 27:11–13), 'navel of the earth' (Judg. 9:37), 'eternal hill', 'house of God' (Beth-El) and, finally, 'primordial mountain', for that, according to the Samaritans, was where Eden was. The Samaritans held that the flood never covered Mount Gerazim: it was there that Abraham met Melchizedek and offered the sacrifice of bread and wine, the figure of the Eucharist.

2. The same idea, with the accent on 'moral', is expressed by Durandus of Mende. According to him, the steps of the altar recall the *fifteen steps* leading to the Temple of Solomon, that one climbed while chanting the *fifteen* 'psalms of degrees'. Both symbolize the *fifteen* virtues leading to heaven. This is why the steps are also the rungs of *Jacob's Ladder*, which also lead to heaven: 'The steps which clearly indicate the progress of the virtues by which we mount to the altar, that is to Christ, according as the Psalmist says, 'They go from virtue to virtue (Psalm 83:8).' It is probably because of the number of steps of the Hebrew temple that those of the altar are necessarily uneven. In general there are *three* steps, corresponding to the ternary constituting man: *corpus, anima, and spiritus*; which is not a departure from ascensional symbolism, for to these three elements of the human microcosm correspond the three cosmic 'levels': *earth, air, and empyrean*, themselves corresponding to the three 'planes of existence': *material, subtle, and spiritual.*

Pages would be required to speak of Mount Zion—or, rather, merely to transcribe all the passages in which it is mentioned: 'Extol the Lord our God, and worship at his holy mountain' (Psalm 98); 'For there the Lord has commanded the blessing, life for evermore' (Psalm 132); 'I lift up my eyes to the hills. From whence does my help come?' (Psalm 120). Mount Zion and the Holy City mark the center of the world. According to Rabbinical tradition, the world was created like an embryo growing from the navel, which is Zion. It is said that Mount Zion, supporting the City of the Great King, is situated 'in the far north', (Psalm 47; Isa. 14:14); this signifies that it represents the great cosmic mountain of beginnings, of which the axis is the pole of the universe.

It was upon Moriah, a part of Mount Zion, that the temple was built. Out of Moriah came four sacred streams, which were reputed to issue, by underground channels, from the spring of living water welling up under the temple. One of them, flowing to the north, was called Gihon, which is the name of one of the four rivers of Eden. Thus one finds on Mount Zion the configuration of the Primordial Mountain supporting Paradise and its four rivers.

For Christians today, Mount Zion remains a sacred mountain and the figure of paradise to come:

> In the last days the mountain of the house of the Lord shall be prepared on the top of mountains, and it shall be exalted above the hills; and all nations shall flow into it (Isa. 2:2).

The great vision of the 'age to come', prototype of our earthly liturgy, is that of the Lamb: 'on Mount Zion stood the Lamb, and with him a hundred and forty-four thousand....' (Apoc. 14:1), for we have 'come to Mount Zion and to the city of the living God, the heavenly Jerusalem' (Heb. 12:22). Nor should we forget that the Upper Room, where the New Covenant was sealed, was also situated on Mount Zion.

We should also bear in mind that Our Lord chose to appear in the fullness of His glory on a 'high mountain' (Mark 9:2), which tradition identifies with Thabor, which name probably means navel (= center of the earth); that He was raised to heaven from the top of

the Mount of Olives, and finally and above all, that He chose to die on a mountain, which is the other great Christian sacred mountain: Calvary. Ancient tradition, still alive among Eastern Christians, says that Calvary is the summit of the world, the center of the earth, and the place where Adam was created and buried.

In light of all we have said concerning the sacred mountain, the scene of Calvary assumes a striking relief. Jesus willed that His death, through which the new creation was effected, be accomplished on the mountain—synthetic image as well as center and summit of the world—on that axis which joins earth to heaven and where the original Paradise re-appeared:

> They shall come and shall give praise in mount Zion, and they shall flow together to the good things of the Lord, for the grain and wine and oil [the Eucharistic feast]. . . ; and their soul shall be as a watered garden [Paradise regained] (Jer. 31:12).

The complete symbolism of the mountain of salvation was often treated in early and Byzantine Christian art. Christ is depicted as standing or seated at the summit of the mountain whence the paradisiacal rivers arise; sometimes He is seated on the Tree of Life blended with the Cross, the Wood of Life, at the foot of which gushes forth the Fountain of Life, in four branches. Christ, the new Adam, restores Paradise. He is the Tree of Life and the Source from which the living waters of eternal Life gush forth to the four regions of the universe. This image is a wonderful plastic expression of the Eucharistic mystery, which renews the drama of Calvary, restores the world to its primordial purity, and re-establishes communion between heaven and earth.

And so it is that when, after the first prayers of the Mass, the priest ascends to the altar, he climbs the Mountain of Salvation to renew, at the center and summit of the world, the sacrifice intended to save it.

* * *

So far we have not left the domain of architectural symbolism, since the holy mountain, like the temple, is an image of the world.

In addressing the study of light, we shall for a moment depart from the line followed thus far in our researches, but only for a moment, for in doing so, we shall be led in due course to consider how the liturgy, which is essentially 'luminous', is in continuity with architectural symbolism that is closely coordinated with it.

The altar is a cultic complex, which has inherited from the distant past some of the components of the natural sanctuary, both mineral and vegetable: first, the hillock (= the steps) with the tree, which, as we shall see at the end of this book, became the tree of the cross in our churches, and then on top of the hillock, the stone of offering (= the altar) with the sacred fire, which became our light.

Fire, we know, plays an important role in the different religions. Doubtless, it no longer occupies the same place in Christianity as in ancient Judaism for the very simple reason that no longer is there a holocaust, that is, the victim to be burnt. This, however, is not to say that fire has disappeared. It is important to remember, first of all, that among the Hebrews, fire served not only to burn the victims, but also to consume the incense—this also being a sacrifice—and as perpetual fire in the seven-branched candlestick.

Now these last two usages passed into Christianity. Nor should we forget that the rekindling of the fire lies at the heart of the paschal ritual. In this instance, the manner in which it is produced and blessed proves that it is truly a question of a sacred fire, the image in the temple of the heavenly Fire. In principle, this sacred fire should feed the light of the church throughout the whole year, and do so through the intermediary of the oil lamp in the sanctuary. This, we recall, was still the case during our childhood. Our good parish priest would never have dared to light the candles of the altar except from the oil lamp in the sanctuary. But alas, since then, as they say, 'We have changed all that!' There is no longer any hesitation in polluting the air of the temple with the fuel of profane cigarette lighters and we are lucky if the sanctuary lamp, as well as the candles on the altar, is not electrified. These electric lamps and candles, which have tended to come into general use nearly everywhere, these motionless candle-tips, congealed and dead, are to our eyes—and we are

not alone in thinking this—one of the most characteristic signs of the fact that our age has completely lost the sense of the sacred.

Leaving aside other aspects of the sacred fire, we shall now look solely at the light upon the altar, the six candles lit for the celebration of high mass. The little known symbolism of this light opens up astonishing perspectives on the meaning of the Divine Liturgy.

In a general way, it can be said that the candles on the altar are connected with the paschal candle representing the 'pillar of fire' and the resurrected Christ. In the Syrian Mass, two beautiful prayers recited while the candles are being lit remind the faithful that Jesus is the true light:

> Through your Light we see the light, Jesus full of light. You are the true light that enlightens every creature; enlighten us from Your beautiful light, oh icon of the heavenly Father... Oh Pure and Holy One, who livest in the spheres of light, remove far from us evil passions and impure thoughts. Grant that we may do the works of justice with purity of heart.

But this general meaning of the candles themselves is coupled with a particular meaning that depends on the *number* used. It is on this last, by far least-known, point that we would like to dwell. In order to celebrate Mass, there must normally be six candles on the altar, three on either side of the Cross. Now, it is almost certain that these *six* candles should really be *seven*, because it is also certain that these same candles recall the Israelites' seven-branched candelabra. Thus, in the past, various churches in Vienne, Lyon, and Rouen, had a beam bearing seven candles that spanned the whole width of the sanctuary, and was expressly intended to represent the Hebraic candlestick.[3] Then, at an episcopal Mass, there are seven candles on the altar, the cross no longer situated in the middle of them, but in front of the central candlestick.[4] This having been established, it is

3. In the eastern churches, a 7-branched candelabra is still used on the altar. TR

4. In the main church built by St Benedict of Aniane, there were seven candelabra above the altar symbolizing the sevenfold grace of the Holy Spirit (PL 103, 360–365).

by referring to the symbolism of the Israelite candelabra that we will
be able to attempt a definition of the symbolism of our own light.

In the Temple at Jerusalem, the candelabra, called the *menorah*,
was placed to the left of the altar of incense. It was made up of a
straight central branch and six curved branches in concentric semi-
circles. The seven branches communicated by means of interior
channels filled with consecrated olive oil that fed the lamps. Like the
Temple itself, and the Ark of the Covenant, the *menorah* was made
according to a heavenly model seen by Moses on the Mountain
(Num. 8:4. —Specifications relating to this cult object can be found
in Exod. 25:34, 37:20–23 and Lev. 24:2–4, 6:5–6).

The reason the *menorah* passed from Jewish to Christian worship
is that it also belongs to the New Testament. In the Apocalypse, in
fact, Christ appears surrounded by seven candlesticks (Apoc. 2:1)
and, surprisingly, this apparition resembles that perceived by the
Prophet Zechariah, which we shall discuss further. The importance
of this *menorah* is thus obvious, subject as it is to minute prescrip-
tions and linked to eschatological and messianic manifestations.

This importance naturally holds for the symbolic meaning of the
menorah, which needs to be closely studied.

Seven is one of the most important sacred numbers, whether we
think of the seven days of Creation, the seven ages of the world, the
seven Angels of the Presence, the seven Gifts of the Holy Spirit, the
seven virtues, the seven sins, the seven sacraments, the seven Patri-
archs, the seven planets, the seven metals, the seven colors, the seven
notes of the scale, the seven liberal arts, the seven requests of the
Lords Prayer, etc. The number seven, considered as 3 + 4, is the sign
of the relationship between the Divine and Creation, 3 being the
Divine World and 4 the created world. From this we have the seven
days of Creation, the expression in time of the relationship between
the created and uncreated, of which the seven planets are the expres-
sion in space. Moreover, with each day of the week corresponding to
a planet, the calculation of time according to the weekly rhythm is
an actual affirmation of these relations. This explains the role of the
Sabbath, in particular, which we shall treat presently.

Such is the cosmological or natural symbolism of the *menorah*.
Philo, to whose work Clement of Alexandria returned, asserts that

the seven branches of the *menorah* represent the planets, the center branch being the sun, which gives its light to all. But Clement hastens to add that this middle branch is identified with Christ, the 'Sun of Justice'. In fact, here too, cosmic symbolism conceals a theological symbolism.

The theological symbolism is based on the mystical doctrine of the *Sephiroth*, a doctrine found particularly in St John. The *Sephiroth*, of which there are ten, are aspects or energies of the Divinity, and are divided into two groups: the three higher *sephiroth* correspond to the Divine Nature itself, while the seven lower ones are the attributes or, again, the energies or powers of God, which preside at Creation. All the objects and beings cited above, created to the number seven, are in one way or another, and each at its own level, expressions of these Powers. The lower *sephiroth* are radiations of God, the influences He pours out over the universe, the lights through which the Unfathomable reveals Itself, the instruments wherewith the Divine Architect constructs Creation and maintains its harmony.

These *sephiroth* are commonly called 'Voices', 'Thunders', 'Lamps', and 'Eyes', which enables us to understand the passage from the Apocalypse (5:6) where it is said that the Lamb has seven eyes, which are the seven spirits of God. These 'eyes' are the same as the 'seven bright lamps' burning before the throne (4:5). At the same time, in the prophecy of Zechariah (3:9), seven eyes are engraved upon the mysterious stone designating the Messiah, which we mentioned above. In all these cases, it is a question of the seven lower *sephiroth* or creative powers of God and, in particular, of the Divine Word.

It is easy then to understand the lofty meaning of the light upon the altar.

The seven lamps (more often reduced to six, the seventh merging with the central Crucifix) recall the seven spiritual lamps before the heavenly throne of Christ; they represent the total world and, more exactly, the world transfigured by the divine presence of Christ, whose seven powers are at work in it. The world restored to its purity exists today only within the enclosure of the sanctuary, and thanks to the divine effect of the Mass. This spiritualized world,

indicated to our eyes by the lamps, is ultimately the Church and the Mystical Body; the Church with its seven sacraments, sprung from the altar—the Stone with seven eyes!—illuminating the faithful and uniting them to form the Mystical Body, which is already 'the new earth and the new heavens'.

The divine liturgy of the Mass fully actualizes the meaning of the Hebrew liturgy, the Feast of Tabernacles and the Sabbath in particular. Extended over seven days, the Feast of Tabernacles (*Sukkot*) was dedicated to the seven Patriarchs who 'incarnate' the seven *sephiroth* watching over the harmony of the world. Likewise, the liturgy of the Sabbath, or seventh day, celebrated the universal equilibrium through the blessings descending from the seven *sephiroth* or spirits of God.

The correspondence between the light on the altar and the celestial candelabra of the Apocalypse was sometimes emphasized in Romanesque churches in the pictures decorating the vault of the apse above the altar. This vault, the image of the heavenly dome, regularly bore the icon of the Pantocrator seated on the royal throne. Now, in certain cases, for example in the crypt of St Etienne at Auxerre, the heavenly seven branched candelabra was depicted before the throne of Christ. Thus, a really sacred art suggested the purpose of the liturgy, which, by means of the altar, re-establishes communion between Heaven and earth and causes the grace and peace sprung from the Sevenfold Light to descend upon the world so as to renew it.

14

SPACE AND TIME, TEMPLE AND LITURGY

AFTER TRAVELLING THE PATH that led from the porch to the altar, that living center of the temple, we saw there the shining lamps which are the seven Spirits of God, facing east where the Sun of Justice arises. Thus the journey of the faithful which takes them into the sanctuary, is a journey towards the light, towards the Divine Sun.

And the liturgy, to which the temple is ordered and which is its *raison d'être*, is essentially luminous and solar, as well. From everything we have said, who can fail to see that in this respect an intimate connection exists between divine worship and the place where it unfolds, that in its profound nature a Christian church is a solar temple intended for a liturgy that is also solar.

It is above all in the great cathedrals of the thirteenth century that we can grasp the luminous nature of the temple in all its splendor, rendered palpable through the tremendous development of stained glass windows. Through these the solar light plays and sings on a register of a thousand nuances. The masterpiece of this genre is Sainte-Chapelle in Paris, where the possibilities of stone are stretched to their limit, such that it could be said of this movement that it was about 'the immaterial filled with light'. The walls were to give the impression of those of the Heavenly Jerusalem, which are of precious stones. This was the age when Hugh of St Victor and Suger said that the house of God should be illuminated, dazzling like paradise, and this, without any doubt, under the influence of the neo-Platonic renewal due to John Scot Eriguena's translation of the works of Denis the Areopagite. In this perspective, which, moreover, is in perfect harmony with Scripture, God is light; essential

Beauty is identified with clarity, which, together with harmony and rhythm, reflect Divine Beauty. And for Suger, the builder of the basilica of St Denis, the beauty of the architectural work should illumine the soul so as to guide it towards Christ, who said, 'I am the light of the world', *Ego sum lux mundi*. The blaze of stained glass windows, equal to the blaze of gems, evokes the splendors emanating from the 'Father of Lights' and streaming, through His Son, over the regenerated world.

But we must go further than this overall impression.

The wonderful reality embodied in a church of the those times is not the product of a sentiment, or even a purely aesthetic intention. Inspired by theology, it was also supported by cosmology. We have seen these two sciences working together in the conception and construction of the building, and the same applies in the arrangement of the stained glass windows. It was in no way a question, as it is with too many artists today, of offering the eye sensations of color. Such a result was certainly attained by the old masters, but by way of superaddition, for the principal goal was to transmit a figured teaching through the medium of color. In general, the great stained glass windows retrace the history of the world in relation to the mystery of the Redemption. This teaching is by nature theological; however, the artist did not forget that the temple itself is by nature cosmic, and in that coherent world of thought characteristic of a traditional civilization, he would scrupulously respect the harmony between the theological and cosmic orders. This is why the arrangement of the stained glass windows will be studied in a way that harmonizes with the solar rhythm marking the progress of the day. Thus, in Sainte-Chapelle, for example, the windows are to be 'read' from the north wall, then in passing through the apse and along the south wall to arrive at the western rose. The windows to the north retrace the history of the world from Genesis to the end of the Old Testament; to the east is the stained glass window of the Redemption, while to the south, the eschatological prophets announce the scene of the great rose window inspired by the Apocalypse, which celebrates the Heavenly City where the Lamb is enthroned.

In this way, following the rhythm of the day, the history of the world is covered from the Creation to the *Parousia*. The rising of the

sun in the east marks the victory of Christ over the shadows of evil, which are pictured on the wall to the north, the region the sun never penetrates. And the rose window of the Holy City is to the west, where the visible sun sets, because the descent of the sun at the end of the day also symbolizes the end of this world and the appearance of the new world where there will be no more need of the sun, for the Lamb Himself will be its luminous star. This arrangement is obviously not peculiar to Sainte-Chapelle. It is found, with some differences, in all churches that respect the norms of traditional art. Thus, the whole cycle of our humanity is inscribed within the basic temporal cycle, the daily course of the sun, which corresponds to it analogically, and is itself 'fixed' in a correctly oriented temple.

There is, in fact, nothing surprising in these correspondences, given what we have just said about the temple, which is a 'crystallization' of heavenly movement, of the temporal cycle, within a purely spatial order. The temple is a petrified beat of time and thereby an image of Divine Immutability. The liturgy, to be discussed in the sequel to this study, is itself simultaneously deployed in space and time—in the sacred space of the temple and in the annual cycle of the seasons punctuated by the march of the sun. But, each in its way, the liturgy and the temple intended for it, express the same reality, that of Divine Presence in the world, the temple doing so in static, the liturgy in dynamic, mode. Furthermore, both realize an extraordinary spiritual integration of space and time, the very conditions of the created, by relating and reducing them to their divine origin, to the point where they are 'volatilized' so as to let the eternal appear.

Here we touch upon what constitutes the profound *raison d'être* of the temple and the liturgy.

Time and space are the two essential conditions of the corporeal state, which is man's present state on earth. In this state, these two conditions define finitude. We would venture to say that of these two elements, time is the most 'spectacular'. What above all makes the creature a finite being distinct from its Creator, the Infinite Being, is that the latter is in Eternity, in the timeless, the absence of time, the immutable, whereas the creature is subject to becoming, to birth, growth, and death. Infinite Being is immutable, stable; finite

being is in movement—is movement. 'Time is the contingency that gnaws at things . . . the decay that distances from the (Adamic) origin' (F. Schuon). Subjection to time, to becoming, which implies death, is for man a consequence of the Fall. 'The first man,' writes St Gregory of Nyssa, 'was created in such a way that time passed away, whereas he remained stable.' But after sinning, 'his immortal state once lost, the curse of mortality took possession of him.' In the first place, the fall is a 'fall into time', which amounts to saying that living in time is not normal for man. It goes against his original, heavenly nature; in fact, living in time is a dispersion of the being, a 'departure' from the immutable Divine Center towards the edges of the great cosmic wheel, which drags the world into perpetual change.

And there lies the danger: time is deployed in an indefinite series of mutually engendering cycles, and man the sinner, that is, all men in the state determined by original sin and its consequences, cannot but perpetually busy themselves in this endless vortex of duration. But as all reality here below is ambivalent, and as God 'draws good from evil', this situation is not at all without solution. If time is an evil, it also leads us towards the Messiah and the meeting with Him Who is a way out of time. To escape from time a brutal rupture must take place, snatching man from the vortex and fixing him in his proper state prior to the fall. This rupture is accomplished through baptism, at least virtually, for, on the one hand, our baptism needs to be effectively 'realized', and it is too evident that we are always capable of 'falling again', while, on the other, the state prior to the fall is not normally attained here below in an integral manner, for 'it has not yet appeared what we shall be' (1 John 3:2). Also, to the extent that our individuality is 'in time', that is, during the whole of our life, we need to affirm, to deepen our baptism. It is the role of the sacraments, and of all ritual generally, to help us in this. For earthly man, to pass from time, from movement, so as to rediscover his stable center in God, is to accomplish his salvation, for, as the Psalmist says: 'For he is my God and my saviour. . . . I shall not be moved' (Psalm 61:7); and likewise in the Mass, in the prayer preceding the consecration, we say to God, 'Secure our days in Thy peace.' Man needs to be aware of time, to know that through it he is destined to rejoin Divine Eternity, and that consequently he needs to go beyond

it, to overcome it. To this end, the regular practice of the liturgy in its annual cycle is not only a precious help to him, but also necessary.

Here we should clarify the role played by rites. In the construction and consecration of a sacred building, ritual not only symbolically, but really, brings the whole of space back within the bounds of the temple in such a way that the latter becomes a synthesis of the world, which amounts to saying that in and through the temple space is overcome. In it the true believer finds himself at the 'center of the world'; he is symbolically in Paradise, in the Heavenly Jerusalem. Ritual operates in a similar fashion upon time: it transforms profane time, the time of man the sinner, into sacred time, which is already virtually beyond time. It does this in two ways. First, through what could be called an overview of the totality of time, and then through a re-actualization of the life of Christ.

The year is a cosmic cycle and reproduces on its level the great cycles and total duration of our world. By virtue of the analogy linking all the temporal cycles, whatever their duration, each new year corresponds to 'creation' and the end of each year to the 'end of the world'. Thus, to celebrate a cult throughout the year, making the year a totality, is not only to live sacredly during this time, but also to re-live sacredly the whole duration of the world. This is clearly revealed by the practice of the liturgy and the commentaries of the Fathers. Each year, during the course of the Paschal vigil, the Bible is read starting with the account of Creation until the end of the Old Testament, that is to say except for the last period of our history. Moreover, the liturgical year opens and closes with the Gospel account of the end of the world (the first Sunday of Advent and the twenty-fourth Sunday after Pentecost).

We readily note the parallels with the symbolism of the Holy Book itself, which opens with Genesis and closes with the Apocalypse, the appearance of our world and time, and its resorption out of time: between the two lies 'history'. Now, 'through the spirit of prophecy, that is, the spiritual understanding of history,' writes St Cyril of Jerusalem, 'man, despite his limits, sees the beginning and end of the cosmos and the midpoint of time, and knows the succession of empires.' Thus the individual recapitulates the history of the world and is able to live its whole becoming symbolically: he sees

what his real role is in the unfolding of the divine plan, symbolized by history, rediscovers the beginning, and lives in advance the 'consummation of the ages'. In this way he is raised above time by taking more or less clear cognizance of the identity of the beginning and end, for the end of our world must immediately be succeeded by the restoration of the primordial state.

From another angle, the liturgical year is an ever repeated re-actualization of the life of Christ and, thereby, a spiritual regeneration of the individual. Through the repetition of the ritual each year, we become, in a way, contemporaries of Christ, and gradually incorporate His mysteries until He 'be formed in [us]' (Gal. 4:19), because Christ, from the present point of view, appears as the one who has conquered time. Through the Incarnation, the Infinite was inserted into the finite; He assumed all its conditions, time in particular, and thus made both possible and real the overcoming of them. But it is more especially through the Christ's death that we escape from time, for it is in His death that He was exalted and has exalted man; through His death and descent into hell, Christ exhausted all the consequences of the Fall in humanity, and enabled us to follow Him in His Resurrection and Ascension, that is, in His escape from the cycle of time, in His passage 'beyond all the heavens', beyond cosmic movement. That is why the Glorified Christ is called 'the sun that knows no setting'—*sol occasum nesciens*—immovably fixed at the zenith.

The annual liturgy appears as a 'sacrament of time': it integrates time, which otherwise signifies pure dispersion, into a spiritual perspective by showing that it is one of the forms assumed by the cosmic manifestation of the Divine Word. It thus allows us to 'redeem the time', according to St Paul's powerful expression.

* * *

We have just seen that the goal of the annual cycle of the liturgy is to incorporate us into Christ by causing us to assimilate all the phases of His earthly life. Now, this life was subject to time; we therefore need to assimilate the Christic mysteries into the very texture of time—the time of our life. These mysteries unfold over the liturgical

year, which, in its unchanging, indefinitely repeated cycle, allows for their progressive and, in a way, centripetal incorporation. The periodicity of the feasts puts us in a position to participate in the archetypes of our salvation through the repetition of these archetypes, which finds its adequate form in liturgical representation, the word 'representation' needing to be taken here in its etymological and broad sense, that of 'making present anew' the contents of the archetypes of the life of Christ. The projection of Christ's life upon the year can only be made in virtue of the analogy existing between the historical revelation of the Incarnate Word and the cosmic revelation of the Divine Word, which revelation is none other than the world itself along with the cyclic movement of time, 'the moving image of Eternity' according to Plato's unsurpassable definition.[1] And as Christ was 'king' and 'light' of the world, He was quite naturally likened to the sun, itself the king and light of the physical world, and most adequate symbol of the Divinity.

Thus from the third to the fourth centuries, the Christian revelation was moulded by the solar religion that had gradually overrun the whole Greco-Roman world, and which, with the passing of time, appears to have been a providential preparation for the development of the pageantry of the essentially solar catholic liturgy, solar, that is, like the temple sheltering it. This old solar religion was adopted without difficulty, first, because, to the extent that it exalted the sacredness immanent in nature, it constituted a 'naturally Christian' value, and, secondly, because Scripture itself had decreed the solar Christ.

Sol justitiae, 'Sun of Justice', is a Divine Name that appears with the Prophet Malachi, when he announced the Day of the Lord in the following terms, 'But unto you that fear my name the Sun of Justice shall arise, and health in his wings' (Mal. 4:2). Now it was by alluding to this text that Zechariah saluted Jesus in the Temple:

When the day shall dawn upon us from on high to give light to those who sit in darkness and in the shadow of death.... (Luke 1:78–79).

1. *Timaeus*, 39E.

Who then will deny the suggestive power of such a symbol? The sun, says Plato, is 'the image of the supreme Good such as it is manifested in the sensible spheres.' Commenting on this statement by his master, Denis the Areopagite explains why the sun is the image of the Good, that is, of God: the sun is good because its light illumines all things, and, in the same way, the supreme Good penetrates all beings and enlightens them inwardly. The sun contributes to the generation of living beings; it is the source of the life which it both causes to appear and renews; and not only does everything come from its light, it also tends back toward it. In the same way the supreme Good is the source of all being and leads all being to itself; it is the pole and principle of union for all things. The sun

> rejoiced as a giant to run the way. His going out is from the end of heaven, and his circuit even to the end thereof; and there is no one that can hide himself from his heat (Psalm 18:6–7).

Likewise, it is said of Wisdom, which is the Word acting in the Universe, that 'She reacheth therefore from end to end mightily and ordereth all things sweetly' (Wisd. 8:1).

Thus the visible sun is the center of the world, the 'heart of the world'—*cardia cosmou*—as the Greeks used to say, and, in this capacity, is the image of Him who in all Fullness is the 'Supreme Center' and true 'Heart of the World'. In certain private revelations, Christ, who said, 'I am the light of the world', has confirmed that He should be considered under this solar aspect.

> Look at the sun, how it illumines and warms and causes the plants of the earth to grow...and how it also gladdens the world with its brightness. Behold, this sun you admire in the visible world shines for all, and was created as a symbol of My Divine Presence' (Words of Christ to the Venerable Marie Costarosa).

Under His solar aspect, Christ has two essential attributes: light and warmth, the light of Wisdom and the warmth of Love, the two

attributes that preside over creation as they do over revelation. Christ reveals Himself to us as universal Intelligence, which conceives all beings by illuminating them with the rays of His Being, and as infinite Love, which gives life and whose fire, absorbing all these beings, leads them to Unity.

We might ask what exactly the expression Sun of Justice means. What is justice doing here? To begin with, we can be guided by the fact that in Babylon, Shamash (the Sun) was considered to be the 'god of justice' and the 'lord of judgment'. Since we are aware to what degree Babylon influenced the style of biblical texts during a certain period, it does not seem to be mere guesswork to suggest that this is the first meaning of 'Sun of Justice'. The very regularity of the movement of the sun is an image of order, of justice.

The sun appears as the symbol of Divine Justice especially in its midday position at the zenith, where it divides the length of the day equally. 'The justice of the faithful shall shine like the midday sun,' sings the Psalmist. In this motionless position, image of the eternal moment, the sun is truly like the sign of the power that rules the elements. It is also a symbol of justice, because, as Scripture says, 'it shines upon the good and the evil.' Infinitely above all earthly contradictions, this 'Eye of the world' (Ovid) reveals by means of its light the various actions of beings, and judges them with a calm rigor. Finally, it is as solar wisdom that Christ gives the Law and makes us 'just' and 'sons of light', and this is why He will be the 'lord of judgment' and will open the Book where nothing shall remain hidden.

This allusion to 'judgment' in speaking of Christ the Sun is directly related to His role at the end of time. But while awaiting the end of time, Christ the Sun is 'lord of time', the *Chronocrator* who regulates its movement. Such is the foundation and justification of the solar liturgy, which follows the different cycles of time measured by the movement of the luminary—and in the first instance, the daily cycle.

Christ has been likened to the Day and the Apostles to the twelve hours thereof.[2] His role is compared to that of the daily sun: 'Just as

2. Recension of the principal texts in J. Daniélou, *Primitive Christian Symbols*.

every day the mystical Sun of Justice rises over all, so he appeared for all, suffered for all, and was resurrected for all' (St Ambrose). His death and resurrection, moreover, follow the daily rhythm of the sun: Christ died at the ninth hour, in the evening—and the 'sun's light failed' (Luke 23:45); He descended to the nether regions, like the sun after setting, to return, by the hidden paths of the north, in the matinal east: 'Just as the sun comes round again from the west to the east, so the Lord ascended from the depths of Hades to the heaven of heavens' (St Athanasius).

The daily liturgy, the 'Hours' of the Office, is also punctuated by the progression of the sun, as the name indicates. In this respect, the hymns of the different 'Hours' are significant. At Matins we sing: 'The day approaches, may the works of darkness disappear', and at Easter:

> The brightness of the budding dawn calls us into the temple of the Lord; it demands renewed thanksgiving for the precious gift of His Light that God has given us. Every day the light causes the riches of nature to be reborn for us, riches whose beauty raises our spirits to knowledge of the invisible grandeurs of the Divinity.

And throughout the year, at the moment the sun appears at the eastern chevet of the church, Lauds ends with the Canticle of Zechariah proclaiming 'the tender mercy of our God; whereby the *dayspring* from on high hath visited us, to give light to them that sit in darkness and in the shadow of death. . . .' —The brilliant light of the sun invites us to offer fervent prayers to God. At Terce, the solar fire that ascends is that of the Divine Spirit. On reaching the zenith, it kindles the world. At Sext, we pray:

> The sun, now in all its splendor, fills the earth with the most vivid light. . . . O Jesus, Thou who art the Sun of Justice and the true flame of the world, cause the fire of Thy Love, ever increasing in us, to rise to the perfection of charity.

At this point, the ascendant phase of the day comes to an end, and the luminary begins its descent. At None: 'The sun in its decline

announces the approaching night.... It is thus that our life advances towards its end.' Then Vespers, the 'evening office', and finally Compline, which, the night having already fallen, expresses nostalgia for the light:

> We give thanks to Thee, O Lord, at the end of this day: before Thee we prostrate ourselves and offer our humble prayers at the beginning of the night. When shall we see that day shine, which Thou promised us, that day that knows no night at all? ... Oh Jesus, splendor of the Father and true Sun of Justice, Who, issuing from the inaccessible light, comes to dissipate the shadows of our spirits, now that the sun strips us of its brightness to make place for darkness, grant us peaceful rest during the night.... (Season of Lent).

But the Christian remains hopeful at heart, even in the night and the dark, for he knows that the sun, descended into gloomy Hades, will be reborn at dawn. Thus throughout the year, Compline ends with the Canticle of Simeon, which, so to say, takes the place of the Canticle of Zechariah sung at morning Lauds, and contains the promise of the return of the Sun Christ:

> Lord, now lettest thou thy servant depart in peace.... For mine eyes have seen thy salvation.... A light to lighten the Gentiles, and the glory of thy people Israel.

Before going into the structural detail of the annual liturgical cycle modelled on solar time, let us return once again to the harmonious 'consonance' of liturgical space and time within the temple. The decoration of the great portal of the cathedral will serve as 'text' for our reflection, and more especially that of Amiens, which is the most illuminating for our purpose. The wonderful façade represents, from bottom to top, the cycle of the year with the signs of the zodiac; on each side of the uprights, are past and present history, the Old and New Testaments, symmetrically arranged in relation to the Christ of the trumeau, the central pier; at the top, finally, is the future, with the scene of the Last Judgment. In the center of the

tympanum, Christ sits enthroned, the Father of time, the Alpha and Omega. Below him, St Michael weighs souls. The corresponding signs of the zodiac are the Ram and the Scales, which are those of the two extremities of the equinoctial line, the axis of the liturgical year. Easter is situated in the ascent of the zodiac, the passage from the zone of darkness to that of light; St Michael, on the contrary, recalling the death of men, is placed in the descent of the zodiac, in the passage from the zone of light to that of darkness. To the left of Christ are the damned; the scene corresponds to the sign of Cancer, to the solstice and the St John of summer. According to the terminology of the Ancients, this solstice is the 'door of men'; it opens the descending half of the cycle and leads to darkness, to the nether regions: *Janua inferni.* To the right of Christ shine the elect with St Peter, who opens Heaven: the scene corresponds to the St John of winter and the winter solstice or 'door of the gods', which opens the ascending half of the zodiac and leads to heaven: *Janua coeli.* The corresponding sign is Capricorn, the sign of Janus, the *claviger* god or 'bearer of the keys', the keys to the doors of heaven, who was succeeded by St Peter, also *claviger,* and the two St Johns—the Forerunner, 'who prepares the way of the Lord', and the Evangelist, who reported the words, 'I am the Door (of Heaven).' The whole portal, centered on Christ and the Judgment, is, like the sequence of stained glass windows studied above, both a theology of history and an eschatology, and there as here, the cycle of history is in consonance with the astronomic cycle. The portal at Amiens—and the same can be said of the majority of portals—is a solar door, a solar theophany of the Divine Logos. And, sculpted in stone, this portal presents a diagram of the liturgical cycle, of which the oldest and most essential feasts, like Christmas, Epiphany, Easter, St John of Summer, Michaelmas, etc., are situated on the line of the equinoxes and the solstices, corresponding to the zodiac and the Last Judgment.[3]

3. We have based this analysis of the portal of Amiens on Luc Benoist's, *Art du Monde.* In what follows in this Chapter and Chapters 15 and 16 concerning the relationships of the liturgy to light, we are much indebted to the rich studies of *Nouvelles de Chrétienté: O Oriens* and *Lumen Christi* (see the bibliography).

Placed at the two extremes of the solstitial line are, on the one hand, Christmas and the feast of St John the Apostle, and, on the other, that of St John the Baptist. The sun, 'born' at Christmas, gradually rises in the sky until the spring equinox, which assures its triumph; then, until the summer solstice and Zenith are reached, it continues its ascent during the course of which the Feasts of the Ascension and Pentecost are celebrated. This is the march of both the Invincible Sun, *Sol invictus*, who conquers the darkness of winter, and the Christ-Sun, who triumphs over the shadows of sin and death. During the first half of this progression, the lesser feasts mark the stages of the Divine triumph: the 'feasts of light' do not end with Christmas and Epiphany. Candlemas falls on February 2nd, the feast a solar theophany related to the great celebrations of December and January. It recalls the entrance of the Christ Child into the temple at Jerusalem (gradual, epistle), that is, the fulfilment of the prophecy of Ezekiel: '[T]he Glory of the Lord entered the Temple' (43:4). It also glorifies Mary as 'door of heaven': 'Prepare thy nuptial chamber, O Zion, and receive Christ the King; embrace Mary, the Door of Heaven, for she is like the throne of the Cherubim. She bears the King of Glory.' 'The Virgin is a luminous host bearing her son, born before the Morning Star' (Processional Anthem). 'You give passage to the All-High King, shining Door of Splendor' (Hymn of Lauds, Office of the Virgin). Each day, the sun of Christmas rises higher, and the season of Lent, which prepares its Easter victory, retraces its battles against the darkness of sin (cf. the temptation in the desert, the chosen theme of the liturgy for this season).

After the summer solstice, the sun, but not Christ, *sol occasum nesciens*, which 'has ascended above all the heavens', begins to decline. It is the time of the Feast of St John the Baptist, who said, 'He must increase, but I must decrease.' This descending phase of the annual cycle is taken up with the 'season after Pentecost', that long period corresponding to the life of the Church on earth, still subject to the passage of time that gradually drags us to the death of winter.

At one end of the equinoctial line, besides Easter, are found both the Annunciation (March 25th), the solar feast of the conception of Christ fixed according to the date of Christmas (nine months), and

the vigil and feast of St Gabriel, whose name, 'Power of God', accords well with both the vernal rising of the sun and his mission to announce the coming of Jesus, the 'Mighty God'. At the other end, September 29th, is Michaelmas, also a solar feast: the representation of the Archangel armed with a sword (a solar symbol) battling the dragon, is altogether within the tradition of the great myths that tell of the struggle between light and darkness, like that of a hero against a monster formed like a snake. We shall have occasion to speak of it again. Thus the two archangels 'guard' the equinoctial stations, just as the two St Johns 'guard' the solstitial stations. Moreover, these four stations correspond to the four cardinal virtues represented by the personages in question: Strength (Gabriel), Justice (Michael), Temperance (St John the Baptist), and Prudence (St John the Evangelist).[4]

On September 21st (the equinox), paralleling the feast of St Michael, we have the feast of St Jonah, whose story belongs in this same category of solar myths: the hero swallowed by the monster is an image of the descending cycle 'devouring' the sun. The importance of the 'sign of Jonah' can be observed with regard to Easter[5]. In addition, St Michael finds a double in St George (April 23rd), who is himself also a dragon-conquering hero, his struggle in April reflecting the victory of Easter. And the September St Michael is in keeping with the decline of the sun to autumn. Indeed, it is said that Lucifer wished to rise like the 'Day Star, son of Dawn' (Isa. 14:12–15), but was struck down and fell into night at the moment the sun declines towards winter. Moreover, the Scales are the sign of September, and are themselves related to St Michael weighing souls at the end of the cycle, as we saw on the portal at Amiens. The Ember days are found in the same season and are obviously solar festivals,

4. J. Tourniac, *Le Septenaire* (*Le Symbolisme*, January, 1959).

5. It is well understood that for us the word myth need not prejudice the reality of the Archangel St Michael or Jonah. In particular, we in no way think, as some do, that the story of Jonah could be a 'fable'. Nor is a myth a 'fable'; it merely refers to a different plane of reality from theology or history, expressing cosmic reality to the extent that it is sacred; and the liturgy is right to use this language, which is that of man's cosmic existence, to translate onto its own plane of action certain aspects of realities also belonging to other planes of existence.

since they correspond to the four seasons and thus to the solstices and equinoxes. The Ember days of September very probably replaced the Jewish Feast of Tabernacles, which, according to Philo, was not only associated with the autumnal equinox, but was also an echo of the Roman festival of the vintage.[6]

Other examples, should they be wanting, are, first, the Transfiguration on August 6th, the day falling midway between 21st June and 21st September, and therefore the middle of summer, which corresponds with the subject of the feast where Christ's face 'shone like the sun'. Then, on August 17th, which again falls around 'mid-summer', Janus, the god of the sun door, the celestial door (*janua coeli*), was feted, and on the 13th, Diana, the goddess etymologically connected with Janus, whose name reduces to Dianus. The root of these words, *di*, found in *deus* (god), expresses the idea of shining, the brightness of heaven illuminated by the sun. Furthermore, Diana, who was both virgin and fecund, was the sister of the sun Apollo, and associated with the moon, the reflection of the day-star. It is not surprising, then, that the Assumption of Mary was placed on August 15th, between these two dates. She too is '*Janua coeli*', '*felix coeli porta*', the *Virgin* 'clothed with the sun, with the moon beneath her feet' (Apoc. 12:1) at the moment she ascends to heaven, illumined by the glory of her resurrected Son, the Christ-Sun. Finally, in the descending phase of the cycle, we notice September 14th, the Exaltation of the Cross, which is a reminder of the victory of Easter, and is also near to St Michael, and, on November 1st, the sun being in full decline but with the promise of its return, the Feast of the Dead. A closer scrutiny of the various Temporal and Sanctoral Feasts would doubtless provide other proofs of the arrangement of the liturgy according to the solar cycle, but this would be beyond the limits we have set and beyond the specific object of our work. Further investigation would in any case add nothing essential to what we have just said, which is sufficient to provide a general outline of the liturgical cycle from the present point of view. We shall thus leave it aside and proceed to show how the fundamental themes of solar religion are developed and combined in the elaboration of ritual.

6. J. Daniélou, *La Maison-Dieu*, no. 46 (1956), pp 114ff.

15

'SOL JUSTITIAE'

THE BROAD OUTLINE we have traced of the interrelationship between the liturgical and solar cycles gives the celebration of the feasts their particular color and explains their formulation of the mysteries, as can be seen particularly in the two great Christian feasts of Christmas-Epiphany and Easter.

Christmas and Epiphany are 'festivals of light' which derive their character and 'poetry' from being placed at the winter solstice. And in this respect, there is no reason to divide the two feasts, which in reality are but one. The twelve days separating them represent the difference between the lunar year of 354 days and the solar year of 365 days. The existence of this sacred and festive period is due to the fact that, after the adoption of the solar calendar, there was a desire not to abandon all remembrance of the older lunar calendar. We shall find a similar series of intercalated days at the time of the Easter equinox. Besides, the feast of Christmas, a creation of the Latin Church, is relatively recent (end of the third century), the nativity of the Lord previously being celebrated only on January 6th. The celebration of December 25th was born of the Church's desire to substitute the worship of Christ for the worship of the Sun, around which all pagan piety in the Empire had so to speak crystallized at that time. The festival of the winter solstice had become extremely popular. December 20th was called *Dies Natalis invicti* or 'Birth of the Invincible Sun', invincible, because having reached the lowest point of its course at the solstice, it began to re-ascend in the sky, to 'come to life again'. Everywhere a festival of fire and light was celebrated at the solstice with wood fires and lighted wisps of straw or burning wheels that were tossed into the fields. These fires were both a tribute to the life-giving star and a fertility rite intended to

fecundate the fields, and these remarks naturally hold true for the fires of St John at the summer solstice. In addition, the non-Christians also lit candles as a sign of joy. The Christians adopted these practices, which have been transmitted to us in the form of candles on a tree, the Yule-log, and, better still, the candles of Candlemas (linked to the Christmas cycle), and the Paschal candle, for, as we shall have several occasions to see, the Paschal liturgy inspired those of Christmas and Epiphany, the bond uniting them being, precisely, solar symbolism. Christmas, in the depths of winter, anticipates Easter; it is the debut of a mystical spring. There is a certain vernal mystery to Christmas, which inspired these beautiful words from an anonymous Greek:

> When after the winter's cold, the light of gentle spring begins to shine, then the earth shoots forth grass and greenery, the branches of the trees adorn themselves with new buds, and the air begins to shine with the splendor of the sun. . . . But behold, for us Christ was raised up as a heavenly spring, for, like the sun, he arose from the womb of the Virgin.

The whole Advent liturgy celebrates this approaching Light, which gradually pierces the darkness. 'The Lord shall come to illumine the depths of the darkness and shall be manifested to all the nations' (Anthem, Third Sunday). The Saturday Mass of other seasons borrows the magnificent metaphor from Psalm 19, depicting the daily course of the sun, and applies it to the Sun of Justice:

> The sun . . . hath rejoiced as a giant to run the way. His going out is from the end of heaven, and his circuit even to the ends thereof: and there is no one that can hide himself from his heat.

Then there is the very beautiful anthem of December 21st (the exact day of the solstice):

> O Orient, splendor of the eternal light, Sun of Justice: come and illumine those sitting in darkness and in the shadow of death.

On the 24th, the expectation of the light becomes more insistent:

> When you see the sun on the horizon, it will appear like the groom sallying forth from his nuptial chamber' (First Vespers).

> Already the east is lit up, behold even now the precursory signs; already our God comes to flood us with His light (Anthem of the Vigil).

At Epiphany, the same theme of fire and light is endlessly repeated:

> This star burns like a flame and manifests God, King of kings. . . . (Anthem of Vespers).

> Arise, shine; for your light has come, and the glory of the Lord has risen upon you. For behold, darkness shall cover the earth, and thick darkness the peoples; but the Lord will arise upon you, and his glory will be seen upon you. (Epistle, repeated at the Hours—Isa. 60:1–2).

Christmas and Epiphany are the solar manifestation of Christ the Savior, light of the nations (*Lumen ad illumenationem gentiium*) and 'Orient of the world' (*ecce vir: Oriens nomen ejius*) (Zech. 6:12).

All the Fathers have emphasized the correspondence between the cosmic and mystical meanings of the winter solstice: it is a renewal of nature and of souls.

> The people are not wrong to call this holy day of the birth of the Lord 'the new sun' . . . because with the appearance of the Savior not only was the salvation of humanity renewed, but also the brightness of the sun,

writes St Maximus of Turin. The Apostle confirms this, moreover, when he says that through him (Christ) all things are restored (Eph. 1:10). If then the sun was darkened at the time of Christ's passion, it needed to shine more brightly than usual at his birth. '[T]he pagans called this day "the birth of the invincible sun",' says an anonymous

third century author. 'But who is as invincible as Our Lord, who cast down and conquered death?' St Gregory of Nyssa writes that at the solstice,

> you see the rays of light becoming thicker and the sun higher than usual. Understand this of the appearance of the true light, which illumines the whole universe with the rays of the Gospel.

But the light of the divine Sun of Christmas only takes on its full meaning when confronted with the night. The mystery of Christmas, like that of Easter, is the mystery of the 'luminous night'. The light of Christmas is manifested at midnight, for it is written:

> While all things were in quiet silence, and the night was in the midst of her course, Thy almighty Word, O Lord, came down from heaven from Thy royal throne (Wisd. 18:14–15,

this serving as the introit for the Sunday within the octave of Christmas). Night symbolizes sin, the 'shadow of death' that the Christic light comes to dissipate. But we should also not forget that the Birth of the Messiah, like His Resurrection, effects a new creation and takes place in conditions similar to those of the first creation. In this sense, the 'night' of Christmas corresponds to the 'chaos and darkness . . . upon the face of the deep' (Gen. 1:2) that the '*Fiat lux*' comes to illuminate and put in order.

Moreover, since there is a correspondence between all the cycles of time, the daily cycle reproduces at its own level the annual cycle, and the hour of midnight corresponds rigorously, within the span of the day, to the 'winter solstice' within the span of the year. Just as the year is divided into two parts, one ascending from the winter to the summer solstice, the other descending from the latter to the former, so the day also is divided into an ascending half, from midnight to midday, and a descending half, from midday to midnight. Thus the symbolism of midnight reinforces that of the winter solstice, which in a way is the 'midnight' of the year. In both cases we are made aware of the rising up again of the sun out of darkness which, on the sensible plane, conveys the renewal effected by the

newly born Christ on the spiritual plane. 'The light shone in the darkness. . . .'[1]

Since Christ is the Sun of Justice, it can equally be said that He is the 'Sun of Midnight'. The Ancients asserted that, in the Mysteries, it was given to some to 'contemplate the sun at midnight'. This latter expression symbolizes supreme Knowledge, which is the reduction of contraries, represented by the opposition of day and night, and the perception of unity. In fact, if one contemplates the sun at midnight, this means in reality that the night has disappeared and that the word of Scripture has been accomplished: 'The night is illumined like the day.' In sum, this means that time has ceased, giving way to Eternity. This knowledge, which is nothing other than the 'Light of Glory' and the 'Beatific Vision', is effected by Christ, which is why He is hailed in the ancient hymns with the name already cited several times of *sol occasum nesciens*, 'sun that knows no setting' or motionless sun at zenith. The Christmas mystery's light of midnight constitutes the first fruits and promise of this Light of Glory. Jesus said, 'Then the righteous will shine like the sun in the kingdom of their Father' (Matthew 13:43), which was extremely well glossed by Origen, as follows: 'The righteous will shine in the kingdom of their Father, for they will have become a single solar light. . . . All will be completed in one perfect Man and they will all become a single sun.'

<p style="text-align:center">* * *</p>

Epiphany is not simply a duplicate of Christmas. Its liturgy develops the theme of fire and light in a triptych abundantly exploiting all the rich imagery of solar religion.

The meaning of Epiphany is wonderfully summed up in an anthem from Vespers:

> We honor a holy day marked by three wonders. Today the *star* led the Magi to the manger; today *water was changed into wine*

1. According to the *Apostolic Constitutions*, the Nativity took place at *midnight* (which corresponds to the winter solstice) and the Ascension at *midday* (corresponding to the summer solstice).

at the wedding [of Cana]; today Christ, to save us, chose to be baptized in the Jordan by John.

The disparity between these three events, which are manifestations of the Lord, is only apparent. In actuality there is an intimate bond between them, inherent in the underlying solar symbolism, and in order to be understood, they must be studied within this solar context.

We saw above that Epiphany, like Christmas, is a festival of fire and light; and, in this respect, there will perhaps be reason to grant more importance to the *star* of Bethlehem than is usually the case. Thus, for St Ignatius of Antioch, Jesus Himself descended to earth like a new star, 'escorted by all the stars, with the sun and the moon forming a choir.' And it will be instructive to study the definite connections between the light of this star, the baptismal dove of light, and the fire of Pentecost. We hope to say some words about this in due course.

But while Epiphany is a festival of fire, it is also one of water. The western liturgy has allowed to fall into disuse the rites still preserved in the East, rites that explain the correspondence between the three marvels presented rather summarily and abruptly in the anthem cited above. During the night preceding Epiphany there is in all the Eastern rites a ceremony somewhat similar to that of Easter night, celebrating the baptism of Christ in grand fashion. With variations according to the different rites, the ceremony unfolds following this general pattern: a torchlight procession outside the church, a blessing of the waters and springs (in Palestine, the Jordan), and sometimes a communal bathing of the faithful in the sanctified river or fountain; the projection of a cross into the water, a censing of the water, the infusion into it of a burning coal and holy oil, and the floating of a calabash containing five lighted candles on it; the return in procession to the church, and the blessing of baptismal water placed in a basin in the middle of the choir.

In order to fully understand these rites, we should remember that in the non-Christian East, as in Rome, the season of the winter solstice was observed with celebrations of a particular kind. Especially in Alexandria, in Egypt, the feast of Osiris, a Hellenized Osiris

assimilated to Dionysius, was celebrated on 11th Tybi (January 5th–6th). First came the days of mourning for Osiris, the Sun, who died at the solstice: the burial of the god was mimed, after which Isis set out in search of her spouse and, at dawn on January 5th, gave birth to Harpocrates, god of the new-born sun. The following day the water of the Nile turned into wine. In a fit of zeal, Epiphanius of Salamis, who reported these facts, even specifying that there is on this occasion a candlelight procession, accuses the pagans of having sacrilegiously imitated the Christian ceremonies. Nothing could be further from the truth, and Epiphanius' opinion has as little foundation as does that of the rationalistic critics who, on the contrary, claim that the Christian liturgy is nothing but a pastiche of the pagan mysteries. The truth is that, in this as in so many other cases, Christianity adopted a non-Christian rite to the extent that it contained an authentic religious meaning. As with the *sol invictus* in Rome, what it inherited here was the solar religion, which, as we shall see, was linked to the theme of the waters. Moreover, we can, without loss of continuity, follow the transition from the pre-Christian to the Christian rite in Egypt, where from the very earliest times until today, the Copts have on 11th Tybi celebrated the *Eid-al-ghitas* or 'festival of submersion', which is a festival of the Nile which unfolds according to a ritual similar to the one described above for the Eastern liturgies as a whole.

The solar religion of the ancients taught that fire, the principle issuing from the sun, in order to produce the spring, vegetation, and universal life, united with the earth, but also and in the first place with water. At this stage, the solar god needed to battle the powers of darkness, which were not only trying to oppose him in heaven, but also infested the waters. These dark powers assumed the form of a foul dragon, which was hidden in the water. This pattern is to be found in Babylon, where Marduk, borne on the solar chariot, defeated Tiamat, and in India, where Indra overthrew the serpent Vrita, who had imprisoned the waters, and also in Greece, where the solar god Apollo is the vanquisher of the great serpent Python. Among the Hebrews this pattern takes the form of the Lord, the heavenly and solar God, struggling against the monster Rahab, and it reaches its culmination and grandest orchestration in

the Apocalypse, where the Lamb, mounted on a white horse—white like the horses of Apollo's chariot—and cloaked in purple, finally defeats the beast, the last avatar of Rahab and the Leviathan.[2]

By his victory, the Sun destroys the dragon, the principle of death, and frees the waters. The bathing of the solar god regenerates the waters into which he descends; uniting with them, he fecundates them, thus making renewal possible. This is what is signified by the strange tradition in Antiquity of 'vinous fountains' at several religious centers. We saw earlier that on 11th Tybi, the water of the Nile turned into wine; likewise, on January 5th, both at Teos and Andros, the sacred spring flowed with wine instead of water during the ritual marriage of Dionysius (Osiris).

In our view, all these just enumerated details need to be very carefully borne in mind. We have here the themes of solar light, the solar bath, water turned into wine, and marriage. Now these are precisely the themes that are again taken up and developed in the liturgy of Epiphany.

If the light of the star, the night-herald of the Sun of Justice, who is about to be born and ascend irresistibly to the zenith, is a sign of renewal, the Baptism of the Christ-Sun in the Jordan is no less certainly another. Since Epiphany is the feast of the birth of the Sun of Justice, we see its connection with baptism, that is, the second birth. According to St Maximus of Turin,

2. Cf. Isaiah (27:1): 'In that day, the Lord with his hard, and great, and strong sword shall visit Leviathan the bar serpent, and Leviathan the crooked serpent, and shall slay the whale that is in the sea.' The assimilation of Christ in this role to the Greek Apollo went further. An attempt has been made to show that the Christian church at Delphi absorbed elements of the Apollonian cult; in any case the cult of St George was implanted there very early on (Ejnar Dyggie, *Cahiers archeologiques*, III, 1948). A hymn attributed to St Paulinus of Nola celebrates the victory of Christ in these terms:

> *Hail, O true Apollo, illustrious Pean,*
> *Vanquisher of the infernal dragon!*
> *Lo! magnificent triumph!*
> *Hail, blessed Victory over the world*
> *Who inaugurates an era of happiness.*

Finally, early iconography represented Christ with the traits of Apollo, riding in a chariot and with a nimbus of twelve rays.

Christ was visibly born as man in the manger; in the Jordan, at the time of his investiture, He was symbolically reborn. In the manger, the Virgin brought Him into the world; in the Jordan, He appears reborn by the heavenly witness.

There is, moreover, a remarkable parallel between the cosmic renewal of nature through the visible sun fecundating the waters, and the renewal of man through the Incarnation of the Word, the intelligible Sun Who gave us baptism as a sensible sign of this regeneration.[3] The theology of salvation fits and is expressed in a symbolism that recalls the periodic regeneration of time and the world through the repetition of the archetypes: 'each new year again takes up time at its beginning, repeats the cosmogony' (M. Eliade). The teaching of the first chapter of Genesis: *Spiritus Dei ferebatur super aquas*, is repeated at the Baptism of Christ, when the Spirit descends upon the waters of the Jordan at the same time that Christ enters them. The bathing of the Lord in the Jordan is a *mysterium tremendum*:

> On that night, the river of Jordan burned with heat when the Flame [Jesus] descended to wash Himself in its waters. On that night the river was brought to boil and its waves pressed against each other in order to be blessed by the steps of the All-Highest on His way to baptism (Blessing of the Waters in the Maronite rite, in *L'Orient syrien*, March 4th, 1959).

Here we very clearly see that the descent of the Son of God into the river is interpreted, according to the pattern of solar religion, as that of the celestial fire into the waters. This descent is ritually represented by the gesture of plunging a lighted candle (West) or a cross (East) into the water in the river or basin. Another theme indicated above, that of the solar hero fighting the dragon, is applied to Christ descending into the Jordan to kill the dark dragon hidden there (according to Psalm 73). Among the numerous expositions dealing

3. The Pisa baptistery shows Christ bringing to men the tree of life, its top encircled with the solar wheel. Below the relief is the inscription: *introitus solis.*

with it, we shall call to mind only two. First, a passage from St Cyril of Jerusalem who says in his *Mystagogic Catechism*, citing Psalm 73, that at the Jordan Jesus 'voluntarily descended into the abode of the symbolic whale of death so that it would disgorge those it had swallowed'. Then, the Armenian introductory prayer to the Blessing of the Waters:

> Having arrived at the edge of the Jordan, Thy Son saw the frightful dragon hidden in the water, gaping at the mouth and impatient to swallow mankind. But Thy Only Son, through His great power, trod the waters down under His feet and severely chastised the lusty beast according to the words of the prophet: 'Thou hast crushed the head of the Dragon beneath the waters.'

The entrance of the Son into the waters is also interpreted as the bathing of the solar god, magnificently celebrated in one of his hymns by Meliton of Sardis (second century):

> When with his team of light the sun has run his daily race, as a result of the turbulence of his course, he becomes the color of fire and seems like a burning brand. When he is pressed to run half his celestial way while burning during the whole of his course, he seems near to us as if he would set the earth alight with ten bolts of lightning that flash their beams. Then, without being easily visible to the eye, he falls into the Ocean. . . . Bathing in a mysterious depth, he also gives numerous shouts of joy; the water is his food. While remaining one and the same, he shines for men like a new sun, strengthened by the deep, purified by the bath. He caused the darkness of the night to withdraw and brought us the bright day. By following his course, the dance of the stars proceeds in the same way as the activity of the moon. Like good disciples, they bathe themselves in the baptistery of the sun, for it is only because the stars and the moon follow the course of the sun that they have a pure brightness. When the sun with the stars and the moon are bathed in the Ocean, why cannot Christ be baptized in the

Jordan? The king of heaven, the prince of creation, the rising sun who appeared also to the dead in Hades and the mortals on earth. Like a veritable Helios, He has gone to the heights of heaven.

The waters, illuminated by this reborn sun, generate anew the newly baptized, who 'have been struck by the ray of the sun of the Unique Divinity' (St Gregory Nazianzen).

But if the waters are thus able to regenerate men, it is because they have been made fecund by a mysterious marriage. We find the theme of the marriage of the waters and the solar god as a sign of the marriage of Christ to His Church: 'Today the Church is united with her heavenly spouse, because Christ purified her of her faults in the Jordan: bearing gifts, the Magi hasten to this royal wedding, and the water turned to wine gladdens the hearts of the guests' (*Benedictus* Ant.). In the Eastern liturgies, the motif is taken up almost endlessly in lyrical pieces that are veritable nuptial poems:

> In every tempo the Spouse Thou hast acquired from the waters of baptism celebrates Thy glory through the voices of her sons. . . . She lifts all praises and glorifications to Thy Name, and all exultation to the Father who sent Thee, as well as to the Holy Spirit. . . . On this day of Thy baptism, O Son of God, the Church, Thy fiancée, rejoices greatly, for through Thee she with all her children has been sanctified.[4]

Little need be added in order to shed light on the third mystery commemorated on the day of Epiphany, the marriage at Cana. Over and above its historical sense, it evidently has a spiritual meaning. The water turned into wine is an announcement of the Eucharist, and, according to the tradition of the Fathers, the Eucharist in its profoundest sense. The mystery of the Eucharistic wine is that of water, that is to say, of nature already purified through baptism in the Jordan, raised through an astonishing transmutation to the state of wine, that is to say, of the supernatural. What in fact, in terms of

4. The Maronite ritual.

mystical chemistry, is wine if not 'igneous water', vivified water, reheated and in a way reduced, subject to the action of the solar fire, to its quintessence, first, through gentle vegetal elaboration in the vine, and then through death in the wine-press and the vat—as wheat is reborn after perishing in the earth. Substantial union of water and fire, inaugurated at the Baptism of Christ at the moment of the 'boiling of the Jordan', and consummated in the 'chemical marriage' of water and fire that gives birth to wine, of human nature and Divine Fire in the 'mystical marriage' of the soul, the sacramental sign of which is the holy Eucharist.[5]

5. The mystery of Cana is represented in the Mass at the moment of the Offertory when the priest mixes a drop of water with the wine of the sacrifice, symbolizing human nature destined, according to the words of the ritual, 'to share in the Divinity of Him who deigned to assume our humanity.' Let us remember, following on what has been reported above, that, according to St John Chrysostom, 'vinous springs' were to be seen at the time of Epiphany at Cibyre and Garasa, in Asia Minor, for example, and he himself was there to taste them.

16

THE PASCHAL LIGHT

AS WE HAVE ALREADY SAID, the Office of Easter scarcely takes us away from that of Epiphany.

The Great Vigil commemorates the resurrection of Christ, the principle and pledge of our own resurrection. The Passover, the central mystery of Christianity, is the 'passage' (*pesah*), the passage from death to life (Phil. 2:5–11), the crossing of Christ and, with Him, all men 'out of this world to the Father' (John 13:1).

> But God . . . even when we were dead through our trespasses, made us alive together with Christ . . . and raised us up with him, and made us sit with him in the heavenly places in Christ Jesus' (Eph. 2:4–6).

In conformity with the Scriptures, this passage from death to life is presented as an emergence from darkness into light:

> [T]he Father, who has made us worthy to be partakers of the lot of the saints in light; who has delivered us from the power of darkness' (Col. 1:12–13).

> But you are a chosen race . . . that you may declare the wonderful deeds of him who called you out of darkness into his marvelous light' (1 Pet. 2:9).

For Christ, 'the light [that] shines in darkness' (John 1:5), said,

> I am the light of the world; he who follows me will not walk in darkness, but will have the light of life (John 8:12).

I have come as light into the world, that whoever believes in me may not remain in darkness (ibid., 12:46).

This scriptural base governs all symbolism of the feast, which uses the now familiar images of solar religion: fire, light, and water, in accordance with the very date of Easter, which is that of the equinox, for the rites of the Great Vigil are those of regeneration, both cosmic and individual, borrowing their formulations from the renewal of nature. It will be immediately apparent that the solar symbolism of Easter differs a little from that of Christmas, in the sense that it is a combination of the solar and lunar cycles. As is known, the date of Easter belongs in fact to the lunar calendar, and this pertains to a very ancient concept according to which the full moon was considered to be a sacred day because it corresponded with the position of the stars at the time of the Golden Age; but this applied above all in the case of the full moon that coincided with, or was at least closest to, the vernal equinox. In this perspective, the month of March, in which the equinox occurs, was the first month of the new-year, which restored time to its beginning in order to regenerate it. This was how things were viewed in Rome until the time of Julius Caesar, the author of the solar calendar, and among the Jews, where the month of Nisan, the month of the equinox, was the first month of the year. The Passover of the Jews falls on the day of the full moon following the equinox, and their calculations led them to place the beginning of the month, and thus the beginning of the year, fourteen days earlier than the equinox: the date of the Passover oscillates between March 8th and April 4th of our calendar. The Jewish Passover (14th Nisan) is the first moon of the year. In the perspective of the Ancients, the preceding 14 days were also considered to be sacred, because they are the period in which the moon, fighting against the darkness, grows from the eclipse of the new moon to the fullness of the full moon. In our liturgy, this time corresponds to that of the Passion. And so Easter is situated at a time analogous to that of the Creation of the world, to the Golden Age, and to Paradise, and thus is characterized as a restoration of the primordial state. In this regard, an interesting parallel is that of the *No-Rouz* or Iranian New-Year, celebrated at the vernal equinox, which

recalls the creation and presages for the end of time the definitive triumph of Yima, the solar hero, and the resurrection of the dead. Thus is evident the extent to which this theme, in which the lunar reinforces the solar symbolism, was equal to expressing the Christian mystery of regeneration, of the new creation brought about by Christ the Sun, pledge of our resurrection and the final restoration of Paradise. It is the subject of the two rites of the Great Vigil: the re-kindling of the fire and the blessing of the baptismal water.

The extinction followed by the re-kindling of the fire, naturally recalls the death and resurrection of the Christ-Sun, in the daily cycle, the setting and rising of the luminary. Each evening, it descends through the 'western door' into the shadows of the night, the realm of death, Hades, which it traverses without suffering any harm, re-appearing at dawn through the 'eastern door', completely unchanged. This elementary rhythm of the luminary is the most magnificent and exact figure of Christ, the Sun of Justice, descending into Hell to bring the dead back to life and arising with them on Easter morning. The poets of the first centuries celebrated this return of Christ as the dazzling procession of the solar Apollo in his chariot, or of the Roman victors connected therewith.

> After three days, the day breaks more brilliantly; the softness of the former light is restored to the sun. Christ, the Almighty God, is adorned with the brightest rays of the sun. The salvation-bearing Divinity conquers, and His triumphal chariot is escorted by the company of the righteous and the saints (*Firmicus Maternus*).

> The Day of Salvation, the driver of the eternal chariot, who, in the circular movement He must follow every year, directing His steps towards the final goal, has arrived. He follows and precedes Himself, and although old is nevertheless the ever young genitor and offspring of the year, God, Our Lord, who set and rose again, so as nevermore to repeat His disappearance, for this is the day when the shadows of death have been rent asunder (Zeno of Verona).

This is the great night, for the Most Holy God ascends from the mire of Acheron, not like the Morning Star, which, rising from the Ocean, feebly lightens the darkness with its flame; but to everyone still weeping over the cross, he makes the gift of new day: for he is greater than the sun' (Prudentius).

Dissipating the darkness of the sanctuary as it advances, the procession of the Paschal candle, with its five nails of incense a substitute for Christ, represents this triumphal procession of the luminous Christ, vanquisher of the infernal regions and death. But the daily cycle of day and night is analogously reproduced in the annual cycle wherein night corresponds to winter (solstice) and morning to spring (equinox). The Passover is the festival of spring, and for the first Christians, as for the Israelites, it was the beginning of a new year. Finally, the annual cycle reproduces on its own level, the total cycle of our world, the end of the year corresponding to the end of the world, and its beginning to a new creation. Each new spring is a regeneration of the world, and this is why it symbolizes the first day, when light was created.

That the Paschal liturgy makes this connection with Creation is clearly evident in the reading from the Office of the first chapters of Genesis and the account of the Flood. The latter, as is known, marks the end of the world and the passage to a new world, but also a regeneration of humanity, a 'salvation'. The ritual of the light reproduces the process of Creation, while in its sphere sacred architecture repeats cosmogony.

On Holy Saturday evening the light is extinguished at the end of Lauds, and the sanctuary left in darkness. As the temple represents the world, this extinction is equivalent to a 'death' of the world, which is once again plunged into primordial chaos, the night of the sanctuary corresponding to 'the darkness on the face of the abyss.'[1] The light is then rekindled under the porch outside the temple, in the night. This process reproduces the *Fiat lux*. A new world, a cosmos, succeeds the chaos; the world and time are regenerated, recreated by the *lumen Christi*, the same light that is manifested in the explosion of

spring. An ancient paschal hymn, *Salve festa dies,* celebrates this renewal of paradise regained:

See how the earth again takes on life and beauty. . . .Everything smiles at the triumphant Christ, Who has just left infernal Tartarus: the trees offer their leaves, the fields their flowers. The God crucified yesterday now reigns over the universe; the entire Creation prays to its Creator. . . .

The *Exultet,* for its part, is also a hymn of renewal, a solar hymn:

May the earth, illumined with such glorious rays, rejoice; may the splendor of the eternal King reflected upon her, make her feel that the entire universe is delivered from darkness.

This regeneration of the world through fire and light is, as we have seen, the presage of the Ultimate Return of Christ at the end of the world, the return that will mark the definitive victory of the Divine Sun over the darkness of Evil. According to what is probably an apostolic tradition, St Jerome tells us that the return of the Lord should take place during Easter night. And Lactantius writes the same:

This night is doubly holy, for during it the Lord returned to life after His passion, and during it, too, He will come to take possession of His kingdom over the whole universe.

The same allusion to the Parousia appears in the long prayer accompanying the blessing of baptismal water, in which the bishop calls to mind the day when Christ will come 'to judge the world by fire.' In broaching the subject of this second rite of the Great Vigil,

1. Again, as at Christmas, the mystery of the 'luminous night'. 'It is from the night that Christ was born at Bethlehem, it is from the night that he was reborn at Zion' (Pseudo-Epiphanius). He is born on Christmas night, in a cavern, which is like a maternal womb, and reborn on Easter night from another cavern, his tomb 'hewn from the rock', says the Gospel, for it is from the night that the sun rises.

we are once again faced with the association of fire with water so characteristic of solar religion already studied in the corresponding ceremony of Epiphany. But first, it is important to perceive clearly the parallel between the two rites of rekindling the light and blessing the water, and baptism, a parallel easy to understand, given the analogy between the macrocosm and the human microcosm. The individual man is an image of the universe. It is therefore natural that the regeneration or spiritual recreation of the individual be effected according to a ritual that reproduces the creation of the universe. Baptism is the rite of individual recreation. It allows the individual to participate in the Death and Resurrection of Christ, that is, to realize at his own level as an individual man, the new creation that Christ, the Universal Man, realized for the whole universe.

> [A]nd you were buried with him in baptism, in which you were also raised with him through faith in the working of God, who raised him from the dead (Col. 2:12).

The central ritual gesture of baptism is immersion followed by immersion (replaced in the Roman Church by a simple pouring of water). Immersion corresponds to a 'burial', to the death of the old man; the water recalls the primordial Waters (*Maïm*) of Genesis, that is, the universal Womb (St Denis calls the baptismal font 'the womb of all filiation'). The individual 'sinner' is symbolically destroyed, restored to the unformed state, the state of 'chaos'. The immersion, or coming forth from the water, is the rebirth or resurrection, the creation of the 'new man'. It corresponds to the *fiat lux*, for light plays a primordial role in baptism, which is the sacrament of 'illumination' (*photismos*). And if the baptismal water illumines the neophyte, this is because the water has itself been visited by the heavenly Light and Fire: the bathing of the divine sun in the water has preceded that of the neophyte. Such is the meaning of the rite of blessing. After pronouncing a prayer in which the cosmic correspondences of the baptismal rite are clearly indicated—the allusion to the Spirit of God covering the primordial Waters, and to the Flood, the image of regeneration—and after having divided the waters in the form of a cross and sprinkled the surrounding space

following the cardinal axes while expressly recalling the four rivers of Paradise, the bishop plunges the lighted paschal candle into the water three times. The words he pronounces at that point leave no doubt as to the meaning of this act: 'May the Power of the Holy Spirit descend upon all the water of this fountain.' Since the candle represents the resurrected Christ, it is the Latter who descends into the water and, at the same time, His Spirit manifested by the Dove above the Jordan. Moreover, both prayers of the *Exultet* and the blessing of the water are replete with a biblical baptismal typology confirming this. First, they recall the Crossing of the Red Sea, which corresponds to the Passover (*pesah*: passage) at which God was present in a 'pillar of fire' (represented by the candle), which caused St Paul to say that the Hebrews had been baptized in water and fire. Next, they recall the crossing of the Jordan River, also on dry land, on the eve of the Passover, to enter the Promised Land; this was at Bethabara, where later Elijah, in his turn, crossed the river on dry land and was raised to heaven in a chariot of fire (the sun-chariot),[2] and, finally, it is where Christ was baptized. Here again we find nearly the same symbolic pattern of the fecundation of the water by the divine solar fire already observed at Epiphany.[3] The descent of the fire as at the Jordan River is better suggested in the Greek ritual, since, at the church of the Holy Sepulchre in Jerusalem, the coming of the fire from heaven is mimed, descending from the cupola to light the candle. Likewise, in certain regions of Italy, a dove bearing the fire descends into the middle of the crowd. The solar symbolism is no less present even in the rite of baptism, especially its oldest form. Baptism is said to be the sacrament of *illumination*, a participation in the solar light of Christ. What is more, in the early ritual, the preliminary ceremony to which the recipient was subjected consisted of an abjuration of the devil and a consecration to Christ effected according to a double orientation: he first abjured, with hands extended to the west, the realm of darkness where the sun sets, and then, with hands raised to heaven, was consecrated facing east, the point whence Christ the Sun is reborn. The baptismal bath

2. This episode is integrated into the Greek liturgy of Epiphany.
3. 'The sun inclines its rays into this water' (Syrian Liturgy).

is therefore also a solar bath, like that of Christ in the Jordan; the neophyte is baptized in both water and fire, is reborn from the water and the fire incorporated therein, and emerges from the bath a 'child of the light' (Eph. 5:8)—as the sun rises from the ocean at dawn[4]—and assumes the white habit 'shining like snow', recalling the light of Thabor.

<p style="text-align:center">* * *</p>

The solar symbols punctuating the Easter Office are far from exhausted by our observations above. To conclude, we shall cite two other symbols, the bee and honey, and eggs.

Towards the middle of the hymn of the *Exultet*, the deacon pronounces these words:

> On this sacred night, Holy Father, receive from the hand of her ministers the offering Holy Church presents to Thee as an evening incense, through the solemn oblation of this candle, for which the bees provided the material. . . .

He lights the candle and extols the flame, which 'feeds on the wax that the mother bee (*apis mater*) produced for the making of this precious candle.'

That is all. Previously, however, the evocation of the *apis mater* had been greatly elaborated in the 'Eulogy of the bee' featured in the Gallican Sacramentary, but it was removed from the office some centuries ago. This eulogy, which in the present ritual is inserted into the *Exultet* after the words *apis mater eduxit*, is a rather long and very beautiful piece of prose poetry developing the following themes: the bee holds first place among animals because it is gifted with a 'great soul' and 'vigorous temperament'; this temperament is manifested in industrious work, the end of which is wax and honey, 'this nectar squeezed from flowers', which it pours into wax cells; finally, the bee is a virgin animal, 'the virginity of which is never

4. An ancient funerary inscription gave a Christian the name of 'son of the sun' (*heliopaïs*).

violated but which is nevertheless fecund', which constitutes an analogy with Mary, who conceived in this way.

Thus the industrious bee produces the pure food that is honey, as well as wax, also a pure material, which, in mediaeval symbolism, represented the body of Christ begotten by Mary the divine Bee. In the Paschal ritual of today, only wax is mentioned, but the evocation of nectar in the Gallic ritual should not be forgotten. And thus, as is shown by its insertion in the ritual at this point, the symbolism of the bee is directly related to the resurrection, since the lighting of the paschal candle represents Christ's exit from the tomb.

The symbolism of wax is all about humility: perfect but humble matter that is effaced and destroyed to the extent that it 'nourishes' the flame. Honey, on the other hand, is, like the bee, a 'triumphant' symbol, traditionally related to the sun. Just as gold is mineral light, honey, the color of gold, is vegetable light, the quintessence of the solar light elaborated in flowers. This is why clear honey has always been taken as an emblem of purity, as well, (the worshippers of Mithras purified their lips with honey), and as the symbol of knowledge, as it corresponds to the knowing disposition of the bee. This is the meaning of the beautiful legend reported by Elien according to which bees formed a comb in Plato's mouth, a sign of the supernatural character of his philosophy. But how many know that the same story is told about St Ambrose? It is said that when the future doctor was still but a baby in a cradle, some bees entered his open mouth, then flew up towards heaven, higher and ever higher, until out of sight, which enraptured Ambrose's father, who saw therein a sign of his son's future glory.

Emblem of knowledge, honey is also the emblem of poetry, which, according to the traditional concept, is, like knowledge, a gift from heaven and more especially from Apollo, the solar god. It is curious to note in this regard that in Greek the words denoting lyricism—*melike*—and the lyrical poet—*melikos*—come from the same root as *meli* (honey). Consequently, it is not surprising that honey has also served to designate spiritual food. In India, the ritual drink soma is sometimes called honey (*madhu*), and it is said in the *Rig Veda* that the bees gave honey to the Açvins as a present. In the classical mysteries, the priestesses, such as those of Demeter, were

often called bees (*melissai*). In the *Mysteries of Eleusis*, among others, the bee was considered divine, *melissa thea*, and during the celebration of the mysteries, the bee-priestesses ritually dispensed honey to the neophytes. Food of immortality, honey was used in funerary rites, for, as Plutarch tells us, it was believed to protect against corruption. In Greece, pots of honey were placed near pyres and upon tombs; the dead were even coated with honey, and it is almost certain that this was the origin of wax mortuary masks.

These remarks lead us straight to the office of the Great Easter Vigil. In in the first centuries, during the course of the Mass they were attending, neophytes received *melikraton*, a drink made of milk and honey, as a pledge of their resurrection in Christ. *Melikraton* played the role of drink of immortality.[5] This rite was based on the passage in Exodus (13:5) where God depicts the Promised Land as 'flowing with milk and honey'. The Eucharist is the feast of the true Promised Land; and as it was in the footsteps of the risen Christ that the neophyte entered as it were the Promised Land, we can see how this old rite came to be inserted into the Easter Office, where even today the bee is still associated with the mystery of the Resurrection.

Regarding this, we need to speak of a curious rite of the Ancients, which may seem far removed from our subject, but which, in reality, will shed new light on it. Everyone knows the episode of Aristaeus recounted by Virgil in his *Georgics* (IV, 294 ff.), in which the poet reveals how bees are born from a bull sacrificed according to certain rules. For a long time this rite was misunderstood, until it became known that it was inherited from the Egyptian Mysteries of Isis. During the course of these mysteries, the generation of bees in the skin of a sacrificed bull was recalled: the flight of the swarm out of the skin symbolized the rebirth, in the world of *Khepri* or the rising sun, of the neophyte, whose first state, abandoned by him in a symbolic death, was represented by the corpse of the bull. This episode from Virgil must have caused Christian antiquity to ponder, especially as the great Latin poet was regarded as a sort of 'para-Christian' prophet.

This is all the more probable as there exists in the Bible a somewhat

5. Among the Eucharistic symbols decorating the catacombs, one finds representations of bees hovering around a pot of honey or milk.

similar episode, doubtless less circumstantiated, and more obscure, but which no doubt alludes to a belief and rites of the same kind. It features in the story of Sampson (Judg. 14). Sampson, it is said, slew a young lion, and a few days later, when passing again by the place where he had killed it, found a swarm of bees in its remains and some honey, which he was eager to eat. The rather badly elucidated moral enigma that he proposed to the inhabitants of Timna regarding this event thoroughly proves that he accorded it a symbolic value, and a connection must certainly have been made between the passages from the Holy Book and Virgil. In any event, it is interesting to note that three hundred bees close to a bull's head were depicted on Chilperic's tomb, obviously to represent death and resurrection.[6] This tomb relief was very probably inspired by the memory of Virgil, whose meaning at that time was perfectly understood. In any case, this provides proof that Virgil's symbolism had been sufficiently integrated into the Christian tradition to pass into funerary art.

A no less significant allusion is found in an admonition to neophytes, attributed to Caesarius of Arles: 'You, fresh green branches of holiness,' he wrote, 'you holy seed; you, my *new swarm of bees*, floral crown of my happiness. . . .' How is it possible not to see here an allusion to the account from the *Georgics*?

Thus, there must have existed in Christian antiquity and the High Middle Ages a rather developed symbolism of the resurrection centered on the bee and honey, a symbolism attested by the *melikraton*, the motif on Chilperic's tomb, and Caesarius' text, a symbolism of which only very little remains to us today in the Easter Office, ever since the development of the Gallican Sacramentary was halted. This 'little' appears especially precious.[7]

6. A. de Gubernatis, *Mythologie zoologique* (L'Abeille). — The number 300 is that of the letter Tau (Greek T), symbol of the victorious cross, that the Middle Ages saw prefigured in Gideon's 300 soldiers. It could very well have the same meaning here.

7. The bee still appears as a solar symbol of Christ. Indeed, if we bisect the angles within the hexagonal cell of wax, we get six lines crossing at the center, that is, the Chrismon. The bee, the industrious architect of the hive, is like the reflection in the animal world of the sublime Architect of the world. This is further confirmed by the Hebrew name of the bee, *deborah*, which, like *dabar*, means Speech, Word.

* * *

The other solar symbol of the Resurrection to be discussed is the egg in its two forms: the 'Easter egg' and the ostrich egg, the latter of which decorated or still decorates altars, and which is also directly related to the Paschal egg.

The custom of Easter eggs, if in large part belonging to folklore, is for all that not less connected to the liturgy, since these eggs are blessed at the Mass of the Resurrection before being eaten at the Paschal meal and given to friends.[8]

Some writers, and serious ones at that, have tried to explain the custom of eating blessed eggs at Easter purely in terms of the joy experienced by the faithful on rediscovering a food they had been deprived of during Lent. This is to see only the lesser aspect of things.

The Easter egg is a sacred symbol, no doubt seriously debased today, which nevertheless still preserves some vestiges of its ancient glory. The egg has been or remains a considerable and universal sacred symbol. Its symbolism is deduced quite naturally from its function, which is to assure the permanence of life and of the species in the succession of individuals. In all species, the egg with its vital germ constitutes the original state of individuals. Through an altogether legitimate transposition, we have the cosmic, or world egg, that is, the collection of the seeds of all being. The cosmic egg, found in every tradition, summarizes all creation, and this summary is repeated analogously in the birth and development of each individual.

A luminous egg laid by the celestial Goose was worshipped in Egypt, while the creator god, Kneph, was shown with an egg coming out of his mouth: a magnificent image of the world which issues from God and more especially from His mouth, that is to say from His Word. In Phoenicia, cosmogony was also based on the primordial

8. This tradition is especially alive in Slavic countries, where on Easter day the master of the house offers every visitor an egg, which the latter breaks with his fingers and shares with his host. For French folklore traditions, see M. Vloberg, *Fêtes de France*.

egg. Eternal time, through the intermediary of Air and Breath, engendered the egg, which contained the seeds of all beings. Likewise in Greece, Zeus, the god of heaven, in the form of a swan, fertilized Leda (Nature), who laid an egg whence were born the twins Castor and Pollux, representing the two poles of creation. Among the Celts, the famous 'serpent's egg' is connected to the same tradition. The cosmic egg is found in Black Africa, Australia, and Polynesia. But the tradition is best preserved in India. The Laws of Manu relate that in the beginning, in the world plunged in darkness and without form (cf. the beginning of Genesis), appeared Swayambhu, who produced the waters and there deposited a seed in the form of the golden egg (*Hiranyagarbha*), which shone like the sun and contained Brahma. Brahma broke the egg into halves, from which he made heaven and earth, after which he proceeded to the creation of all beings. The tradition of the cosmic egg is also to be found among the Jews. 'How does God create the world?' the 'Haguiga' asks. 'He takes two halves of an egg and fertilizes the one with the other.'

The function of the mythical egg at the beginning of the world has led to its being looked upon as an image of the perpetual renewal of life, particularly in connection with the renewal of nature and vegetation in spring.

In Rome, during the festival of Ceres at the vernal equinox, matrons marched in procession carrying eggs. New-year trees, as well as the trees of May and the Feast of St John, were often decorated with eggs, in this way combining two symbols of renewal. Even to the present day, the feast of the new-year in Persia is the 'feast of red eggs'.

If the egg is a sign of the renewal of the world, it is also, quite naturally, a sign of the renewal of the individual, first of all in death. This explains the use of eggs in funerary rites, where they are a pledge of new life after death. Silver eggs have been found in numerous sepulchers in Russia and Sweden, and, in the tombs of Boeotia, there are statues of Dionysius holding an egg. In recent excavations in the desert of Mari, egg-shaped tombs were discovered in which the dead lay like foetuses. In Gallo-Roman sepulchers there were 'serpent eggs' and this practice persisted during the Christian High Middle Ages.

It is thus clear to see how Easter eggs have their place in the feast the object of which is the renewal of nature and the spirit. Recalling the cosmic egg, Easter eggs fit into that symbolic group of water, light, and darkness that nourishes the Easter Office. The red color they are almost universally tinted is itself significant: red is related to fire, to vital warmth, and, on the spiritual plane, to the sanctifying and regenerating Holy Spirit.

The Easter egg is therefore a symbol of resurrection, both on account of the phenomenon of hatching (new life) and of the seed it contains. In the first place, it symbolizes the resurrection of Christ and the whole of nature, which is thereby renewed and recreated. Christ appears here as the seed of the new world. What is more, God calls the Messiah 'My Servant the Seed' in numerous places in the Bible.[9]

Next, the Easter egg symbolizes the resurrection of the neophyte. Through the death of the 'Old Man', the sinner is restored to the state of infancy, and even of seed, so as to be 'born anew' in the Light of Easter. Thus the egg is linked to the symbolism of baptism. In eating the blessed eggs, the faithful partake of the grace of the Resurrection.

This symbolic teaching by way of the egg is particularly clear in an ancient liturgical drama that was enacted until the eighteenth century at the cathedral of Angers. Chamberlains, representing the Holy Women, came out of the sepulcher, which was represented as is the Christmas cave today; each had an ostrich egg in his hand and together they sang *Resurrexit*. The first chamberlain presented his egg to the bishop saying '*Surrexit Dominus, alleluia!* (The Lord is risen)' and the bishop answered, '*Deo gratias, alleluia!*' Each chamberlain then repeated this scene before each member of the chapter, after which the eggs were taken back to the sacristy.

After Matins on Easter Day, in the church of St Maurice at Rouen, two chamberlains wearing dalmatics suspended two ostrich eggs above the high altar.

9. The author is using the French version which translates the phrase in Zachariah 3:8 as 'Mon serviteur Germe'. This is translated in English versions here and in other passages as 'Bud', 'Branch', and 'Orient'. TR

During the middle ages, nearly every church treasury contained ostrich eggs, which were patently reserved for the same or a similar use. In eastern churches they can be seen hanging before the iconostasis or above the altar, alternating with the holy lamps. They are also found in mosques. This is an adapted vestige of an old customs of the Semites, who, in accordance with their doctrine of the origin of the world, hung ostrich eggs in sacred trees... In the drama at Angers, the ostrich egg evidently represented the risen Christ. It is only in the light of the old traditions of the origin of the world mentioned above that this rite can be understood. The ostrich egg recalls the cosmic egg; it is the Lord as the Divine Word, creator of all things. More exactly, the Word, within the egg, is the golden seed, the solar seed, containing Universal Life.

* * *

We shall limit ourselves to these few observations on the cosmic and, more particularly, solar symbolism of the liturgy. Many other emblems should be considered, such as the sword, the arrow, the solar trees, and flowers such as the heliotrope and the olive with its oil, which play a similar role in the liturgy; and the palm, a solar tree linguistically related to the phoenix, another symbol of the Resurrection and the sacred bird of Heliopolis, the palm whose branches we cut to celebrate the triumph of Palm Sunday. We should also treat pictorial art, the gold background of the icons and the mosaics in the apse, the mandorlas of the Christs in Glory, the monstrances, etc., etc. But volumes would be needed for that, and such expositions would exceed our purpose, which was solely to show the cosmological and ultimately solar correspondences uniting worship and temple, which, in deploying its pageantries of light in the solar temple, making of the liturgy a veritable 'cosmic liturgy' at which the entire universe assembles to offer the Creator the 'sacrifice of praise' through man. It is in the Mass that worship attains its summit, and by way of ending this study, we would like to consider for a moment that transcendent synthesis towards which all the symbols we have been studying converge, that jewel of which the temple is the casket.

17

THE MASS AND
THE CONSTRUCTION OF
THE SPIRITUAL TEMPLE

WE BELIEVE THE TERM SYNTHESIS best suited to capture the fullness of the Divine Sacrifice, its 'all-embracing' character.

Even when considered solely in its outward aspect, the Mass is already an extraordinary spectacle, a harmonious synthesis of all the arts: around the dramatic poetry which forms its kernel, since the sacrifice is in no way 'recounted' but 'represented', are grouped, as in a choir, lyricism, rhetoric, and music, followed by the more humble arts, like goldsmithing to chase the vessels, perfumery to create the skilful blends of aromas, weaving and embroidery for the making of the vestments, etc. Not since Greek tragedy has the combination of arts and letters produced such a perfect marvel.

However, its essential qualities must be sought at greater depth. More than a synthesis of the noble activities of man, it is a synthesis of the world where his life unfolds. Here the whole of nature is as though assembled for the 'Great Work' of the Divine Liturgy. Present at the Mass are the four elements: 'earth' provides the sacred stone, 'fire' serves to light the candles and burn the incense, 'water', symbolizing our humanity, is mixed with the wine in the chalice, and, finally, 'air' is the vehicle of the incense and of the energies of the Divine Pneuma, when, at the moment of the epiclesis, the officiant waves the veil above the offerings. Also present are the three kingdoms, the three degrees of corporeal existence: the mineral in the stone, the vegetable in the bread, wine, and incense, and, finally, the animal in its highest representation, man, whose exact function

it is to gather together all the kingdoms and elements in order to offer them to their Creator. According to St Irenaeus, the liturgy is of cosmic importance, for the Holy Gifts are the first-fruit of Creation called to glory.

If we really want to understand this aspect of the Holy Sacrifice, we shall have to link it to the meaning of the Cross placed in the center of the altar. We already know this meaning through the texts of St Paul and Clement of Alexandria, but in order to understand the so to speak 'inner dimensions' of the Mass, we need to re-examine and deepen this notion of the cross as the measure of space and time, in conjunction with the 'axial pillar'.

Whereas the temple constitutes the outer architecture of the Holy Sacrifice, its inner architecture is determined by the Tree of the Cross. The harmony between the two is perfect, because the Mass, as the renewal of the death and resurrection of Christ, like the temple enclosing it and the whole liturgical cycle of which it is the heart, is itself also a cosmic mystery: the offering and reintegration in God, through the God-Man, of all Creation, of which the Tree of the Cross is the *measure*.

* * *

The Cross, the cosmic mystery, defines the mystery of the Mass. Let us again consider St Paul's text (Eph. 3:18–19):

> [T]hat you, being rooted and grounded in love, may have power to comprehend with all the saints what is the *breadth* and *length* and *height* and *depth*, and to know the love of Christ.

All the Fathers have understood these lines as referring to the Cross, and more exactly to the extension of the Cross to the universe. Recalling the famous passage from the *Timaeus*, where Plato shows that the whole celestial vault turns about the great X formed by the plane of the equator and that of the ecliptic, they applied it to Christ the Logos, builder of the world: hung on the 'cross' that crucifies the world, He contains the cosmos and makes it 'hang upon' the mystery of this cross. Thus, the cross 'recapitulates' the whole of cosmic becoming:

He who, through obedience to the Cross, erased from the wood the ancient disobedience, is Himself the Logos of God Almighty who penetrates us all with an invisible presence, and this is why He embraces the whole world, its *length*, and its *breadth*, its *height* and its *depths*. It is through the Logos of God that all things are conducted in an orderly way and the Son of God is crucified in them, whilst He affixed His imprint on all in the form of a cross. It was therefore right and proper that in making Himself visible, He impressed on everything visible His communion in the cross with all things. For His action needed to show visibly in visible things that it is He who illumines the heights, that is to say heaven, who reaches right into the depths and foundations of the earth, who extends the surfaces from the east to the west and lays out the distances from the north to the south, and who summons from everywhere all that is scattered to knowledge of His Father.

This text, most illuminating from our point of view, is from St Irenaeus, who, in the same spirit, and in a potent formula, says elsewhere that 'Christ was fixed to the cross, thereby summarizing the universe in Himself.' This is echoed in a hymn of St Andrew of Crete for the Feast of the Exaltation of the Cross:

O Cross, reconciliation of the cosmos, delimitation of earthly spaces, height of heaven, depth of the earth, bond of creation, extent of everything visible, breadth of the universe.

The words 'extent of everything visible' are significant: the Crucifixion of Christ symbolizes that the Redemption extends to the whole cosmos.

This symbolism, however, is completed by the symbolism of the tree. The Cross of the Tree of Life is the very tree that was planted in the center of Eden and from the foot of which flowed the source of the four rivers of Paradise (Gen. 2:9–10), the very tree that is found at the center of the heavenly Jerusalem (Ezek. 47:12; Apoc. 2:7, 22:2) and which Scripture identifies with Divine Wisdom, and therefore with the Word (Prov. 3:18). The Cross—the Tree of Life—substituted

for that of Eden, is likewise situated at the center of the world. At the summit of Golgotha, the tree rises to heaven and embraces the world at the very place where, it is said, Adam was created and buried, so that the rivers of water and blood flowing from the Crucified One who has become the 'Fountain of Life', stream over the body of the first man to resuscitate it from among the dead.[1]

The cosmic tree, growing both vertically towards heaven and horizontally to encompass the world, is the image of the Redemption spread to include the whole universe. Hippolytus of Rome has some wonderful words to celebrate this marvel:

> This Tree, reaching to the sky, rises from earth to heaven. It is the solid support of all things, the foundation of the whole world, the cosmic polar point. It gathers and unites within itself all the diversity of human nature. . . . It touches the highest summits of heaven and upholds the earth with its feet, and with its infinite arms embraces the immense middle atmosphere in between.

A Greek commentator, Oecumenius of Trikka explains St Paul's passage regarding the four dimensions of the Cross in the following way: the length, he says, refers to the mystery of the cross having been foreseen from all eternity; the breadth, to all having benefited from it; the depth, to Christ's having extended His benefits even to the Infernal Regions; and the height, to the fact that He who descended is also He who ascended above all the powers (Eph. 4:9–10). Clearly, it is the whole mystery of salvation and its application to the world, time, and space.

The four dimensions of the cross can ultimately be reduced to its two axes, the horizontal and the vertical, which may define its meaning even more exactly. The horizontal axis indicates the sense of 'amplitude', the sense of the extension of the mystery at the very level of our world, to our human state, its extension to all ages and

1. 'God opened his hands upon the cross in order to embrace the ends of the earth, and this is why the hill of Golgotha is the pole of the world' (St Cyril of Jerusalem).

all the regions of the earth. The vertical axis, that part of the axis situated above the horizontal, indicates the sense of 'exaltation', of ascension to superior states of Being, to heaven; whereas the part below represents inferior states of Being, the 'infernal regions' in the widest sense—*inferi*—that is, inferior in relation to the human state.

These two axes determine the inner dimensions and spiritual architecture of the Mass.

Architecture is displayed in the sense of 'amplitude'; ritual time, within which the Mass is celebrated, symbolizes the full duration of the world. The Mass recapitulates all the ages, the whole of human history. Before the Consecration, the officiant recalls in a solemn formula that he offers the sacrifice in the footsteps of Abel, Abraham, and Melchizedek. In the Syrian rite, he even recalls the beginning of the world and announces:

We commemorate at this Eucharist the whole of Thy economy, first, our father Adam and our mother Eve. . . .'

Then, after the consecration, he mentions the ages to come:

We commemorate, Lord, the whole of Thy economy for us: Thy Crucifixion. . . . Thy glorious second coming at which Thou shalt judge with glory the living and the dead,

since, according to the Lord's command, we offer the sacrifice in His memory 'until He returns'. Thus, at this point the rite recapitulates history as do, so we have seen, the figurative pictures on, or stained glass windows in, the walls of the temple.

But this recapitulation is not an end in itself; this 'horizontal' gathering is the prelude to an 'exaltation' along the vertical axis, the axis of redemption: Christ, who descended from heaven to earth and even into the depths of hell, 'has re-ascended above the heights, taking the captives with Him' (*Ascension Anthem*) enabling men and the world to go to the Father. The vertical axis of the Cross, the axis of the world, measures and traverses the three 'tiers' of the cosmos: hell, earth, and heaven, and although it is the direction of the Incarnation and Descent into hell, it is also that of the Ascension.

The horizontal axis is the 'quantitative' axis, measuring terrestrial time and space; the vertical is the 'qualitative' axis, that which transcends the terrestrial state, delivers us from time and space, and leads us to the heavenly Kingdom. It is around this axis that the architecture of the mass is raised and completed as again the priest recites in the Canon: Commemorating the blessed Passion of Christ. . . . His Resurrection from *hell* and His glorious ascension into *heaven*. . . .' The 'scenery' of the mass is deployed on these three cosmic levels: in the Infernal Regions, the Suffering Church, that is, those who sleep and for whom one implores 'the place of refreshment and light' (*Reading of the Diptychs*); on earth, the Church Militant gathered in the temple; in heaven, the Church Triumphant of the Apostles, Patriarchs, and Martyrs recalled in the Canon. The celebration of the Holy Mysteries is a perpetual dialogue between heaven and earth along the vertical axis of the Cross; it is the singing of the *Gloria*— 'Glory to God in the *highest* and on *earth* Peace to men of good will'; it is the chanting of the *Sanctus*, that door in heaven opening onto the eternal liturgy of the Angels and Blessed, with which the Preface invites us to blend our voices:

Lift up your hearts. . . . The Angels praise Thy Majesty . . . Vouchsafe to ordain, we beseech Thee that our supplicant voices may blend with theirs in saying: Holy, Holy, Holy is the Lord, God of Sabaoth. . . .[2]

This continual upward symbolism becomes clear in the invisible architecture that binds the earthly altar to the heavenly Altar of the Lamb by means of the 'axial pillar'. We can observe this on two occasions. First, in the Canon for the offering of the Holy Species, the celebrant says:

We beseech Thee, Almighty God, to ordain that these offerings be borne by the hands of Thy Holy Angel up to Thy sublime

2. Today we too often forget this presence of the angels and their participation in the Mass. On this subject, see the texts of the Fathers cited in J. Daniélou, *Les Anges et leur mission* (1953), pp 83–91.

Altar, in the presence of Thy Divine Majesty, so that... we may
be filled with grace and the heavenly blessing.

Here the words recall that circulation of prayers and grace that
respectively ascend and descend along to the vertical pillar of the
Cross uniting all the worlds.

Almost identical expressions are found in the offering of the
incense:

May the Lord, through the intercession of the Blessed Archan-
gel Michael who stands at the right of the altar of perfumes,
vouchsafe to bless this incense, and receive it as an odor of
sweetness.

We think it worthwhile to dwell a little on the rite of incense, the
value of which needs to be reasserted. It constitutes a *sacrifice*,
inherited moreover from the Jewish cult, which is why it takes place
immediately after the offering of bread and wine.[3] We read in Lev-
iticus (16:13) that Aaron was charged to bring the incense 'within
the veil', and in the Syrian Mass this very elaborate offering is called
'the service of Aaron', since it constitutes a whole section of the
Mass. As it is a little-known subject, which, to our knowledge, has
never been dealt with, at least as regards its symbolism, we are going
to consider this rite in its different aspects. First, the material of this
sacrifice is particularly significant in that incense is one of the
emblems of divinity, and its scent, like that of holy chrism, is the
'sweet smell of the Spirit' (O. Casel). This is due to the solar charac-
ter of incense. Generally speaking, all plant resins pertain to the
sun, whereas flowers are connected with the moon, but incense is
more particularly the perfume of the sun and consequently of the
Divinity it symbolizes.[4] Thus we meet again with that solar symbol-
ism that was gradually revealed in the study of the temple and the

3. In Israel, the offering of incense constituted the *evening sacrifice* (Psalm 140
recited at the Mass) and, in this capacity, it passed into our office of *vespers*.
4. We are not speaking here of the more outward purpose of censing, which is
to purify the place of sacrifice and ward off evil 'influences', this being well-known.

liturgy, and are going to see that it governs the whole rite of incense. In the offering, the resin then is 'sacrificed'. With its gross form obliterated by the fire, born of the sun, the material is made evanescent and returns to its celestial source; 'earth' is transformed into 'heaven'. It is a sign of the sacrifice of the heart, which must be ignited by the Divine Fire:

> May the Lord light the fire of His love in us and the flame of eternal Charity', recites the celebrant, and in commenting on this rite, St Gregory the Great claims that 'the holy soul makes of her heart a censer which exhales its fragrances before God.

The gestures involved in censing, so minutely regulated, emphasize the solar character and significance of the rite. These movements are the circumambulation, the circular censing, and the vertical censing. First, the circumambulation, during the course of which the celebrant circles the altar while swinging the censer. This ritual movement around the altar is not peculiar to censing, for, at least in the Byzantine rite, it is also made for the procession of the Gospel; besides, a procession is more or less always a circumambulation made either around the temple, if on the outside, or around the altar, if on the inside. In both cases, it is a question of a movement around the Center, the *omphalos*, and this movement imitates the march of the sun and the movement of life around the immobile axis of the world. The aim of this ritual march is to become imbued with the 'virtue' that emanates from the center and to cause it to radiate over the world.[5] This is patently the same goal pursued by the cruci-circular censing that is done at the moment of the offertory and before the circumambulation. Although it occurs in all the rites, we shall describe it according to the Syrian ritual, in which its meaning is far more strongly apparent. First the officiant

5. Usually the circumambulations are made from left to right, in the direction of the sun's displacement. A delicate point, as far as we are concerned, is that the circumambulations of our liturgy are made in the opposite direction, that is, to the left. The latter are related to a polar symbolism (which is known to Islam). Now, one sees hardly any traces of polar orientation in the Catholic liturgy. In spite of all our research we have not been able to shed any light on this point.

censes the offerings in the form of a cross, and the rubrics specify that the intention is thereby to send the incense to the four cardinal points in the following order: east, west, north, and south. Then he censes them in the form of a circle. Thus, the censing is done according to the essential figure studied at the beginning of this book, a cross inscribed in a circle, which is the diagram of the universe, the tracing of which is the initial operation in the construction of the temple—a further harmony is thus revealed between the structures of the temple and liturgy. As we have seen, this is also the figure of the terrestrial paradise and of the cosmic mountain with the four oriented rivers that symbolize it. It is most significant that this figure is traced with the incense above the offerings placed upon the altar, for the altar represents Golgotha and Mount Zion with the immolated Lamb whence flow the four rivers sprung from the fountain of life, the image of Paradise regained, of the regenerated universe.[6] In our opinion, there can be no doubt that the rite of cruci-circular censing is a different way of affirming and realizing the extension of the redemption to the entire universe, an extension symbolized by the Cross, the four branches of which correspond to the cardinal points forming the name Adam,[7] the New Adam, who is to be offered on the altar;[8] but in another way it is also a concentration, a synthesis of the universe reduced in its essential 'lines' to its divine center and marked with the sign of salvation. The world, thus brought together from the four horizons, is to be offered and therefore *raised* to heaven. This is the object of the third, vertical, censing, which is done before the image of the crucifix. That its meaning surpasses that of a simple homage to the image of Christ, however, is proved by the prayers accompanying it:

O Lord, may this incense, blessed by Thee, *rise* to Thee and may Thy mercy *descend* upon us.

6. See above, p107.
7. See above, p39.
8. The ritual of the Syrian Jacobites contains this incensing prayer: 'The whole of creation is saturated with the fragrance of Thy divine sweetness. Grace is spread over all creatures.'

> May my prayer rise to Thee, like the smoke of incense in Thy presence, and my *up-lifted* hands, like the evening sacrifice.

The column of smoke that rises following the direction of the axial pillar, which in a way it materializes, rejoins the corner-stone, or key of the vault, which it thus reunites with the altar stone and, finally, passes symbolically beyond the vault to pursue its way even to the summit of heaven, a fiery vehicle that leads prayer up to the divine throne and thence brings down blessings upon the earth. *Incensum istud ascendat ad te et descendat super nos misericordia tua.* Our interpretation here is by no means the fruit of our imagination, but is modelled upon a fundamental and universal sacred pattern. It has been demonstrated in a decisive fashion with regard to the Vedic sacrifice: the smoke of the sacrifice is likened to the world axis; it conveys prayer up to the temple vault, to the eye of the dome, the opening that plays the same role as the key of the vault in our build-ings,[9] and is identified with the door of heaven. Then the souls of the officiant and the faithful mount 'in the footsteps of Agni' (the divine Fire), and, in return, heavenly grace descends to earth fol-lowing the same axis.[10] The rite of the calumet, the principal rite of the Sioux Indians, which is accomplished in their tradition accord-ing to the essential cruci-circular figure, is in the same pattern. The

9. This 'eye' can be found in Eastern and certain Western churches dating from the classical age, but inspired by ancient monuments, like the Pantheon of Rome. This opening is a souvenir of the hole made at the apex of the first hut and also found today in those of the American Indian or in the 'yurt' of the Siberian sha-man. This opening has everywhere been thought of as symbolizing the 'door' through which one escapes from this world to heaven. Regarding this, there is an altogether significant tradition about the Church of the Ascension, built on the top of the Mount of Olives directly above the place where Christ was raised to heaven. It is said that when the vault of the sanctuary was to be closed, an obstacle arose: 'The stones would not stay in position and fell as soon as they were placed. The fin-ishing of the *highest part* of the building had to be abandoned, so that it *remained open* as if to teach men that the way inaugurated on the Mount of Olives by Emmanuel is always accessible to them, and that they should ceaselessly aspire to rejoin their Divine Head who awaits them in the heavens' (Dom Guéranger, *L'Année liturgique*, Temp pasc. III, p256).

10. A.K. Coomaraswamy, *Janua Coeli* (in *The Door in the Sky*, pp6–61).

bowl of the calumet is filled with pinches of an aromatic herb,[11] placed according to the directions of space so as to concentrate symbolically the whole of creation in the bowl: 'In this herb is the earth and everything inhabiting it,' and to offer it to God: 'We offer Him everything in the universe.' Man, who summarizes all creatures and thereby occupies a central position in the world, is identified with both the calumet and the fire that transmutes the herb into smoke in order to send it to heaven, thereby announcing that everything created returns to God ('May the way of Thy people be as this smoke').[12]

Thus the rite of censing, like the liturgical texts themselves, reveals for us this inner architecture of the Mass arranged about the cross, which, in its turn, reveals the whole import of the holy sacrifice. The latter is truly the spiritual integration of man and universe and their transmutation. According to the horizontal axis of the cross, the whole universe, summarized in the temple, and every man of all the ages, symbolized by the congregation of the faithful, are brought back to the unity around a center, the stone of the altar. Indeed, the first stage of the Holy Mysteries is the passage from the circumference to the center, the 're-gathering' of what was 'scattered'. On the stone of the altar, which is the point of intersection of the horizontal axis of the great cosmic cross with its vertical axis, the second stage of the Mysteries is realized: the assumption of the universe and man, both integrated in Christ. They are raised along the axial pillar towards the 'door of heaven', the key of the vault, pass through it, and reach the abode of the sun. This subtle architecture, which can be made out, as in filigree, by means of the volumes and forms of the material temple, is the very architecture of the spiritual temple, the 'living stones' of which pile up and rise higher by forming the tree of the cross.

11. The ritual tobacco, which among these peoples plays the same role as incense.

12. Black Elk, *The Sacred Pipe*, p 24.

BIBLIOGRAPHY

The problem of sacred art as it currently concerns the art of church building, has been very thoroughly aired in Otto R. Hoffmann's little book, *Der moderne Kirchen bau ein christlicher Tempel?* (1976). A different point of view can be read in *La Maison Dieu*, 63, (1960), 'Batir et aménager des églises', and *Art sacré*, Sept.–Oct., 1960.

The traditional conception of sacred art has been expounded by F. Schuon in 'The Question of the Forms of Art', in *The Transcendent Unity of Religions*, 1953; 'Aesthetics and Symbolism' in *Spiritual Principles and Human Facts*, 1954; 'Principles and Criteria of Universal Art' in *Castes and Races*, 1959; T. Burckhardt, *Sacred Art in East and West*, 1969; A.K. Coomaraswamy, *The Transformation of Nature in Art*, 1956, *Christian and Oriental Philosophy of Art*, 1956; L. Benoist, *Art du monde*, 1941; various authors in 'l'Art traditionnel', special number of *Le Voile d'Isis* (April 1953); and finally R. Guénon, *The Reign of Quantity and the Signs of the Times*, *The Great Triad*, *The Symbolism of the Cross*, 'The Symbolism of the Dome', 'The Exit from the Cave', 'The Mountain and the Cave', 'The Narrow Gate', 'The Cornerstone', '*Lapsit exillis*', 'Concerning the Two St Johns', 'The Solstitial Gates', 'The Solstitial Symbolism of Janus', 'The Zodiac and the Cardinal Points', 'Brute Stone, Hewn Stone', 'The Octagon', 'The Cave and the Labyrinth', 'Frameworks and Labyrinths' in *Symbols of Sacred Science*. (Although they are connected with different chapters of our book, we cite here all the works of Guénon used by us because, over and above their specific subject matter, these articles often deal with very general doctrinal views, upon which we have relied in the very conception of our inquiry.)

General works on religious symbolism include J. Kreuser, *Christliche Symbolik*, 1868 (totally forgotten, but good); Abbé Auber,

Histoire et théorie du symbolisme religieux avant et depuis le Christianisme, 1884; A.M. Didron, *Christian Iconography*, 1965; M.M. Davy, *Essai sur la symbolique romane*, 1955; R. Gilles, *Le symbolisme dans l'art religieux*, 1961; G. de Champeaux and Dom S. Sterckx, *Introduction au monde des symboles*, La Pierre qui vire, 1966; O. Beigbeder, *Lexique des symboles, idem*, 1969; L. Charbonneau-Lassay, *Le Bestiaire du Christ*, 1940 (reprinted 1974, abridged Eng. trans. 1991); '*Valeur permanent du symbolisme*', special number of *La Maison-Dieu*, 22 (1950).

One will also find a great deal of information on the symbolism of churches in E. Mâle, *Religious Art in France: The Twelfth Century* (1977), *Religious Art in France: The Thirteenth Century* (1985), *Religious Art in France: The Late Middle Ages* (1987), and *Chartres*, (1985); H. Focillon, *Art of the West*, 1963; T. Koves, *La formation de l'ancien art chrétien* (space, composition, plastic conception), 1927; R. Rey, *L'art roman et ses origines*, 1947; E. Panofsky, *Gothic Architecture and Scholasticism*, 1951; K.J. Conant, *Benedictine Contributions to Church Architecture*, 1949; J. Froment, *Spiritualité de l'art roman*; L. Gillet, *La cathédrale vivante* (with the complete reproduction of the album of Villard de Honnecourt), 1964; J. Gimpel, *Les Batisseurs de cathédrales*, 1959; Chr. Jacq and F. Brunier, *Le message des bâtisseurs de cathédrales*, 1974; P. de Colombier, *Les chantiers des cath-édrales*, 1973; J. Reyor, '*Du compagnonnage et de son symbolisme*' in *Voile d'Isis* (April, 1934); L. Benoist, *Le compagnonnage et les métiers*, 1966; above all in three fundamental works: H. Sedlmayr, *Die Entstehung der Kathedrale*, 1950: Otto von Simson, *The Gothic Cathedral*, 1962; T. Burckhardt, *Chartres and the Birth of the Gothic Cathedral*.

Among works considering more especially the symbolism of Christian buildings in relation to theology and liturgy: Denis the Areopagite, *The Celestial Hierarchy*, in *Pseudo-Dionysius, the Complete Works*, trans. Colm Luibheid, 1987; Maximus the Confessor, *Mystagogia* in *Selected Works*, 1985; Simeon of Thessalonica, *Traité du saint temple (Peri tou haghiou naou)*, in Migne's *Patrologia Graecae*; Mason, Neale and Webb, *The Symbolism of Churches and Church Ornaments* (with essential pages from Durandus of Mende's

Rational of the Divine Offices); Alan W. Watts, *Myth and Ritual in Christianity*; J. Daniélou, *The Presence of God*, 1959; J. Sauer, *Die Symbolik des Kirchengebäudes und seiner Ausstattung in der Auffassung des Mittelalters*, 1902; J. Jungmann, *Die Symbolik der Katholischen Kirche*, 1960; L. Sprink, *L'art sacré en Occident et en Orient*, 1962 (one will find a great deal of information and interesting views in this book, even if one does not agree with the fundamental thesis of the author); some unsuspected perspectives sometimes come to light in J. Tourniac, *Symbolisme maçonnique et tradition chrétienne*, 1965, *Les tracés de lumière*, 1976.

On the Platonic origins of mediaeval cosmology, by way of Saint Augustine and Denis the Areopagite: O. von Simson, op. cit., chap. 1; R. Klibansky, *The Continuity of the Platonic Tradition during the Middle Ages*, 1939.

On the temple as image of the heavenly city, besides Denis the Areopagite, Maximus the Confessor and Simeon of Thessalonica (cf. *Supra*): A. Stange, *Das frühchristliche Kirchengebäude als Bild des Himmels*, 1950; J. Baltrusaitis, 'L'image du monde céleste du IXe au XIIe siècle' in *Gazette des Beaux Arts*, 6e ser., 20 (1938); A. K. Coomaraswamy, 'Mediaeval Aesthetics' in *The Art Bulletin*, 17, (1935).

On the temple as image of the cosmos: M. Eliade, *History of Religious Ideas, Images and Symbols*, 1991, 'Sacred Space and the Sacralization of the World' in *The Sacred and Profane*, 1968; P. Gordon, *L'image du monde dans l'Antiquité*, 1949, *Le sacerdoce à travers les âges*, 1950; '*Le Symbolisme cosmiques des monuments religieux*', Annales du Musée Guimet, 1953; L. Spitzer, 'Classical and Christian Ideas of World Harmony' in *Traditio* II (1944), III (1945); J. Baltrusaitis, *La Cosmographie chrétienne dans l'art du Moyen Age*, 1939; T. Burckhardt, 'La genèse du temple hindou' in *Etudes traditionnelles* (Oct. 1953); L. Hautecoeur, *Le symbolisme du cercle et de la coupole*, 1954; A. K. Coomaraswamy, 'Symbolism of the Dome' in Historical Quarterly, 14, 1938; A. H. Allcroft, *The Circle and the Cross*, I–II, 1927–1930; W. Müller, *Kreis und Kreuz*, 1938; and the articles of R. Guénon cited above.

On geometry and numbers in the art of building: E. Moessel, *Die Proportion in der Antike und Mittelalter*; F.M. Lund, *Ad Quadratum*, I–II, 1921; Matila C. Ghyka, *The Geometry of Art and Life*, 1977, *Le Nombre d'or*, I–II, 1931, *Essai sur le rythme*, 1938, Gyorgy Doczi, *The Power of Limits: Proportional Harmonies in Nature, Art and Architecture*, Petrus Talemarianus, *De l'architecture naturelle*, 1949; Ch. K. Ledit, *La cathédrale au nombre d'or*, Tetraktys (Troyes), 1960, *Les chanoines de Pythagore*, 1960, *La mosquée sur le roc*, 1966, *A l'Orient de France*, 1973 (2nd ed. 1976), *Visages de Troyes*, Zodiaque, 26, 1955.—The review *Les Cahiers du Nombre d'or*, Paris.

On gematria in Christian architecture: Mgr Devoucoux, *Notes relatives à l'architecture sacrée et en particulier au rôle de le gématrie* in Edme Thomas, *Histoire de l'antique cité d'Autun*, Autun, 1846, the most important pages of which were republished in *Etudes traditionnelles*, March 1947, and Dec. 1952 to June 1957; Ch. Ledit, op.cit.

On ritual orientation: H. Nissen, *Orientation*, 1906-1910; Cyril Vogel, 'Sol aequinoctialis' in *Rev. des Sc. religieuses*, 1962, 175–211, 'Versus ad Orientem' in *La Maison-Dieu*, 70, 1962, 'L'orientation vers l'Est' in *L'Orient syrien*, 9, 1964, 3–35; E. Peterson, 'La croce e la preghiera verso l'oriente' in *Ephemer. liturg.*, 59, 1945.

On alchemical symbolism in cathedrals: Fulcanelli, *Le Mystère des Cathedrales*, 1971, *The Dwellings of the Philosophers*, 1999.

On the temple as image of the body of man: besides the general works on medieval art and the history of religions (for example the works of Eliade already cited), T. Burckhardt, 'Le temple corps de l'homme divin' in *Etudes traditionnelles*, June 1951; R.A. Schwaller de Lubicz, *The Temple of Man*.

On the temple as the Mystical Body: J.C. Plumpe, 'Vivum Saxum, vivi Lapides' in *Traditio* I, 1943, 1–14.

On the door, essentially: T. Burckhardt, 'I am the door' in *Sacred Art in East and West*.

On labyrinths: *The Labyrinth*, ed. by S.H. Hook 1935; W.F. Jackson Knight, *Cumaean Gates*, a reference of the Sixth Aeneid to Initiation Pattern, 1936; K. Kerenyi, 'Labyrinth Studien', *Albae Vigilae*, 15, 1941; P. Santarcangeli, *Le Livre des labyrinthes*, 1974; A.R. Verbrugge, *Labyrinthes archéologiques*, catalogue of 70 specimens with illustrations, 'Les labyrinthes d'église' in *Archaeologia*, May-June 1967 and *Atlantis*, March–April 1976; and R. Guénon's articles cited above.

On the altar: J. Braun, *Der christliche Altar*, I–II, 1924; F. Duquesne, 'Le symbolisme mystique de sanctuaire chrétien' in *Les Cahiers du symbolisme chrétien*, I–III, 1938; 'Le Mystère de l'autel', special number of *Art sacré*, 3–4, 1955; and R. Guénon's articles on the cornerstone cited above.

On the notion of the temporal and liturgical cycles: M. Eliade, *The Myth of the Eternal Return*, 1971; O. Casel, *The Mystery of Christian Worship*, 1962; L. Bouyer, *Rite and Man*, 1963; H. Rahner, *Greek Myths and Christian Mystery*, 1963.

On the symbolism of the sun and light: F.K. Dölger, *Sol salutis*, 1925, *Lumen Christi* (Antike und Christentum 5, 1936); A. Audin, *Les fêtes solaires*, 1945; the collections published by *Nouvelles de Chrétienté*: Num. 213, 1959 'Lumen Christi' and Num. 154, 1957 'O Oriens'.

Lightning Source UK Ltd.
Milton Keynes UK
UKOW042040280513

211391UK00001B/317/P